Modern Dreams

Dreams

The Rise and Fall and Rise of Pop

The Institute for Contemporary Art
The Clocktower Gallery
New York, New York

The MIT Press
Cambridge, Massachusetts
London, England

Lawrence Alloway
Reyner Banham
Judith Barry
Leo Castelli
John Coplans
Tom Finkelpearl
Kenneth Frampton
Howard Halle
Richard Hamilton
Dick Hebdige
Alanna Heiss

Betsey Johnson
Thomas Lawson
Edward Leffingwell
Roy Lichtenstein
Claes Oldenburg
Patricia Phillips
Alison and Peter Smithson
Eugenie Tsai
Brian Wallis
Glenn Weiss
Graham Whitham

Modern Dreams: The Rise and Fall and Rise of Pop, accompanies the "The Pop Project," a series of exhibitions presented by The Institute for Contemporary Art developed for The Clocktower Gallery, from October 22, 1987, through June 12, 1988. The four-part series of exhibitions consisted of *This Is Tomorrow Today,* curated by Brian Wallis; *Public Image: Homeless Projects by Krzysztof Wodiczko and Dennis Adams,* curated by Tom Finkelpearl; *Present Tensions: 25 Years of Irreverence in Architecture,* curated by Patricia Phillips and Glenn Weiss; and *Nostalgia As Resistance,* curated by Thomas Lawson.

"The Pop Project" is sponsored in part by a grant from the National Endowment for the Arts and Jay Chiat. Additional support has been provided by the New York State Council on the Arts, and the David Bermant Foundation: Color, Light, Motion.

Modern Dreams was supported in part by the Booth Ferris Foundation and The New York Community Trust. *This Is Tomorrow Today,* a publication produced in a limited number of copies, was printed on the occasion of the first exhibition in "The Pop Project" series.
Its contents are included in the first section of *Modern Dreams.*

The Clocktower Gallery, 108 Leonard Street, New York, New York 10013, and P.S. 1 Museum, The Institute for Contemporary Art 46-01 21st Street, Long Island City, New York 11101, are non-profit centers for contemporary art committed to the presentation of a broad range of artistic activities in various media through exhibitions, performances, film, and video screenings, and related activities.
The Clocktower Gallery's facility is owned by the City of New York. Its operations are supported in part by the Department of Cultural Affairs, City of New York.

Design: Lawrence Wolfson *Design*
Project Editors: Edward Leffingwell, Karen Marta
Project Director: Tom Finkelpearl

Contents

6 Edward Leffingwell
Introduction

9 Brian Wallis
**Tomorrow and Tomorrow and Tomorrow:
The Independent Group and Popular
Culture**

19 Thomas Lawson
**Bunk: Eduardo Paolozzi and the Legacy
of the Independent Group**

31 Lawrence Alloway
The Long Front of Culture

35 Graham Whitham
**This Is Tomorrow: Genesis of an
Exhibition**

41 Judith Barry
**Designed Aesthetic:
Exhibition Design and the Independent
Group**

47 Kenneth Frampton
**New Brutalism and the Welfare State:
1949–59**

53 Alison and Peter Smithson
But Today We Collect Ads

57 Richard Hamilton
Persuading Image

65 Reyner Banham
Vehicles of Desire

71 Eugenie Tsai
**The Sci-Fi Connection: The IG, J.G.
Ballard, and Robert Smithson**

77 Dick Hebdige
In Poor Taste: Notes on Pop

87 Leo Castelli, John Coplans, Alanna Heiss, Betsey
Johnson, Roy Lichtenstein, and Claes Oldenburg
An Observed Conversation

105 Claes Oldenburg
I am for an art that . . .

111 Tom Finkelpearl
**Public Image: Homeless Projects by
Krzysztof Wodiczko and Dennis Adams**

119 Patricia Phillips
Why Is Pop So Unpopular?

133 Glenn Weiss and Edward Leffingwell
**The Necessity of Walls: The Impact of
Television on Architecture**

145 Howard Halle
A Brokerage of Desire

151 Thomas Lawson
Nostalgia as Resistance

172 Alanna Heiss
Afterword and Acknowledgments

176 Bibliography

184 Index

Introduction

Images, objects, ideas, and materials drawn from everyday life ornament the history of modern art. By the Eisenhower era of the 1950s, however, artists, architects, and critics began to transform this source material in ways that changed the way we see. The work of these pioneers overtly stimulated new generations to think about popular culture and its implications for the contemporary material world. Their focus implied a permission to look at everything.

The voices brought together in this book constitute a diversity of views that acknowledge a distinction between the theoretical and sociological production of London in the fifties and conceptually related work of New York in the eighties. The effects of media images, particularly those communicated by photographs and television, can be read in the objects and theoretical strategies presented by the artists, architects, and writers included in this publication and the exhibitions that are its source.

In the process of assembling the contents of this book, it became evident that certain members of the Independent Group—particularly Richard Hamilton, Peter and Alison Smithson, Reyner Banham and Eduardo Paolozzi—have a specific, continuing impact on a younger generation. Their names appear again and again in the pages of this book, cross-referencing art, architecture, and the theoretical. This invigorated embrace of the theoretical has something of a moral or ethical position of great interest to the authors of this publication. The stance signals a regard for discourse in the face of the proliferation and ubiquity of mass media in an art scene that has taken on the characteristics of mass media: ephemeral celebrity, rapid communication, disposability, interchangability, commodification.

Initially, this project of publication and exhibitions intended to focus on four areas of investigation: the work of the Independent Group as proto-Pop; the utilization of art-related technology and imagery as a kind of agit-Pop of the streets; the examination of the possibilities of archi-Pop, its theoretical ramifications and qualified accomplishments; and the self-referential, picture-oriented production of post-Pop. It became known to the participants as "The Pop Project," and in October, 1987, the Clocktower presented the first of these exhibitions, *This Is Tomorrow Today*. Working closely with a team of artist-preparators and exhibition theoreticians, curator Brian Wallis and project editor Karen Marta, with project coordinator Tom Finkelpearl, produced a detailed document that objectified the sociological and anthropological underpinnings of the Independent Group (pages 9–85). The exhibition provided a first-hand look at the archives of the group in some detail and examined their interest in the shards of the machine age as found in the products and images of American culture. At the heart of this presentation lies an interest in display and the possibilities of the exhibition format.

This Is Tomorrow Today prompted a conversation between a group of individuals whose names are closely linked to the phenomenon and rise of Pop as an expressive and ironic art. The participants, including Roy Lichtenstein, Claes Oldenburg, Betsey Johnson, John Coplans, and Leo Castelli, met in the pavilion installations of The Clocktower Gallery. There, led by Alanna Heiss, the participants examined not only the effects of London's Pop achievements, but revealed their own

thoughts about the sources of their work and considerations about the output of a later generation of media-affected artists.

Among earlier writings reprinted in this volume, Claes Oldenburg's Whitman-like ode-cum-manifesto of the temporal, written by the artist in the early 1960s, has a freshness and immediacy that remains valid today. The "I am for an art that . . ." refrain emphasizes the radical nature of Oldenburg's thinking and serves as a codification of concerns voiced in "An Observed Conversation."

The second exhibition, *Public Images: Homeless Projects by Krzysztof Wodiczko and Dennis Adams,* stepped directly into the cultural environment in a way that commented on, rather than glorified, the conditions of the present. In his essay, curator Tom Finkelpearl explores the conscience of the artist who addresses contemporary problems by utilizing the tools and images drawn from the sources or protagonists of those problems. That Wodiczko effects collage by projection, ephemerally, or that Adams radically uses the vehicle of portraiture in an architectural surround, does not qualify the ends of political comment.

Patricia Phillips and Glenn Weiss explored the viability of Pop as source material for the phenomenon of Pop architecture. In her essay, Phillips analyzes relevant players and their production, from Archigram and Venturi to SITE, assessing not only realized projects but also the importance of theoretical programs. Phillips comments succinctly on the failure of Pop architecture to forge any lasting contribution on a level commensurate with the vernacular. Much of Phillips' argument can be abstracted to apply to areas other than architecture, as the interdisciplinary characteristics of Pop's beginning seek application and the rudiments of style in practice.

Weiss brings his thoughts to bear on the impact of the photograph as a means of representation and the situational force of television's pervasive influence on architecture. In the redacted interview "The Necessity of Walls." the curator calls for an awareness of the possible meanings of an observant, committed architecture

intellectual responsibility, without discarding the appropriate enjoyment of style.

Howard Halle's cultural critique outlines the ahistoricizing impact of the media on the meaning and distribution of art. In his essay "A Brokerage of Desire," Halle identifies the role cultural institutions and corporations play in the commodification of art.

In *Nostalgia As Resistance,* Thomas Lawson brings our increasingly pointed investigation to a conclusion, if not to a close. Like Tocqueville, Lawson sees the acceptance of the most dissident comment as a sign of the problem of potency in an age that has mastered the logic of appropriation as a means of co-optation of dissent. He examines Pop in New York over the last ten years. In something like harmony with other voices heard in this publication, he offers a hope for an advance through ". . . the discovery of talk as an antidote to the unremitting tyranny of the all-seeing," the omnipresent scrutiny of mass media.

The production of Pop may be the entrails through which we understand our collective past and individual futures. There is something of a seduction and a surrender to the lures of cultural attraction, but an insistent self-awareness and a sense of dissatisfaction, even at the moment of celebration, implies a sense of the artist's call for the humanization of our environmental machinery.

It has not been the intention of this publication to explore every facet of Pop's development or to allude to all its sources. Rather, it is a cataloging and representation of specific moments, creators, and ideas that are germane to the larger question of the role of complex culture in the fabrication of art and the generation of ideas. The exhibitions and publication taken together consider the issues faced by the producer of art in the last thirty years, their impact on the user or consumer of the product, and the concomitant impact that work has effected within the culture itself.

Edward Leffingwell

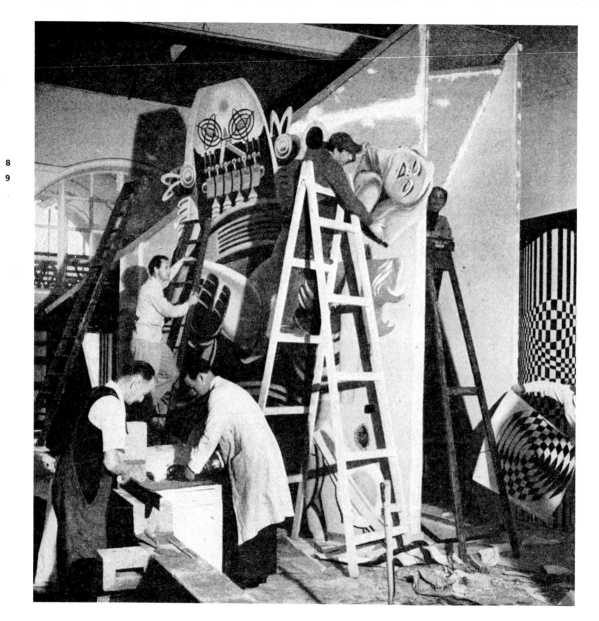

Brian Wallis

Tomorrow and Tomorrow and Tomorrow:
The Independent Group and Popular Culture

Just inside the entrance to the exhibition *This Is Tomorrow*, which opened at the Whitechapel Art Gallery on August 8, 1956, visitors encountered a most unexpected structure. Shaped like a house of mirrors or a distorted duck blind, this odd piece of architecture incorporated familiar images from the repertoire of popular culture: billboard-size robots, optical illusions, Marilyn Monroe, advertisements, a rock 'n' roll jukebox, a giant beer bottle, and a cineramic wall of film posters. This cacophonous installation, designed by Richard Hamilton, John McHale, and John Voelcker, must have seemed to many visitors like a noisy intruder in the sanctimonious realm of the art exhibition. Instead of embodying the cerebral and contemplative aspects of geometric abstraction as did many of the other eleven installations in *This Is Tomorrow*, the Hamilton-McHale-Voelcker funhouse impudently asserted the impermanent, the pleasurable, and the sensorily jarring. As a result, the installation was immensely popular. Children from the working-class neighborhood came in off the street to hang out by the jukebox, critics loosened their aesthetic criteria, and many viewers explored the exhibition no further than this whimsical installation just inside the door. In its obvious playfulness, its reliance on recognizable, mass-produced representations, and its alliance with the culture of a wider audience, the funhouse installation challenged the exclusivity of the dominant ways of regarding art, and opened an avenue for a more democratic analysis of art and cultural criticism.

By virtue of this insertion of popular imagery into the context of fine art, *This Is Tomorrow* (and, in particular, the Hamilton-McHale-Voelcker pavilion) is frequently cited as the source of the pop art movement. But such a reductive and linear notion of art history only encour-

ages the idealized and purely stylistic version of aesthetics which the participants specifically sought to repudiate when they asked mockingly in the catalogue, "Are We Cultured?" Certainly their impulse in drawing elements of popular culture into the orbit of *This Is Tomorrow* was not to argue for their inherent beauty as cultural forms or to validate their insertion into the fine art context. But neither, apparently, was it an attempt to critique the capitalist structure of the cultural industry or, by extension, the prevailing manipulations of the American mass culture. In this sense the proto-pop artists who participated in *This Is Tomorrow* and who, for the most part, also participated in the activities of the Independent Group, defied the critical readings that theorists of the left and the right later applied to Pop Art. Instead, the members of the Independent Group embraced contemporary American popular culture— picture magazines, Hollywood movies, fintail Cadillacs, advertising, science fiction—with the whole-hearted enthusiasm of consumers. Their interest in what was generally regarded as low culture or kitsch was founded not on aesthetic or political principles, but on the fundamental allegiance to an entire range of representations to which they, as a particular generation, were particularly responsive.

That this advocacy of mass culture was shaped by a utopian vision is reflected in a group photo taken of Hamilton, McHale, and Voelcker (as well as Terry Hamilton and Magda Cordell) just before the opening of *This Is Tomorrow*. Posed amidst the incomplete structure of their installations, as if interrupted in their activity, they personify the transformative idealism of earlier constructivist projects. Recalling specifically the images of Tatlin and his assistants building the model of the *Monument*

to the Third International, this group photo clearly identifies an underlying purpose for the extended program of studies in popular culture initiated by the Independent Group: to build a new society. The link between constructivism and its social purposes in post-revolutionary Russia and the transformative capacities of popular culture in postwar England depended on a faith in a radically different future which would be born out of the concrete reality of the present. This "latency of being to come," equivalent to Ernst Bloch's "figures of hope," is what the members of the Independent Group found in the familiar, but largely overlooked, sign systems of popular culture.[1] The sudden occurrence of this potentiality for social change—this "concept utopia"—signalled for the Independent Group the hope for the future in the present, a hope reflected in the bold title *This Is Tomorrow.*

Inevitably, such a radical formulation of the utopian ingredients of popular culture was the result of both a protracted study and a particular historical moment. For this reason it is especially complicated to attempt to recuperate and to reinvest with meaning the original theoretical issues raised by the Independent Group. As with all historical inquiries, however, this attempt to reanimate the past is intended to discover the relevance it retains for the present. The early demythologizing investigations of the Independent Group, their acceptance of the mass cultural forms of advertising, commerical film, and television, and their efforts to abolish the hierarchical distinctions between high art and popular culture, all find their reflections in the interests of contemporary artists and critics in the persuasive distortions of the media, the complicities of art and consumerism, and the subversive potential of popular culture forms. A reinvestigation of the critical approach of the Independent Group, then, holds the potential for allowing us new access to the critical issues of today.

The Independent Group was formed rather inauspiciously in early 1952 by young members and staff of the Institute for Contemporary Arts (ICA). From the start it was conceived of as a rather informal seminar or study group in which the members could meet to discuss

issues of relevance to contemporary art and culture. As a result, the formation of the ideas and positions of the group emerged as part of a dialectical process, rather than in the assertion of position papers or manifestos. Although many of the ideas generated in the Independent Group sessions eventually found their way into the artworks, writings, exhibition designs, buildings, and publications of the participants, the most coherent understanding of the shifting nature of their sharply debated positions can be found in the schedule of their discussions. The discourse engaged in by the group is as important as the artworks they produced and is of critical importance for understanding their contribution to cultural studies. Yet, due to the ephemerality of discourse, it is precisely this side of the Independent Group that is often omitted from art-historical surveys.

The ICA formed a significant context for these group discussions because of its own curious relationship to the history of modernism. Originally conceived during the International Surrealist Exhibition in London in 1936 by E.L.T. Mesens and Roland Penrose, the idea of a museum of modern art in England was briefly revived by Mesens and Peggy Guggenheim during World War II.[2] Finally incorporated by a larger committee including Herbert Read, the ICA was officially announced in 1946. From the start the idea was to perpetuate the premises of English surrealism and to emulate the ideological take on modernism provided by the Museum of Modern Art in New York.

At that time, the particular brand of liberal modernism advocated by the ICA was characterized by the writings of Herbert Read, the ICA president. Through a series of influential books, particularly *Art and Industry* (1934), Read advocated a view of modernism derived from Bauhaus principles and stressing functionalism, economy of material, and clarity of form. Read, however, injected into this harsh continental purism an appeal to tradition and for an enlightened humanism which would maintain within the technological propensity of modernism an expression of human feelings. What Reyner Banham later called "the marble shadow of Sir Herbert Read's Abstract-Left-Freudian aesthetics"[3] provided not only the direction for the ICA's crusade on behalf of mod-

[1] On the utopianism of Ernst Bloch, see Fredric Jameson, *Marxism and Form* (Princeton: Princeton University Press, 1974), pp. 116–159, and Tom Moylan, "The Locus of Hope: Utopia Versus Ideology," *Science-Fiction Studies,* no. 9 (1982): 159–166. Bloch's *Das Prinzip Hoffnung* (1959) has recently been translated as *The Principle of Hope,* trans. Neville Plaice, Stephen Plaice, and Paul Knight (Cambridge, Mass.: MIT Press, 1986), 3 vols. Also see, Maud Lavin, "Advertising Utopia: Schwitters as a Commercial Designer," *Art in America* 73, no. 10 (October 1985): 135–139, 165.

[2] The early history of the Independent Group, in particular its relationship to the founding of the ICA and English Surrealism, is given in Anne Massey, "The Independent Group: Towards a Redefinition," *Burlington Magazine* 129, no. 1009 (April 1987): 232–242.

[3] Reyner Banham, "Futurism for Keeps," *Arts Magazine* 35, no. 3 (December 1960): 33.

Richard Hamilton, *This Is Tomorrow*, 1956. Collage, 8¼ x 8¾ in. (21 x 22.1 cm). Museum Ludwig, Cologne.

Hamilton-McHale-Voelcker pavilion entrance.

ernism, but also the catalyst for the hostile rejection of modernism by members of the Independent Group. As Richard Hamilton recalled, "If there was one binding spirit amongst the people at the Independent Group, it was a distaste for Herbert Read's attitudes."[4] Those attitudes, governed by a belief in the transcendental nature of art, in a hierarchical stratification of styles and forms based on quality, and in the heroic figure of the individual creative genius, provided an immediate foil for the emerging theoretical position of the Independent Group.

12

13

The first indication of the formation of the Independent Group is provided by a brief note in the minutes of the ICA subcommittee on lecture policy in January 1952. There Anthony Kloman reported that "a committee of young members of the ICA connected with the arts had recently been formed and has made the following suggestions for lectures: one by A.J. Ayer; one on Decadence in Twentieth Century Art; on Mannerism in Art, with a separate lecture on Mannerism in Twentieth Century Art; and on Photography. Mr. [Peter] Watson added that they also asked for a lecture on Existentialism, and on the designs for Coventry Cathedral."[5] A few months later the same lectures were referred to, but the group was now officially designated as the "Young Group."

This early name, though surely generic, emphasizes the generational differences that separated the younger artist-members of the ICA from the older leadership. And nothing could be more different from the interests of that older group than the program of lecturers suggested by the upstart "Young Group." Each suggestion—decadence, mannerism, photography, and existentialism—marked a transgression of the accepted doxa of high modernism. Instead of Read's version of an idealist, Aristotelean aesthetic, the "Young Group" was clearly interested in the more pragmatic, perverse, and psychologically inflected approaches to art which typified the postwar condition. In this respect the request for a lecture on the rebuilding of Coventry Cathedral is emblematic: how could art adjust to and address the conditions of life in the aftermath of the total destructive capability of World War II?

The first meetings of the Independent Group—still called the Young Group—were held in the spring of 1952 under the direction of Richard Lannoy, a young gallery assistant at the ICA. Among the regular members at this time were Richard Hamilton, Nigel Henderson, Eduardo and Freda Paolozzi, Alison and Peter Smithson, William Turnbull, Victor Pasmore, Toni del Renzio, and John McHale. Three meetings were organized by Lannoy before July 1952 when he left for India. Of these, by far the most famous was the first, in April, at which Paolozzi projected tearsheets, postcards, and advertisements. This raw material was selected from Paolozzi's growing image bank and apparently included "some art, some showgirls, some advertisements, radio, television, detail circuitry" as well as specific material later incorporated into various collage scrapbooks and finally into the print series, *BUNK*.[6]

This first meeting already indicated the direction of the group's visual studies: away from fine art toward the randomly assembled variations of mass media reproductions. This imagery was collected from various American magazines which were available and assembled not so much in formalistic collages—such as those of Schwitters or Ernst—but in files of like subject matter. This practice was justified by the group's perusal of the great image collections of high modernism—Amedee Ozenfant's *Foundations of Modern Art* (1924), Laszlo Moholy-Nagy's *The New Vision* (1931), and Siegfried Giedion's *Mechanization Takes Command* (1947)—works that were prized not for their progressive modernist texts, but for their random and non-hieratic collections of scientific, journalistic, commercial, and art images.

If Paolozzi's demonstration contained all the elements necessary for the development of pop art—according to Lawrence Alloway, "a serious taste for popular culture, a belief in multi-evocative imagery, and a sense of the interplay of technology and man,"[7] then the other two meetings organized by Lannoy stressed the diversity of that interplay of technology and man. The second meeting featured an American named Hoppe who presented some sort of avant-garde light show accompanied by music, recalled by Lannoy as "rather short on

[4] Richard Hamilton, "Fathers of Pop," a film by Reyner Banham and Julian Cooper (Miranda Films, London, 1979).
[5] Minutes of the *Meeting of the Sub-Committee on Lecture Policy and Programmes*, January 29, 1952, p. 3 (ICA, London).
[6] For various recollections of Paolozzi's projections, see "Fathers of Pop."
[7] Lawrence Alloway, "The Development of British Pop," in *Pop Art*, ed. Lucy Lippard (New York: Thames & Hudson, 1966), p. 36.

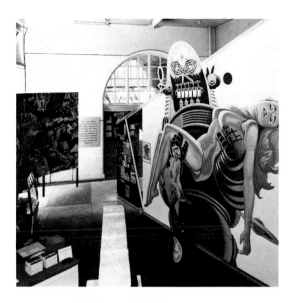
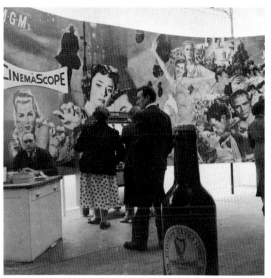

Sequence of views around Hamilton-McHale-Voelcker pavilion.

this is tomorrow

effects, rather delicate, elusive, and low on technology." A third meeting, probably in May, featured an aircraft designer from de Havilland who unfortunately "gave a depressing picture of what it was like to be a small cog in an enormous complex machine . . . with five hundred designers each doing one small thing . . . This picture of the industrial design process was profoundly at variance with the aesthetic of pop culture."[8]

This technological interest of the Young Group soon became the principal focus of the discussions. For after Lannoy left in July and del Renzio served briefly as director of the group, Peter Reyner Banham emerged as the group's leader in September 1952. Banham was at that time a student of Nikolaus Pevsner's at the Courtauld Institute of Art, from which he graduated in 1958 with a thesis later published as *Theory and Design in the First Mechanical Age.* His intensive study of the modern movement in architecture and design involved a rethinking of the emphasis placed on purism, functionalism, and permanence and advocated instead renewed interest in futurist and expressionist trends: toward increased surface decoration, expendability, and engagement with contemporary technologies. This research resulted in his presentation of the lecture, "Machine Aesthetic," to the Independent Group in the 1952–53 season. Also that year, Jasia S. Shapiro spoke on helicopter design, A.J. Ayer lectured on the "Principle of Verification," Peter Floud spoke on "Victorian and Edwardian Decorative Arts," and apparently there was a talk by two crystallographers. These various themes all reflected the general interest within the group in science and technology not so much in terms of technical applications but rather how they transformed the perceptions and social identities of contemporary consumers. Science and design were not apprehended directly, but rather as they were popularly represented: in photography, in diagrams, in X-rays, in films, and in the new technical jargon of the Atomic Age.

These issues were formalized in the following year in a program organized by the Independent Group which sought to address their particular view of the advance of technology in twentieth century culture. This series of

[8] Richard Lannoy, cited in Graham Whitham, "The Independent Group at the Institute of Contemporary Arts: Its Origins, Development and Influences 1951–1961," unpub. PhD. diss., University of Kent at Canterbury, 1986, p. 76.

[9] The assertion of lack of experience came from J.P. Hodin. See minutes of the *Meeting of the Sub-Committee on Lecture Policy and Programmes,* October 13, 1953, p. 1 (ICA, London). The entire program for the series was detailed in a brochure issued by the ICA and in the *ICA Bulletin,* no. 36 (September 1953).

[10] Lawrence Alloway, "Popular Culture and Pop Art," *Studio International* 178, no. 913 (July-August 1969): 18.

nine lectures was formally organized and presented to the public as "Aesthetic Problems in Contemporary Art." Despite objections from within the ICA's Managing Committee that the Independent Group lecturers announced for the series "did not have the necessary experience," the seminars began in October 1953 with Banham's lecture, "The Impact of Technology."[9] In general, the course—which was sold out—sought to define the parameters of art in the fifties through a study of changes brought about by new technologies. The individual lectures treated art and science as equally transformative elements of modern society and stressed the ways in which openness to new ideas from related fields, such as cybernetics, game theory, and semiotics, could rupture the closure of modernist aesthetics.

The following year, 1954–55, the Independent Group resumed its program of private meetings aimed at addressing subjects of interest to the relatively small group. As Banham had resumed work on his PhD. thesis, John McHale and Lawrence Alloway agreed to act as organizers for the year's lectures. Their program marked a significant shift in the nature of the group discussions; from science and technology the primary focus moved to popular culture (see the program, published as an appendix to this catalogue). For the Independent Group, "pop" described the whole field of the new mass culture, primarily American popular culture.

Alloway defined popular culture as "the sum of the arts designed for simultaneous consumption by a numerically large audience. Thus, there is a similarity in distribution and consumption between prints and magazines, movies, records, radio, TV, and industrial and interior design."[10] Moreover, such seemingly diverse forms of representation were—along with the "fine arts"—part of what Alloway called the "fine art/pop art continuum." This referred to a linear, rather than a pyramidal or hieratic conception of images. Asserting the cultural necessity for both high art and popular art, and encouraging a more "anthropological" understanding of cultural representations, this theory proposed an equal status among such forms while acknowledging their differences. As Alloway explained in "The Long Front of

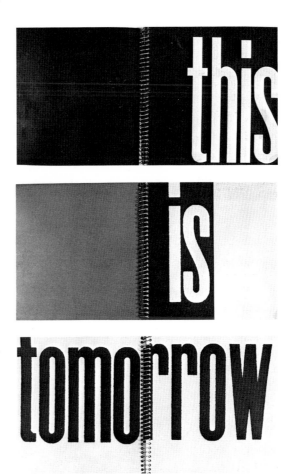

This Is Tomorrow, catalogue designed by Edward Wright, 1956.

Culture," "Unique oil paintings and highly personal poems as well as mass-distributed films and group-aimed magazines can be placed within a continuum rather than frozen in layers in a pyramid . . . Acceptance of the media on some such basis . . . is related to modern arrangements of knowledge in non-hierarchic forms."[11] Clearly, this conception was another effort to deflate the exalted and exclusivist aesthetics of modernists such as Herbert Read and Roger Fry. The fine art/pop art continuum allowed for the consideration of art only within the larger field of information and visual communication. As a form of social experience, Alloway wrote, "all kinds of messages are transmitted to every kind of audience along a multitude of channels. Art is one part of the field; another is advertising."[12] Popular culture was regarded not as "false consciousness," the deliberate manipulation of a passive audience, but as an active agent of social change and individual identity. Members of the Independent Group were quick to point out that popular culture responded in part to economic needs but also to the psychological and social desires of individuals and subgroups. Moreover, as they found, the uses of mass culture were reciprocal with the audience retaining the capacity to appropriate and reshape meanings based on collective needs and responses. In this way popular culture representations and even consumption could embody the hopes, aspirations, and ideals of the viewers for a better future.

Given this unlimited expansion of the concept of representation, the eclecticism exhibited in the sessions convened by McHale and Alloway is not surprising. Lectures on contemporary painting, auto styling, fashion magazines, and non-Aristotelean theory were announced. As explained by Richard Hamilton, the overarching theme of non-Aristotelean logic provided "a very respectable base for rejection and iconoclasm [by saying] that American universities were now putting forward this as a very serious and well-established study. The question of value judgments became so liberating that we were able to say everything we can think of is right and can be used."[13] This complete acceptance of all forms of imagery nevertheless involved a number of paradoxes and conflicts when it came to the enthusiastic reception of

American advertising, styling, and mass culture. For, even given their egalitarian conception that "everything we think of is right," it was difficult to support the "manipulations of capital" when most of the enthusiasts were Leftists who opposed the political system that created the consumer culture. Moreover, it was difficult from the vantage point of British culture not to fantasize about the utopian wish-fulfillment of American advertising, while at the same time attempting to analyze the structure and strategies of its representations. And finally it had to be recognized that their interpretation of consumer culture was still governed by qualitative judgments and iconological systems chiefly supplied for the appreciation of painting and architecture. It is not so much that the Independent Group asserted the primacy of pop culture, then, but that they understood the logic of the interrelatedness of modernism and mass culture. Rather than simply rejecting bourgeois values or high art, they perceived a mutual dependence and source within the structure of late capitalism.

The seminars and discussion groups of the Independent Group yielded no programmatic statements or manifestos. The outcome was largely confined to the critical writings and the exhibition designs of the participants. Some of the ideas also filtered into art works and architecture, but the chief notions of discourse, debate, collaboration, and practice were not translatable into the conventional sign systems of the fine arts. Rather, what emerged was a rough set of working premises, useful for defining an equation of art and everyday life. Among the important and productive notions they advanced were that all cultural images function as signs in a field of communication, and that the sign or the surface warrant analysis as bearers of social meaning—without further reference to inherent or latent symbolism; that authenticity or originality have less meaning than the relative importance of an object or image to a consumer; that any form contains several levels of meaning which can be "read" or used singly or multiply and "played off" one another; and that consumption is a socially legitimate activity which yields potential for individual and collective transformation by embodying certain cultural needs, pleasures, and beliefs.

[11] Lawrence Alloway, "The Long Front of Culture," Cambridge Opinion, no. 17 (1959): 25. (Reprinted in this catalogue, see p. 31.)
[12] Lawrence Alloway, "Personal Statement," Ark, no. 19 (1957): 28.
[13] Richard Hamilton, "Fathers of Pop."
[14] Reyner Banham, "Vehicles of Desire," Art, no. 1 (September 1955): 3. (Reprinted in this catalogue, see p. 66.)
[15] Fredric Jameson, "Reification and Utopia in Mass Culture," Social Text, no. 1 (Winter 1979): 147.

Such formulations obviously depend on a particular understanding of time: a future marked less by stability and continuity than by expendability and planned obsolescence. And these were precisely the terms in which the Independent Group offered their definitions of pop art. Banham, for instance, insisted that modernists had mistaken the nature of technology as something permanent, ordered, and stable, when in fact the essence of mechanical production is expendability. As Banham lamented, ''we still have no formulated intellectual attitudes for living in a throwaway economy.''[14] Expendability referred not only to the limited use of products designed specifically for the limited novelty, but also to the circulation of forms and images—in television, films, magazines—where the only real constant is change. For example, novelty, anti-functional design, and planned obsolescence all contributed the fin-tailed automobile designs of the mid-fifties, designs which dismayed critics, but delighted buyers with an exuberant and whimsical mix of sex, speed, and pleasure.

The aesthetics of expendability would not at first glance seem compatible with the notion of utopia, but it is the very transient nature of desires elicited by popular culture that can be related to an insistent dream of alternatives. As Fredric Jameson has stressed, the utopian element which was once associated with high art in modernism can now be located as well in the products of mass culture. Indeed, as Jameson says, ''all contemporary works of art—whether those of high culture and modernism or of mass culture and commercial culture—have as their underlying impulse—albeit in what is often distorted and repressed, unconscious form—our deepest fantasies about the nature of social life, both as we live it now, and as we feel in our bones it ought rather to be lived.''[15] The signs of utopia then are all about us in ''the flow of random forms and the emergence of connectivity within scatter.'' The satisfactions of small desires, the momentary satisfactions and the more lasting ones, are not all contained within the nature of market consumerism or the predictions of motivation research, but rather are indications of the larger satisfaction we seek in social change and which can also derive from popular culture.

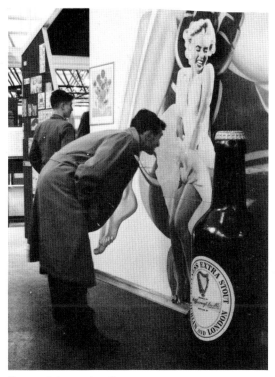

Viewer analyzing popular culture.

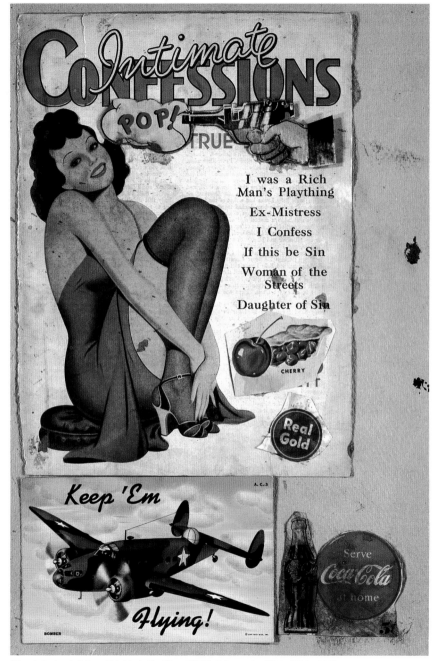

Eduardo Paolozzi: *I Was a Rich Man's Plaything*, 1947(?). Collage, 14 x 9¼ in. (35.6 x 23.5).

Thomas Lawson

Bunk: Eduardo Paolozzi and the Legacy of the Independent Group

Today the work of British artists, writers, and musicians seems to have greater relevance to Western culture than has been the case in fifty years. This is due almost entirely to the profound sense of unease and melancholia that has gripped the West since the early seventies, when the combination of defeat in Vietnam and the oil price shocks created the conditions for both cultural and economic instability. Since British artists are well versed in the small pleasures to be gleaned from the realization of diminished prospects—the pleasures of memory, the fascination with loss, and speculation about the future—they now find themselves at an advantage, since they are already fluent in a discourse that Americans are still struggling to locate. Thus history may be seen to finally absolve nostalgia of its false consciousness. A sentimentality about the passing of time can now be taken as being as forward-looking as any other delusion an artist might find useful.

History has not always been so kind to British art. Indeed, the rearguard action against modernism played out in British culture since the twenties, and the dawning realization that the glory days of Empire were gone, have been a recurring blight on regressive and progressive artists alike. Variously afflicted with a fastidious sentimentality or an orotund preachiness, British artists have until fairly recently produced little work able to face the present squarely and actually tell us something about our lives. In such a situation the attempts of the young writers and artists associated with the Independent Group in the early fifties to come to grips with contemporary life could never be entirely satisfactory. But their failure remains fascinating, at least partly because we now understand that failure can be more interesting, and perhaps, in the long run, more productive, than success.

The easiest way to approach the achievement of the Independent Group is to consider it from the point of view of one participant; and the easiest way to do that is chronologically. Eduardo Paolozzi was born in 1924 in Leith, Scotland, of Italian parents. Without making too much fuss about background influence, this information already tells us a number of interesting things in relation to the responses and motivations of the artist. His birthdate for example, tells us that he would have started taking note of the world around him during the years of the Depression, and done so in Edinburgh's dockland, an area still trying to recover from the damage inflicted upon it in the thirties. Growing up among the working poor in Scotland, he would have experienced directly an estrangement from the official Britishness of London and the South. Growing up in an Italian family, speaking Italian at home, summering in Italy courtesy of the Bellelli, Mussolini's youth movement, can only have doubled this estrangement, alienating him also from the strongly local culture of working-class Scotland. Thus he was left with nothing but the abstract promise of a better future he heard about in summer camp, and two dreams, art and America. These last two would have been linked inevitably, since the only way a boy in Leith could afford to know of America in any detail was through the pictures in comic books. So it is easy to see that the better future for which he undoubtedly yearned—and even the least complex resident of Leith in the thirties wanted something better—took form for the young artist as a sci-fi fantasy.

The outbreak of war in 1939 can only have confirmed the sixteen-year-old's sense of difference—he and his family were interned as enemy aliens. He was soon released, however, and conscripted into the Pioneer Corps, serving out the war in boot camp. After he was demobbed he submitted himself to further alienating torture by enrolling in the Slade School, England's most prestigious art school, which at the time was still holed up in Oxford, its wartime retreat from the Blitz. The combination of Oxford's snobbish élitism and the Slade's preciously academic curriculum must have been maddening, although partial relief came when the school returned to London and took on more students from the armed services. At least he met like-minded individuals, such as William Turnbull and Nigel Henderson, both later colleagues in the IG. In 1947, without taking his degree, Paolozzi left for Paris, looking for his future as an artist. At that time every young artist wanted to go to Paris and hang out with the surrealists. But it was probably a mistake—the Occupation had taken the soul out of Paris, and Parisian artists wanted to re-create the situation they had known and enjoyed before the war. Most were still convinced by surrealist theory that the only way this past could be retrieved was by privileging the interior spaces of the mind, retreating further from the grim realities of the present. But the purely subjective is of limited use as a generator of art, since it tends to be a field almost totally mapped out in cliché and stereotype. For the artist who would dream of the future, the subjective is particularly dangerous, turning easily into a trap which transforms the dream into an obsession with a familiar archaic past. And, sure enough, it was during his time in Paris that Paolozzi began working toward the production of the junk-encrusted monsters for which he became famous. His early success was assured, but at the price of repressing his potentially more interesting obsession with the signs of the American future.

Throughout this period, in fact, Paolozzi's timing seems to have been unfortunate for a futurist. For despite the problems of postwar reconstruction, Britain in the late forties was an interesting place, politically and culturally a progressive oasis between the timorous aridity of the thirties and the fifties. Immediately after the war Britain was swept with an irrepressible optimism. After struggling so hard to defeat the orgre of fascism, it was ready for a new beginning. The arch-conservative Churchill was unceremoniously dumped by the electorate in 1945, and replaced by Clement Attlee's Labour Party, which had campaigned on a commitment to "face the future." Labour immediately began a tremendously ambitious legislative program to redistribute wealth more equitably, creating a rather genteel socialist state. But there was a terrible problem—the exchequer was spent. Like all the European allies, Britain was badly in debt as a result of the war effort, and U.S. aid stopped when the fighting stopped. Wartime rationing had to continue while the process of rebuilding got under way, and it was not until after 1947 and the renewal of credit support from the U.S. under the Marshall Plan that the British economy began to recover. By the early fifties the country was no longer broke, but strangely it had lost its confidence. Control of the future no longer seemed so certain. Partly this had to do with the full realization that the days of Empire were over, partly it had to do with the realization that with the atom bomb firmly in place there was now a real possibility of there being no future at all. This latter fear was exacerbated in 1950 with the outbreak of a war in Korea that looked as though it could escalate into a third world war, a war President Truman was so determined to win that he threatened the use of the bomb as a last resort. That same year in Britain, Attlee barely held on to power in an election that reduced his majority to six; his government was also severely damaged by the ill health of a number of his leading cabinet members. Within eighteen months another general election was called, and this time a nearly senile Churchill was returned, ushering in a decade of cultural enervation and decline. More than anything the fifties showed how deep was the devastation wrought by the slaughter of the 1914 war, for it was in the benighted fifties that the survivors of that war began to take power, leaving no doubt that the best and brightest had indeed been lost in the trenches of the Somme.

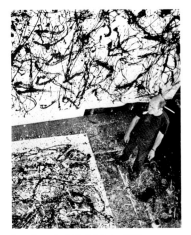

Hans Namuth, *Pollock Painting,*1950.

View of Eduardo Paolozzi's studio, Thorpe-le-Soken, c. 1955.

Parallel of Life and Art: microphotograph.

One of the most remarkable forms the denial of this loss took was a virulent anti-Americanism that possessed the ruling classes of Britain until the mid-sixties. Curiously, there had been a populist strain of this syndrome during the war years when GIs stationed in Britain were envied for their relative wealth, and distrusted for their moral laxity (American men were seen to drink beer from the bottle, an obvious sexual provocation). But once the Labour Party's policies to ensure a higher standard of living for the working classes began to take hold, this prejudice was replaced by the more benignly envious fascination engendered by the movies. With Americans safely back home, America itself could once again become Shangri-La. Increasingly the British working class's mechanisms for escape—basically entertainment and fashion—were colored by a perception of the good life in the U.S.A. At the same time the ruling élite's refusal to accept the altered international scene, their collective denial of present reality, and their concomitant reluctance to modernize anything, were more and more often couched in terms of a distaste for the "vulgarity" of all things American.

Here then was a topic rich in possibilities for an artist, and the reason we continue to be so interested in the IG is the glimpse its history offers of a truth almost grasped. For Paolozzi and the others associated with the IG were certainly aware that the area of what they called "pop art"—mass-produced culture mostly imported from the U.S.—would reward serious study. But the infuriating part is that they were so very slow to act on that perception.

The IG met for a few short years in the early fifties under the auspices of the ICA, an organization set up after the war by Roland Penrose, Herbert Read, and other luminaries of the progressive art establishment, to do for London what MoMA had done for New York—that is, to provide propaganda for modernism. Expanding on the programme of the ICA itself, the IG considered its main job to be the modernization of British art, which basically meant moving beyond the stuffy confines of a polite aestheticism, and repositioning the discussion and production of art within a wider context than that

provided by either the Royal Academy or the School of Paris. Consequently, these young firebrands established different series of seminars to discuss a variety of topics—including anthropology, technology, science, and popular culture—that might somehow broaden the base from which one could think about art. But that was mostly all they did—discuss possibilities. In the short term very little art was generated out of the seminars, and indeed it was the essayists who most clearly benefited at the time, with Lawrence Alloway and Reyner Banham laying the groundwork for their later careers. Indeed, on the evidence of the individual works produced by the members at that time it appears that they were not paying complete attention to what they themselves were saying, since the majority of them continued to work in the vein of the elegantly angst-ridden "brutalist" style then popular in Paris.

But regardless of these failures, an indefinable something did happen, a perceptible shift in attitude can be identified. And if the members of the IG cannot definitively claim to have started it, they can at least claim to have been among the first to suspect that something was up. An example of this can be found in one of the most oft-repeated stories about the IG, concerning the famous quasi-lecture which Paolozzi gave at the first meeting in 1952. (The first meetings were by invitation only; the public seminars that were the center of the group activity took place later, in 1953 and 1954.) It was during this lecture that Paolozzi is reputed to have blown the minds of his colleagues by barraging them with projected images culled from his scrapbook collection of American pop culture. He called his demonstration "Bunk," which suggests an ambivalence (at least) toward his subject matter. In fact it was not until 1958 that he was willing to publicly state that he felt that a higher order of imagination existed in the sci-fi pulp production on the outskirts of Los Angeles than in most contemporary art, and not until 1964 that he finally made a piece, the "As Is When" suite, a tribute to Wittgenstein, using the "Bunk" material. The original presentation was mostly nonverbal; he read a few notes, but the point was to saturate the eye with the images and let them speak for themselves. And what did they say?

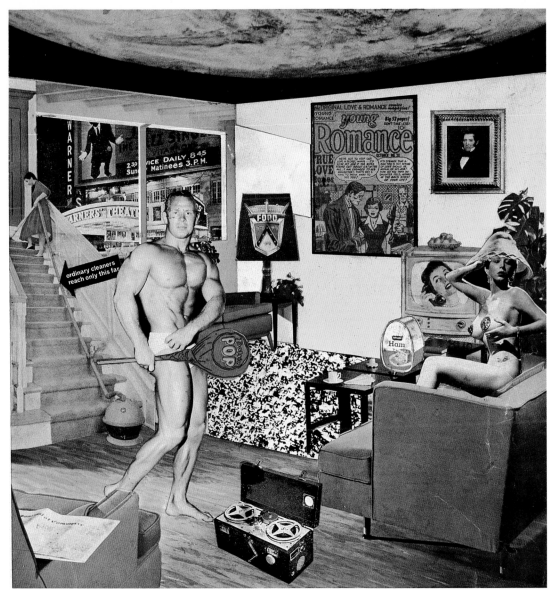

Richard Hamilton, *Just what is it that makes today's homes so different, so appealing?*, 1956. Collage on paper, 10¼ x 9¾ in. (26 x 25 cm).

Mostly they offered evidence that even collecting the pictures of his American Dream, gathering comic books and *Time,* automobile ads and army manuals, Disney and *Scientific American,* Paolozzi never abandoned the basic Freudian analysis provided by surrealism. Paolozzi's pictures, especially in the combinations he preferred, told a simple story of futurist desire mixed with the more carnal kind. His juxtapositions of war machines, monsters, and pin-up girls needed no genius to unravel.

What does need unraveling today is the failure of this apparently astonishing display of information to come into focus. True, it seems as though the evening encouraged, even inspired Banham, and perhaps, at some remove, Richard Hamilton. It also may have confirmed some of the similar experiments in collage John McHale was conducting at roughly the same time. But Paolozzi himself stubbornly kept this material on the margins of his attention, notes kept hostage to a future project. One can speculate about Paolozzi's motivations: an outsider's desire to fit in, the more basic need to succeed financially (his surrealistic works had just won a place in the 1952 Venice Biennale), or perhaps he had yet to think up a suitable format. To Paolozzi the multiple-image demonstration apparently offered no immediate clues. In comparison we might recall another fabled evening of projected images, in New York some years earlier. Elaine de Kooning describes a moment of grace one night in 1948 that transformed Franz Kline from a tentative abstract painter of talent into an artist of some importance; a moment when, on seeing one of his drawings projected large against the wall of the de Koonings' studio, he realized the significance, the impact of scale. From that moment, according to the legend, Franz Kline the mere painter became *the* Franz Kline of the history books. Four years later, Paolozzi enjoyed no such moment of grace, no instantaneous clarity. This is not necessarily a fault, perhaps such grace was not available in London at that time. And even that we wish it had been is only a function of our retrospective wisdom, once Andy Warhol had opened our eyes to the enormous possibilities of the large-scale reproduction of popular culture in the context of the museum.

What the members of the IG did realize—and the interest generated by the "Bunk" demonstration is evidence of this—is that part of what any artist must consider are the conditions of presentation. On the understanding that it was pointless to attempt to refigure the art object in order to more accurately refer to modern life if the new object were simply dropped into the old container (be it gallery or museum) in the same old way, design became an issue. And the most potent issue was the design of spaces that would accommodate both life and art in a mutually supportive way. Thus it was that the IG made its most memorable public statements in the form of exhibitions organized collaboratively by artists, designers, photographers, and architects. Arguably the most important of these was *Parallel of Life and Art,* staged in 1953 at the ICA gallery, and organized by Paolozzi, Henderson, Alison and Peter Smithson, and Ronald Jenkins. The exhibition included photographs of paintings by Kandinsky, Picasso, and Dubuffet, children's drawings, hieroglyphs, and so-called primitive art, as well as many different types of photography—technological, scientific, anthropological, medical, press—all hung, at different angles, floor to ceiling, throughout the entire space of the gallery (which is to say not just on the walls, but hanging from the ceiling, standing up from the floor). In a sense a direct result of Paolozzi's lecture, the exhibition was intended to show how scientific and artistic information could be integrated into a more complex and accurate whole. Contemporary critics, reacting with the angst-ridden mindset of the period, saw mostly images of violence, although the bulk of the pictures dealt with new technologies in mostly descriptive ways, making use of specialized techniques like X-ray and microscopic photography. The violence was not in the pictures, but done to them, the design of the show working to forcefully reposition the viewer within the familiar context of the art gallery. In other words, although there was little mass-media imagery in the show, the aggressive all-over organization of images made the exhibition itself a microcosm of the intrusive reality of pop culture. The sacrosanct space of art was violated by the vulgar future-world of America.

Three years later, after the IG had disbanded, a more ambitious version of this show, to be called *This Is Tomorrow*, was held at the Whitechapel Art Gallery. Organized by Theo Crosby, an IG member, and in many ways a summation of the group seminars, this exhibition marked the beginning of the public dissemination of the participants' ideas, and the start of one of the sustaining myths of contemporary British art.

It is probably the most famous image associated with what is now called British pop art. It looks like a stage-set of modernity, a showroom filled with up-to-date things—there is some Danish Modern furniture, a nice area rug with an abstract, "Jack the Dripper" pattern, a reel-to-reel tape recorder, a television tuned to a cheerful young woman on the telephone, a vacuum cleaner with worker attached. On the back wall a rather stuffy Victorian portrait is outclassed by a framed blow-up of a comic-book cover and a lampshade decorated with a Ford insignia. Center stage is a naked couple, noble savages of the new. He flexes his muscles while brandishing a phallic Tootsie Pop, proud he no longer has to take it from the beach bully. She reclines on the sofa, hiding coyly behind some canned ham while displaying her breasts and trying out a lampshade for a hat. What we see is the domestic interior as the realm of a private fantasy identified with the very public fetishism of mass consumption. Richard Hamilton's small collage asks the question, "Just what is it that makes today's homes so different, so appealing?" And it answers, in ways both sly and direct, that it is this commodity fetishism, tamed and user-friendly, that does the trick, so long as nobody rocks the boat. It is a cozy little future-world pictured here, very British in its claustrophobia. It is safe and conventional (the modern is after all only an appliqué), but threatened by outside elements—Al Jolson masquerading as a black man outside the window, the surface of Mars pressing down from the ceiling, a collison of nostalgias, past and future. This is tomorrow, in which privileged moments of pleasure, made possible by mass production and distribution, are snatched in the momentary interstices of alien dangers.

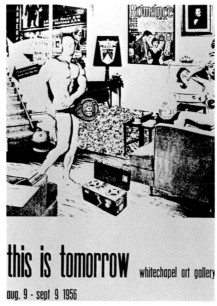

Richard Hamilton, poster for *This Is Tomorrow*, 1956. Collection Theo Crosby, London.

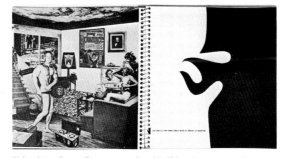

Richard Hamilton collage as reproduced in *This Is Tomorrow* catalogue.

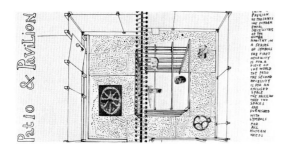

Nigel Henderson, and Alison and Peter Smithson pages for *This Is Tomorrow* catalogue.

Hamilton's tiny collage, like so much else of his work, is iconographically dense, and as a result it has attracted a lot of attention over the years. One aspect of it, however, that rarely gets discussed is its intended status. For the fact is that it was originally meant to be reproduced in the catalogue of *This Is Tomorrow*. It was also to be used, in larger scale and in black-and-white, for the poster advertising the show. This does not mean that the collage is not a work of art, just that it was not hung in the show like a painting. And it is this lack of material presence that is the important thing about the piece. Its significance lies in its condition of reproducibility, Hamilton's understanding that it would reappear, in differing forms, twice during the course of the exhibition (to say nothing of its continued life as an indispensable illustration to every account of pop art ever since). It was in this transubstantiation that a necessary grace was achieved, signaling the possibility, for British artists, of moving beyond the modernists' reverence for material to what is now recognized as the postmodern obsession with representation. Thus the barely existing collage's mythic presence: it has been taken as a sign that the task of the artist, in a period as dominated by the mass media as ours, is to reconsider how we identify ourselves and our desires.

Such, then, was the meager creature from which a mythic being of vast proportions grew, for the IG has become, particularly for British art historians, the fecund originator of all subsequent manifestations of the desire to make art in some relation to mass culture. The myth has grown in part as a result of the fairly understandable need of many in the British art world to see some contribution to the development of postwar art come from London, and partly as a result of the laziness of art writers in general. In researching the IG one is immediately struck by the similarity of most of the accounts— identical incidents described with near-identical phrases, all in apparent debt to Alloway's seminal account of 1966, which has itself been republished quite a few times. Unfortunately, a justifiable despair over the unexamined career of this bloated machine has led a new generation to dismiss the achievements of the IG altogether, and to note with particular asperity the evident

failures to be seen in the "myth" of the artists involved in the group. But this is not entirely fair, for the IG does remain an important carrier of early symptoms of dissatisfaction with modernist purism. That these symptoms were not then developed in any interesting way in either London or New York for another ten years is no cause for regret, or even surprise. At least, in a minor way, the ice had been broken, the supposed nemesis of fine art, popular culture, had been admitted into the field of things to be considered.

If we can agree that the activities of the IG represent the beginning of a new way of considering art and its place in the larger culture, can we get more specific and point to a particular legacy of those seminars on Dover Street? One might argue for Hamilton's influence on the younger generation of pop artists who graduated from the Royal College of Art in the early sixties—David Hockney, Derek Boshier, *et al.*—in particular a shared refusal to move away from the tenets of European modernist painting, no matter how nontraditional the subject matter at hand. At that time London saw little of the technical innovation so central to developments in New York. The truth is, despite his wide knowledge of certain aspects of popular culture and detailed study of the look of mass-production techniques, Hamilton insisted on turning that information back into standard easel paintings, folding in arcane references to early modernist attempts, by the likes of Cézanne and Duchamp, to register quasi-scientific representations of perception. The adjectives that spring to mind to describe Hamilton's pop work are intellectual, art-smart, finnicky, querulous; hardly the adjectives normally associated with pop, yet they would not be entirely out of place in a description of Hockney's work either. And since Hamilton taught design at the Royal College, not painting, he may have exerted no influence whatsoever.

The notion of a legacy bequeathed by the IG artists has to go further than individual cases, for in reality it is the mythic IG that has been important, not the actual group itself. The rumor that some now-older artists had seriously considered mass culture in the distant past gave permission to the desires of succeeding generations,

Paolozzi collage over drawing of *Patio and Pavilion* by Peter Smithson.

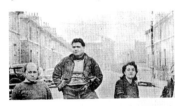

Nigel Henderson, poster for *This Is Tomorrow*, 1956. Silkscreen on paper, 30 x 20 in. (76.5 x 50.2 cm) Collection of Theo Crosby.

gave a legitimacy to pop and all its manifestations. One might even suggest that the art school bands of the sixties like The Rolling Stones and The Yardbirds in London, The Animals in Newcastle (where Hamilton also taught), picked up on the signifying of Howlin' Wolf and Muddy Waters as a result of Paolozzi's observations about sci-fi comics from Los Angeles. If marginal, highly stylized comic illustrators were making some of the best art around, marginal, highly stylized blues singers were probably making some of the best music. Which, of course, turned out to be a truth hardly even suspected in a still-racist U.S.A. until the Stones and the rest proved it. Pure speculation, but given a sort of retroactive validation by events. In 1968 Hamilton's dealer was the very trendy Robert Fraser, a good buddy of Mick Jagger. The two once made the papers together, busted for drugs, and Hamilton made a series of paintings from the news photograph. Fraser was also friends with Paul McCartney, through which connection the artist was commissioned to design the cover of the "white album," "The Beatles." Two incidents calculated to add a super-cool dimension to the IG myth.

This subsequent fusion of pop art and the pop world, and the accompanying takeover of the fashion world by hip art school graduates like Zandra Rhodes and Bibi was so much more glamorous, so much more potent than rather dim stories about a rather naive enthusiasm for American science fiction. Malcolm McLaren and Vivienne Westwood might not have been able to declare punk clothes and music their art without the pioneering work of the IG, but their more immediate debts were to the epidemic of cultural crossovers of the sixties, and the theorizing of Guy DeBord. By the mid-seventies any optimism about the future, any thought about the future, was scorned as cruel fantasy. Only the discovery of oil in the North Sea saved Britain from bankruptcy then, and the fastidious aestheticism of artists like Hamilton and Paolozzi seemed at that point to have sorely missed the point.

I met Paolozzi once. I was still a student, at the University of St. Andrews, and he had come up to donate (temporarily, as it turned out) his collection of scrapbooks and

toys to the art department. There was a lot of fanfare about the importance of this resource, The Krazy Kat Archive, to the future study of contemporary art. The material was cute, all these old magazines from the fifties, and many working robot toys. But there was something profoundly silly about it all, and about the serious claims being made for the radicality of the popular being made by the assorted academics hovering over the prize. The world had too evidently moved on. Watching and listening, I realized that there was nothing shocking, or even remotely surprising about wanting to include mass culture as part of the information one might bring to a work of art. Before my eyes the forty-seven-year-old Paolozzi was turned to stone; caught in the rush of events the erstwhile rebel and outsider stood there, a fossilized relic uncannily reminiscent of his own monster sculptures, a ready-to-be-forgotten monument in a cozy, we-told-you-so culture. The members of the Independent Group, and the myth they created, are now firmly placed within the discourse of the academy, their influence spent. But the problems of representation and contextualization that they raised, however tentatively, remain the pressing problems for artists working today. No matter how distantly, we remain indebted to them.

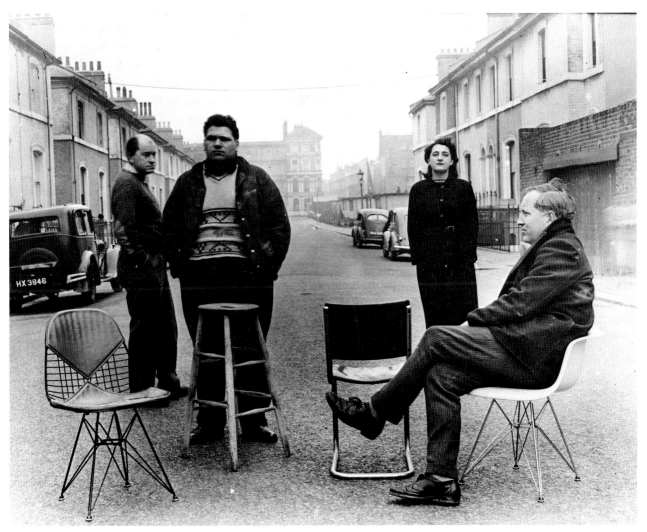

Peter Smithson, Eduardo Paolozzi, Alison Smithson, and Nigel Henderson. Photo by Henderson for *This Is Tomorrow* poster and catalogue (not used).

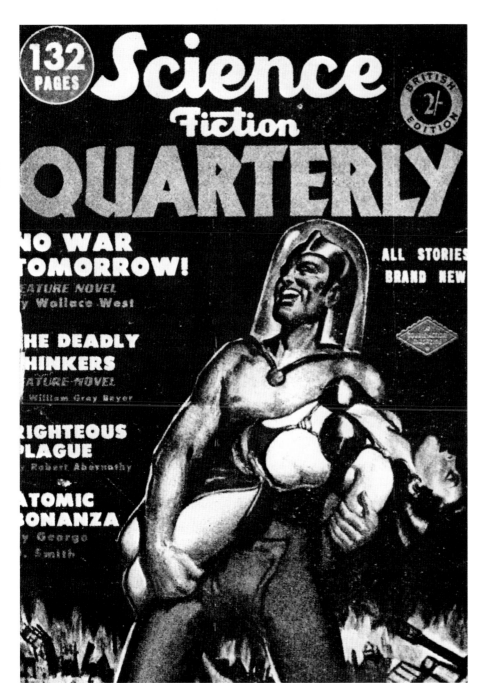

Lawrence Alloway

The Long Front of Culture

The abundance of twentieth-century communications is an embarrassment to the traditionally educated custodian of culture. The aesthetics of plenty oppose a very strong tradition which dramatizes the arts as the possession of an élite. These "keepers of the flame" master a central (not too large) body of cultural knowledge, meditate on it, and pass it on intact (possibly a little enlarged) to the children of the élite. However, mass production techniques, applied to accurately repeatable words, pictures, and music, have resulted in an expendable multitude of signs and symbols. To approach this exploding field with Renaissance-based ideas of the uniqueness of art is crippling. Acceptance of the mass media entails a shift in our notion of what culture is. Instead of reserving the word for the highest artifacts and the noblest thoughts of history's top ten, it needs to be used more widely as the description of "what a society does." Then, unique oil paintings and highly personal poems as well as mass-distributed films and group-aimed magazines can be placed within a continuum rather than frozen in layers in a pyramid. (This permissive approach to culture is the reverse of critics like T.S. Eliot and his American followers—Allen Tate and John Crowe Ransom—who have never doubted the essentially aristocratic nature of culture.)

Acceptance of the media on some such basis, as entries in a descriptive account of a society's communication system, is related to modern arrangements of knowledge in non-hierarchic forms. This is shown by the influence of anthropology and sociology on the humanities. The developing academic study of the "literary audience," for example, takes literary criticism out of textual and interpretative work towards the study of reception and consumption. Sociology, observant and "cross-sectional"

in method, extends the recognition of meaningful pattern beyond sonnet form and Georgian elevations to newspapers, crowd behavior, personal gestures. Techniques are now available (statistics, psychology, motivation research) for recognizing in "low" places the patterns and interconnections of human acts which were once confined to the fine arts. The mass media are crucial in this general extension of interpretation outwards from the museum and library into the crowded world.

One function of the mass media is to act as a guide to life defined in terms of possessions and relationships. The guide to possessions, of course, is found in ads on TV and cinema screens, hoardings, magazines, direct mail. But over and above this are the connections that exist between advertising and editorial matter: for example, the heroine's way of life in a story in a woman's magazine is compatible with consumption of the goods advertised around her story, and through which, probably, her columns of print are threaded. Or, consider the hero of two comparable Alfred Hitchcock films, both chase-movies. In *The 39 Steps* (1935), the hero wore tweeds and got a little rumpled as the chase wore on, like a gentleman farmer after a day's shooting. In *North by Northwest* (1959), the hero is an advertising man (a significant choice of profession) and though he is hunted from New York to South Dakota his clothes stay neatly Brooks Brothers. That is to say, the dirt, sweat, and damage of pursuit are less important than the package in which the hero comes—the tweedy British gentleman or the urbane Madison Avenue man. The point is that the drama of possessions (in this case clothes) characterizes the hero as much as (or more than) his motivation and actions. This example, isolated from a legion of possibles, shows one of the ways in

which lessons in style (of clothes, of bearing) can be carried by the media. Films dealing with American home-life, such as the brilliant women's films from Universal-International, are, in a similar way, lessons in the acquisition of objects, models for luxury, diagrams of bedroom arrangement.

The word "lesson" should not be taken in a simple teacher-pupil context. The entertainment, the fun, is always uppermost. Any lessons in consumption or in style must occur inside the pattern of entertainment and not weigh it down like a pigeon with *The Naked and the Dead* tied to its leg. When the movies or TV create a world, it is of necessity a *designed* set in which people act and move, and the *style* in which they inhabit the scene is an index of the atmosphere of opinion of the audiences, as complex as a weather map.

We speak for convenience about a mass audience but it is a fiction. The audience today is numerically dense but highly diversified. Just as the wholesale use of subception techniques in advertising is blocked by the different perception capacities of the members of any audience, so the mass media cannot reduce everybody to one drugged faceless consumer. Fear of the Amorphous Audience is fed by the word "mass." In fact, audiences are specialized by age, sex, hobby, occupation, mobility, contacts, etc. Although the interests of different audiences may not be rankable in the curriculum of the traditional educationist, they nevertheless reflect and influence the diversification which goes with increased industrialization. It is not the hand-craft culture which offers a wide choice of goods and services to everybody (teenagers, Mrs. Exeter, voyeurs, cyclists), but the industrialized one. As the market gets bigger, consumer choice increases: shopping in London is more diverse than in Rome; shopping in New York more diverse than in London. General Motors mass-produces cars according to individual selections of extras and colors.

There is no doubt that the humanist acted in the past as taste-giver, opinion-leader, and expected to continue to do so. However, his role is now clearly limited to swaying other humanists and not to steering society. One

Gregory Peck in *The Man in the Grey Flannel Suit*, 1956.

"The drama of possessions": Cary Grant in *North by Northwest*, 1959.

reason for the failure of the humanists to keep their grip on public values (as they did on the nineteenth century through university and Parliament) is their failure to handle technology, which is both transforming our environment and, through its product the mass media, our ideas about the world and about ourselves. Patrick D. Hazard[1] pointed out the anti-technological bias of the humanist who accepts only "the bottom rung . . . of the technological ladder of communications," movable type. The efforts of poets to come to terms with industry in the nineteenth century (as anthologized by J.F. Warburg) are unmemorable, that is to say, hard-to-learn, uninfluential in image forming. The media, however, whether dealing with war or the home, Mars, or the suburbs, are an inventory of pop technology. The missile and the toaster, the push-button and the repeating revolver, military and kitchen technologies, are the natural possession of the media—a treasury of orientation, a manual of one's occupancy of the twentieth century.

Finally it should be stressed that the mass media are not only an arena of standardized learning. Not only are groups differentiated from the "mass," but individuals preserve their integrity within the group. One way to show this is to appeal to the reader's experience of the media, which he can interpret in ways that differ in some respects from everybody else's readings. While keeping their essentially cohesive function, providing a fund of common information in image and verbal form, the media are subject to highly personal uses. This can be shown by quoting a reader's reaction to a science fiction magazine cover:

I'm sure Freud could have found much to comment and write on about it. Its symbolism, intentionally or not, is that of man, the victor; woman, the slave. Man the active; woman the passive. Man the conqueror; woman the conquered. Objective man, subjective woman; possessive man, submissive woman! . . . What are the views of other readers on this? Especially in relation with Luros' backdrop of destroyed cities and vanquished man?

The commentary supplied by this reader, though cued by the iconography of *Science Fiction Quarterly,* implies

clearly enough his personal desire and interest. However, it is no greater a burden of meaning that he puts on the cover than those attached to poems by symbol-conscious literary critics. The point is that the mass media not only perform broad, socially useful roles but offer possibilities of private and personal deep interpretation as well. At this level Luros's cover is like a competitor of the fine arts, in its capacity for condensing personal feelings. However, it is the destiny of the popular arts to become obsolescent (unlike long-lived fine art). Probably the letter writer has already forgotten Luros's cover (from the *early* fifties) and replaced it by other images. Both for their scope and for their power of catching personal feeling, the mass media must be reckoned as a permanent addition to our ways of interpreting and influencing the world.

Reprinted from Cambridge Opinion, *no. 17 (1959); This essay was published three years after* This Is Tomorrow. *The illustration on page 30 was published with the original essay and is the science fiction magazine cover referred to in the text.*

[1]Patrick D. Hazard, in *Contemporary Literary Scholarship,* Lewis Leary, ed. (New York, 1958).

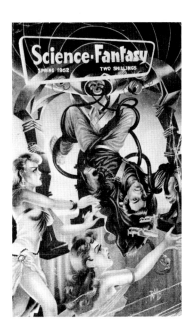

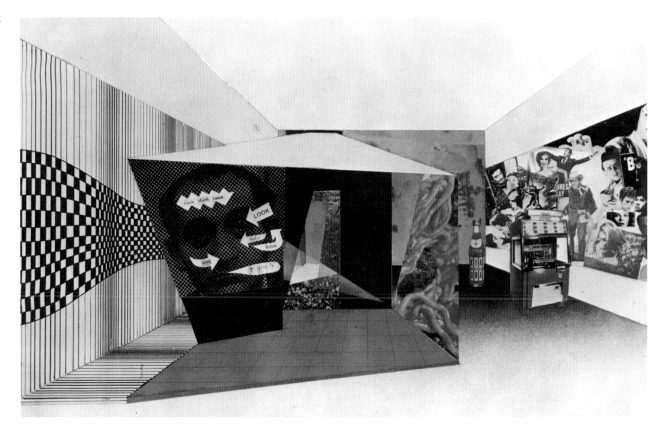

Richard Hamilton, *This Is Tomorrow*, 1956. Collage on paper, 12 x 18½ in. (30.1 x 47.2 cm). Staatsgalerie, Stuttgart. Graphische Sammlung.

Graham Whitham

This is Tomorrow: Genesis of an Exhibition

While political events in Hungary and the Suez dominated the news in England in 1956, other events of that year signalled the fundamental changes reshaping the British cultural scene. John Osborne's *Look Back in Anger* opened at the Royal Court Theater, Robert Conquest's poetry anthology *New Lines* was published, the National Film Theatre screened the first performances of the Free Cinema, and the exhibition *Modern Art in the United States* opened at the Tate Gallery. Meanwhile, in London's East End, an exhibition opened at the Whitechapel Art Gallery entitled *This Is Tomorrow*. Widely publicized in newsreels, on the radio, and in the newspapers, *This Is Tomorrow* caught the imagination of the public eager for diversion from political realities or angry young men. Instead, the showbiz opening of *This Is Tomorrow* on August 8 offered an appearance by Robby the Robot, star of the popular MGM film, *Forbidden Planet*. For tradition-bound art-lovers and for visitors off the street, *This Is Tomorrow* offered a new type of aesthetic experience, one which marked the incursion of popular culture into the field of art.

This Is Tomorrow consisted of installations by twelve groups, each consisting of two, three, or four architects and artists working as a collaborative team. The initial idea for the exhibition, which was to promote an integration of the arts, came in Fall 1954 from the *Groupe Espace,* a constructivist association of artists founded in Paris three years earlier. Through their English representative, the painter Paule Vezelay, the group indicated their intention to organize an exhibition of British constructivism. Vezelay first contacted the architect Leslie Martin, who, prior to the war, had been an editor (with Naum Gabo and Ben Nicholson) of the constructivist anthology *Circle*. Toward the end of the

year, Martin called a meeting of those interested in participating in such an exhibition; included were Vezelay, Victor Pasmore, Roger Hilton, Robert Adams, Theo Crosby, and Colin St. John Wilson.[1] As a result of artistic differences aired at this meeting, however, Vezelay withdrew the support of the *Groupe Espace.* Nevertheless, the others in attendance decided to proceed with plans for the exhibition.

In early 1955, Theo Crosby took over the organization of the exhibition. A meeting was called and it soon became clear that there were two general groups; one comprising people associated with the Independent Group and the other constructivists who had attended the original meeting. As the editor of *Architectural Design,* Crosby had been just on the fringes of the Independent Group, but he knew all the members and was sympathetic to their theoretical position. Crosby designated those associated with the Independent Group "Group X," as if to give some credence to their autonomy, and in the main they were grouped separately from the constructivists.[2]

Crosby's idea of collaboration was somewhat different from the original conception of the *Groupe Espace.* Whereas they had envisaged a "total" exhibition where everyone participated in one great partnership, Crosby planned for a number of groups, each ideally consisting of a painter, a sculptor, and an architect, and each creating its own installation within a given space in the gallery. From the start, the nature of this idea was environmental in that it was necessary for each group to design an installation through which visitors could pass to reach the design of other groups.

[1] Colin St. John Wilson, interview with the author, May 9, 1983.
[2] John McHale, in conversation with Reyner Banham, May 30, 1977. Unedited tape recording for the Arts Council film, *The Fathers of Pop,* 1979; portion not used in the film.

Group 3: J.D. Catleugh, James Hull, and Leslie Thornton.

Group 11: Adrian Heath and John Weeks.

Group 10: Robert Adams, Frank Newby,
Peter Carter, and Colin St. John Wilson.

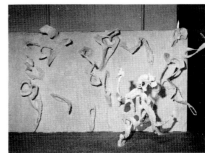

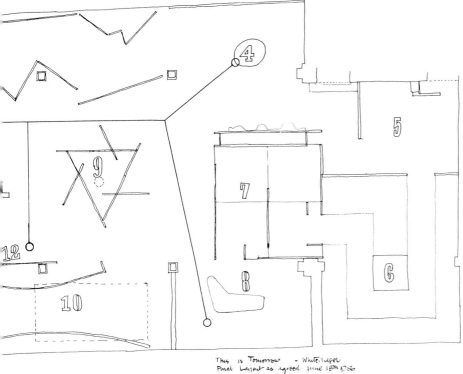

This is Tomorrow — Whitechapel
Final Layout as agreed June 18th 1956

Floorplan of *This Is Tomorrow*, drawn by Colin St. John Wilson.

Group 5: John Ernest, Anthony Hill, and Denis Williams.

Group 8: James Stirling, Michael Pine, and Richard Mathews.

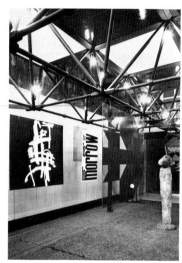

Entrance to *This Is Tomorrow* by Group 1:
Theo Crosby, Germano Facetti, William Turnbull,
and Edward Wright.

The initial concept of the exhibition was proposed to Bryan Robertson, the young director of the Whitechapel Art Gallery, who welcomed and encouraged the group. In the early correspondence between Robertson and Crosby the exhibition was still known as the "*Groupe Espace* exhibition," though by early 1956 it was being referred to as simply "the exhibition." The earliest use of the title *This Is Tomorrow* occurs in memoranda from July 1956, though the futurist-inspired title probably derives from Peter Reyner Banham, who, along with Crosby, was an early organizer.[3]

As early as March 1955, the groups had begun to be formed. Banham wrote to Robertson on March 30 saying, "There has been quite a lot of progress of various sorts, most of the groups now exist, in some form, and most have some idea of what they want to do."[4] But there was still disagreement about exactly which artists should be included. When Robertson wrote to Crosby on May 23 to formally confirm the Whitechapel's plans for the exhibition, he suggested some changes in the constitution of the groups. Not wanting to impose his own taste or to sound "like an old fogey," he nevertheless made a pitch for the inclusion of "a contribution from the Hepworth-Nicholson faction together with work by an architect of approximately their generation."[5] Arguing for the continuity of British artistic tradition, Robertson complained that "many younger artists, barely out of the art school, seem to think that they have originated everything themselves."[6] For the most part, Crosby ignored such suggestions (though Kenneth and Mary Martin were among the older artists in the exhibition) and *This Is Tomorrow* remained an exhibition of mainly younger artists.

The exhibiting groups for *This Is Tomorrow* were established quite early and changed only slightly during the year of planning. On October 27, an organizational meeting was held where each group presented 1" scale models of their installations.[7] Colin St. John Wilson also prepared a floor plan of the gallery and each group was allotted or chose its exhibiting area. Group 1: Theo Crosby, Germano Facetti, William Turnbull, and Edward Wright; Group 2: Richard Hamilton, John McHale, and John

[3]For the shifting title, see *This Is Tomorrow* correspondence, Whitechapel Art Gallery Archives.

[4]Reyner Banham, letter to Bryan Robertson, March 30, 1955. Whitechapel Art Gallery Archives.

[5]Bryan Robertson, letter to Theo Crosby, May 23, 1955. Whitechapel Art Gallery Archives.

[6]Ibid.

[7]Theo Crosby, letter to Bryan Robertson, undated (c. September 24, 1955). Whitechapel Art Gallery Archives.

Voelcker; Group 3: J.D.H. Catleugh, James Hull, and Leslie Thornton; Group 4: Anthony Jackson, Sarah Jackson, and Emilio Scanavino; Group 5: John Ernest, Anthony Hill, and Denis Williams; Group 6: Nigel Henderson, Eduardo Paolozzi, Alison Smithson, and Peter Smithson; Group 7: Erno Goldfinger, Victor Pasmore, and Helen Philips; Group 8: Richard Mathews, Michael Pine, and James Stirling; Group 9: Kenneth Martin, Mary Martin, and John Weeks; Group 10: Robert Adams, Peter Carter, Frank Newby, and Colin St. John Wilson; Group 11: Adrian Heath and John Weeks; and Group 12: Lawrence Alloway, Geoffrey Holroyd, and Toni del Renzio.

These collaborative teams succeeded in creating a wide range of installations. As one early press release stated "THIS IS TOMORROW gives a startling foretaste of the diversity and enormous range of the Art of the Future. It ranges from orthodox abstract art, with its classical regularity and rational order, through room-size sculptures to walk through, to crazy-house structures plastered with pin-up images from the popular press."[8] Although the exhibition was dominated by constructivist installations, it was the "crazy-house structures" which created the greatest interest and which most reflected the ideas of Crosby and the Independent Group; these were created by Group 2 and Group 6.

The most immediately prophetic piece in the show was the Hamilton-McHale-Voelcker environment (Group 2). For many later chroniclers, this installation with its 14-foot high billboard of Robby the Robot, its jukebox and spinning optical disks, its funhouse architecture and its cineramic movie billboard, typified the alliance of *This Is Tomorrow* with pop culture. But, in fact, it was the exception; its concern with optical illusions and pop imagery set it apart from the other exhibits. In manifesto-like style, Hamilton asserted in the catalogue his group's position: "We resist the kind of activity which is primarily concerned with the creation of style. We reject the notion that 'tomorrow' can be expressed through the presentation of rigid formal concepts. Tomorrow can only extend the range of the present body of visual experience."[9] As if to catalogue this range of visual experience, Hamilton's famous collage for the show, *Just what is it that makes today's homes so different, so appealing?*, combined images drawn from a predetermined list of contemporary motifs: "Man, woman, humanity, history, food, newspapers, cinema, TV, telephone, comics (picture information), words (textual information), tape recording (aural information), cars, domestic appliances, space."[10]

The so-called *Patio and Pavilion,* the contribution of Group 6 comprising Nigel Henderson, Eduardo Paolozzi, and Alison and Peter Smithson, was a rather different sort of structure. Consisting of a rude shed set inside of fenced-in courtyard, the whole installation was furnished with discarded objects, such as old wheels and wire implements; brutalist sculptures by Paolozzi; and large photomontages by Henderson. As the group explained in their catalogue statement, "Patio and Pavilion represents the fundamental necessities of the human habitat in a series of symbols. The first necessity is for a piece of the world—the patio. The second necessity is for an enclosed space—the pavilion. These two spaces are furnished with symbols for all human needs."[11]

Insofar as the exhibition sought to emphasize the role of the spectator and break down the distinctions between high art and popular art, many of the exhibits failed. Without a doubt the show's overriding concern was with fine art and, by definition, this made it somewhat exclusive. But one important aspect of the exhibition— for some participants at least—was the establishment of a wider, more populist approach to culture. Alloway's catalogue text spoke of the "responsibility of the spectator in the reception and interpretation of the many messages in the communications network of the whole exhibition" and his press releases stated even more emphatically, "THIS IS TOMORROW . . . believes that modern art can reach a wide public if it is handled without too much solemnity . . . The doors of the Ivory Tower are wide open."[12]

8[Lawrence Alloway], Press release for *This Is Tomorrow,* no date. Whitechapel Art Gallery Archives.
9Richard Hamilton, in *This Is Tomorrow,* exhibition catalogue, London, 1956, n.p.
10Richard Hamilton, *Collected Words* (London: Hansjorg Mayer, 1982), p. 24.
11Eduardo Paolozzi [?], in *This Is Tomorrow,* exhibition catalogue, London, 1956, n.p.
12[Lawrence Alloway]. Press release for *This Is Tomorrow,* no date. Whitechapel Art Gallery Archives.

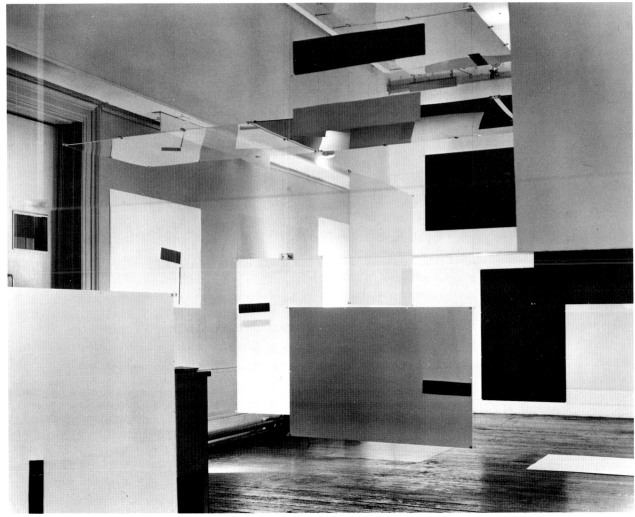

Installation view of *an Exhibit*, designed by Lawrence Alloway, Richard Hamilton, and Victor Pasmore at the ICA, 1957.

Judith Barry

Designed Aesthetic:
Exhibition Design and the
Independent Group

One of the most direct and successful means by which the members of the Independent Group sought to address issues of popular culture and to engage a public was through the design of exhibitions. Over the course of its existence as a loosely formulated group, from about 1952 to 1959, members of the Independent Group were involved on various levels with the design and construction of several major exhibitions at the Institute of Contemporary Arts; and many members of the IG contributed to *This Is Tomorrow* at the Whitechapel Art Gallery in 1956. These exhibitions were characterized by a non-hieratic approach to art and photography, generally eschewing fine art objects and presenting images in the form of reproduction exclusively. In addition, the seemingly random installations utilized a montage approach which encouraged radical juxtapositions and privileged a heightened visual perception.

What is interesting from our contemporary vantage point is the way in which their analysis of advertising, styling, and technology through discussion groups and ''chaotic'' exhibitions provided an index to the ways in which design—both as a product and as a producer of desire—could be approached through popular culture. For the Independent Group, design became an unrepressed term whose circulation made possible the animation of a new series of relations within the fine-arts field. It seems clear that design—particularly product design, but also interior design and exhibition design—offered a visual lexicon familiar to many of the participants. Reyner Banham was a design historian and critic, Alison and Peter Smithson, James Stirling, Colin St. John Wilson, and Alan Colquhoun were architects, Theo Crosby and Edward Wright were graphic designers, and Richard Hamilton taught design at the Central School of

Arts and Crafts. Design, rather than fine art, was the language through which they observed and apprehended the structure of their environment and the technology which was reshaping it. Design also became the medium through which all forms of popular culture could be critically evaluated.

In many respects the Independent Group was like a visual think-tank; its discussions and exhibition plans were hashed out in a manner more similar to that of a design team in an architect's office than an artist in a studio. The lectures and discussions provided the raw materials and ideas for a collective thinking from which emerged a series of exhibitions. The collaborative nature of the meetings and projects distinguished the group efforts from the more private artistic practices of painting, sculpture, design, or collage. The members of the Independent Group came together not so much as artists, but as collectors of images and information, which they sought to share. The exhibitions, rather than the art produced by individual group members, provides the clearest expression of their critical thinking.

Considered as a product, an exhibition is substantially and materially different from a work of art. Since an exhibition is temporary, difficult to represent in two-dimensional form, generally not portable, different from the sum of its parts, expensive to produce, not collectible, and definitely not a commodity, it violates most of the tenets that structure a conventional art object's entrance into the marketplace or into art history and criticism. Moreover, an exhibition, in that it is site-specific and confronts the viewer's passage through time and space while arranging a mass of material into a more or less coherent demonstration of a particular point of

Catalogue from
an Exhibit.

view, is in a rather complex and interactive way about the stimulation and sharing of ideas. Clearly, it is for this reason that the formulation of exhibitions appealed to the Independent Group, but it is also by virtue of their impermanence that the exhibitions they organized are less known than their art works (or that the best-known of their exhibition designs—such as the pavilions for *This Is Tomorrow*—are the most art-object-like).

Given the shifting membership of the group and the widely divergent viewpoints, no coherent strategy was fully articulated, no manifesto written. One clear statement of a fundamental position of the group was expressed in the famous letter which Richard Hamilton sent to the Smithsons shortly after *This Is Tomorrow*. In that letter Hamilton described the Independent Group's important "manifestations" (including discussions and exhibitions) of the postwar years, drawing out the common thread of pop art/technology. The objective of this research, which he proposed to define more clearly in another exhibition, was to define pop art in terms of its main components: "Popular (designed for mass audience), Transient (short-term solution), Expendable (easily forgotten), Low-cost, Mass-produced, Young (aimed at youth), Witty, Sexy, Gimmicky, Glamorous, Big Business." [1] Within the field described by this list, the Independent Group was primarily interested in popular culture that dealt with technological change; they had no interest in soap opera, folk art, or romance novels. Indeed, they seemed most interested in images that showed specifically how technology might change representation, as well as how technological change might be represented.

One of the critical concerns of the Independent Group—both in selecting found images and in formulating exhibitions—was how individuals would respond to and interact with the new technological environment. Exhibitions, combining large-scale reproductions and movement through space, with suggestions of both the museum and the trade fair, served to suggest this change in visual perception as well as social and economic relations. By greatly enlarging photographs originally reproduced in books or magazines, they

Installation plan of *Parallel of Life and Art*, drawn by Peter Smithson, 1953.

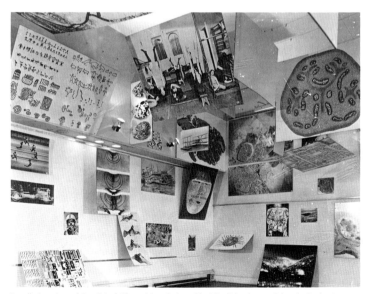

Installation view of *Parallel of Life and Art*, designed by Nigel Henderson, Eduardo Paolozzi, and Alison and Peter Smithson, 1953.

42
43

succeeded in transforming a visual text into something closer to mass propaganda or advertising. In this respect, the exhibitions functioned like an inversion of reading, as a type of fantasy experience sustained by a cinematic scale of imagery and by the potential for group reception.

Photography as a means of representation and as a device for exhibition design had been widely used in European trade, international festivals, and design exhibitions since the 1920s. The pioneering work of El Lissitzky, particularly in the Cologne *Pressa* exhibition of 1928, and others, signaled the great possibilities that large-scale photomontage sequences held for engaging the spectator through a direct and specifically controlled denotative relationship.[2] Some of these ideas were transferred to the Museum of Modern Art in New York in the 1940s in a rather debased form in the work of Herbert Bayer. The MoMA exhibitions—such as *Road to Victory* (1942) and *Family of Man* (1954)—had tremendous influence worldwide through their vigorous program of traveling exhibitions.[3] What the Independent Group derived from the history of exhibition design seems to have been an interest in the production of a visual environment where flux and change, expendability, and the effects of new reproductive technologies might find expression.

In particular, the exhibitions of the Independent Group reflect a conscious engagement with the political and social conditions in England in the 1950s, not just through representations, as in the MoMA exhibitions, but through a concrete (and sometimes metaphorical) analysis of ideologically inflected imagery. *Growth and Form,* for example, which was organized by Richard Hamilton for the ICA in 1951, is clearly a political allegory of the rebirth and restructuring of England and the postwar economy after the devastation of World War II. The theme of the exhibition was derived from D'Arcy Wentworth Thompson's book *On Growth and Form* (1917). The exhibition was originally proposed as part of the Festival of Britain—a sort of postwar spirit-booster—but was vetoed by Herbert Read, president of the ICA, who failed to see the relationship of the exhibi-

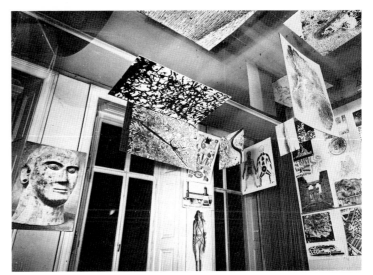

Installation view of *Parallel of Life and Art*.

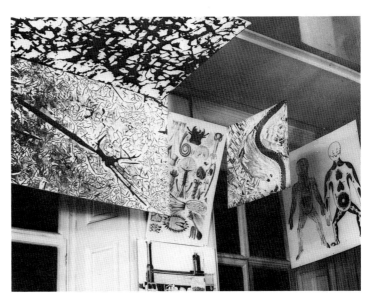

Installation view of *Parallel of Life and Art*.

tion to the festival's stated theme: one hundred years of British achievement.[4] The exhibition, as installed at the ICA in 1951, utilized an organic-looking screen, and floor- and ceiling-mounted projectors to animate the space. These devices also served to link the photographic representations of the diverse forms and structures found in nature.[5]

In 1953, Nigel Henderson, Eduardo Paolozzi, Alison and Peter Smithson, and Ronald Jenkins organized an exhibition at the ICA entitled *Parallel of Life and Art*.[6] This exhibition—originally called *Sources*—was conceived as the externalization of the image collections and scrapbooks assembled by the organizers. It also referred to the great modernist image collections of Moholy-Nagy (*The New Vision*), Ozenfant (*Foundations of Modern Art*), and Giedion (*Mechanization Takes Command*). In all, about a hundred photographic enlargements of various sizes were included in the exhibition, hung at oblique angles to one another and at varying heights. Included were images of machines, diagrams, hieroglyphics, X-rays, microphotographs, children's drawings, and reproductions of works of art. On the whole the photographs presented a rather grim and surreal panorama—especially in contrast to the rather more protean *Growth and Form*—prompting certain critics to accuse the organizers of "flouting . . . the traditional concepts of photographic beauty, [perpetuating] the cult of ugliness and "denying the spiritual in Man." [7] The fact that the representations came from outside the art context, that they were not labeled or captioned, and that they were hung free-floating in a deliberately non-hieratic space, all reflected the organizers' belief that such imagery was altering the experience of daily life more than work being produced by "fine artists."

Richard Hamilton organized and designed another major exhibition at the ICA in 1955, this time focusing on technological development of all types of vehicles in an exhibition ultimately titled *Man, Machine and Motion*.[8] For the design, Hamilton used modular steel frames to which were attached photo blowups and plexiglas panels. This flexible system of cubicle modules completely surrounded the viewer with an open, mazelike

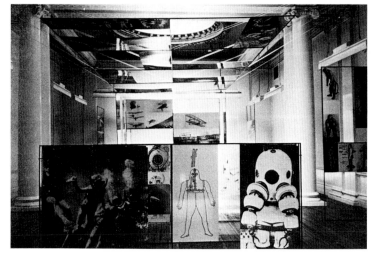

Installation view of *Man, Machine and Motion*, designed by Richard Hamilton, 1955.

Andrew Froshaug, catalogue for *Man, Machine and Motion*, 1955.

structure which had the effect of echoing the exhibition's content (an idea the artist apparently derived from Duchamp): the spectator's motion in relation to a moving object. In one sense, Hamilton's interest in exhibition design was a way of exploring this phenomenon in a three-dimensional environment. In this exhibition in particular, he was able to investigate the history and variety of what he called "adaptive appliances"—or machines which facilitated this changing perception of movement through space. Reyner Banham's essay in the catalogue situates this interest in the context of the legacy of futurism. The ideology surrounding futurism seemed to mimic that of the IG's with its interest in technology and the machine, sharing with it the essence of the popular cultural experience—its expendability, impermanence, and adaptation to change.

This Is Tomorrow, organized by Theo Crosby at the Whitechapel Art Gallery in 1956, gave the twelve architect/artist teams the opportunity to design environments which, while reflecting the generalized interests of the Independent Group, were also expressive of the individual groups' interests. In *This Is Tomorrow* the concept of design is foregrounded to articulate most clearly a series of relationships that at the time of the exhibition could not have been articulated in any other form. And from the vantage point of the present it appears that the design solutions that were fully developed were the ones that made new relations possible in both the fine arts and architecture.

The two installations reproduced as part of *This Is Tomorrow Today* are paradigms of this situation. Richard Hamilton and John McHale as artists, and John Voelcker as architect, produced a visual synthesis of their shared interests in popular imagery, scale, and spectator motion in the form of a built structure that could physically produce a heightened perception of two- and three-dimensional stimuli. A variety of different kinetic and synesthesiac materials were combined in a display system more reminiscent of a funhouse than an art gallery. Not only the sense of sight, but also sound and touch, were activated through the environmental use of a jukebox, movies, and live microphones displayed throughout a

tactile structure. *Patio and Pavilion*, produced by the team of Peter and Alison Smithson as architects and Eduardo Paolozzi and Nigel Henderson as artists, isolated the built world as a set of basic needs—a parcel of land, a patio, and an enclosed space, a pavilion. Less a collaborative effort than a summary of their common concerns, this habitat, with its reflecting aluminum enclosure, forced the spectator to consider him- or herself as a reflection of the environment, while simultaneously alluding to the impossiblity of returning to a more primitive existence, since the entrance to the pavilion was blocked with wire.

The last exhibition associated with the IG was *an Exhibit* organized by Hamilton, Lawrence Alloway, and Victor Pasmore.[9] As Hamilton recalls, *an Exhibit* was structured around the idea of abstraction: there would be "no theme, no subject: not a display of things or ideas, [but a] pure abstract exhibition." What he meant was that the exhibition would have no overt content related directly to popular imagery, but would be about the process of producing visual meaning. The exhibition consisted of panels of various colors and degrees of translucency which were distributed along modular grids and systematically installed. Perhaps the culmination of Hamilton's own exploration of exhibition design, the panels were arranged in such a way that as the spectator passed through them, compositions were generated.

After the late 1950s the discussion group/exhibition format of the Independent Group seemed to splinter as each member became more involved in the exigencies of private practice—Hamilton, McHale, and Paolozzi moved more toward fine art; the Smithsons extended their practical exploration of New Brutalism; and Banham, Alloway and others concentrated increasingly on theory and criticism. Seemingly, the moment to reproduce something temporary had passed. It makes you wonder if the impetus that created the desire to analyze this "designed aesthetic" was satiated, or if what Hamilton had predicted in "Persuading Image" had already happened, "that the consumer will be designed to fit the product," thus rendering analysis improbable.

[1] Richard Hamilton, *Collected Words* (London: Hansjorg Mayer, 1983), p. 28. This letter was written in January 1957.
[2] See Benjamin H.D. Buchloh, "From Faktura to Factography," *October*, no. 30 (Fall 1984): 82–119.
[3] See Christopher Phillips, "The Judgment Seat of Photography," *October*, no. 22 (Fall 1982): 27–63.
[4] Anne Massey. "The Independent Group: towards a definition," *Burlington Magazine* 129, no. 1009 (April 1987): 235.
[5] *Growth and Form* was held at the Institute of Contemporary Art, July 4–August 31, 1951.
[6] *Parallel of Life and Art* was held at the Institute of Contemporary Art, September 11–October 19, 1953.
[7] Reyner Banham, referring to the response of students at the Architectural Association discussion, in "New Brutalism," *Architectural Review* 118, no. 708 (December 1955): 356.
[8] *Man, Machine and Motion* was held at the Hatton Gallery, King's College, Newcastle-upon-Tyne in May 1955, and the Institute of Contemporary Art, July 6–30, 1955. The catalogue included a text by Reyner Banham and was designed by Andrew Froshaug.
[9] *an Exhibit* was held at the Hatton Gallery, King's College, Newcastle-upon-Tyne, June 3–19, 1957, and at the Institute of Contemporary Art, August 13–24, 1957.
[10] Hamilton, *Collected Words*, p. 26.

View of *Patio and Pavilion* by Nigel Henderson, Eduardo Paolozzi, Alison and Peter Smithson at *This Is Tomorrow*.

Kenneth Frampton

New Brutalism and the Welfare State: 1949–59

After the second world war Britain possessed neither the material resources nor the necessary cultural assurance to justify any form of monumental expression. If anything, the postwar tendency lay in the opposite direction, since in architecture, as in other matters, Britain was in the final stages of relinquishing its imperial identity. While Indian independence initiated the disintegration of the Empire in 1945, the class conflict that had so bitterly divided the country during the Depression came to be partially alleviated by the welfare provisions of the Attlee Labour Government. Postwar social reconstruction gained its first impetus from two important parliamentary acts: the Education Act of 1944, raising the school leaving age to fifteen, and the New Towns Act of 1946. This legislation was the effective instrument of an extensive government building program, resulting in the construction of some 2,500 schools within a decade and in the designation of ten new towns, to be built on the model of Letchworth Garden City, with populations ranging from 20,000 to 69,000.

A great deal of this work—outside such precocious authorities as the Hertfordshire County Council which, under the leadership of C.H. Aslin, was to pioneer the wholesale prefabrication of schools—came to be carried out either in the "reduced" Neo-Georgian manner of the average municipal architect, or in the so-called Contemporary Style, which was largely modeled on the official architecture of Sweden's long-established welfare state. The syntax of this style—which was presumably considered to be sufficiently "popular" for the realization of English social reform—comprised an architecture of shallow-pitched roofs, brick walls, vertically boarded spandrels, and squarish wood-framed picture windows, the latter either left bare or painted white. This so-called

people's detailing became, with local additions, the received vocabulary of the left-wing architects of the London County Council, and it acquired a wider acceptance through the influence of the more active editors of *The Architectural Review,* J.M. Richards and Nikolaus Pevsner, who, from having first argued for a stringent modernism, began in the early 1950s to opt for a less rigorous approach to the creation of built form. Pevsner's Reith Lectures of 1955, "The Englishness of English Art," publicly asserted picturesque informality as the very essence of British culture. This humanized version of the modern movement even came to be propagated under the title of "The New Humanism" by the editorial board of *The Architectural Review.*

The Festival of Britain in 1951 served to give this undemanding cultural policy a progressive and modern dimension by parodying the heroic iconography of the Soviet constructivists. Its two most potent symbols, the Skylon by Philip Powell and John Hidalgo Moya, and the Dome of Discovery by Ralph Tubbs, represented nothing more consequential through their structural rhetoric than the "circus" of life for which presumably the "bread" was soon to be provided. It was not that the exhibition was bereft of content, but that its message was presented in a gratuitously casual and even patronizing manner.

While the work of the Swedish architects Bengt Edman and Lennart Holm, in the early 1950s, may have prompted Hans Asplund to coin the term "Neo-Brutalists," it was in England that the radical reaction that it denotes first arose. The gratifying populism of the Festival of Britain was rejected outright by Alison and Peter Smithson, the initial proponents of the brutalist ethos,

who counted among their sympathizers and colleagues many of the immediate postwar generation, including Alan Colquhoun, William Howell, Colin St. John Wilson, and Peter Carter, all of whom were working in the early 1950s for the LCC Architect's Department.

Inasmuch as brutalism embraced an identifiable Palladian tendency, the brutalist response to the new humanism of The Architectural Review was to assert the old humanism, that had in any event always been latent in the prewar modern movement. The 1949 publication of Rudolf Wittkower's Architectural Principles in the Age of Humanism had the unexpected effect of engaging the interest of the rising generation in the methodology and aims of Palladio. On another level the brutalists responded to the challenge of "people's detailing" by making a direct reference to the socio-anthropological roots of popular culture, while rejecting outright the petit-bourgeois respectability of Swedish empiricism. This anthropological aestheticism (closely related as an impulse to the painter Jean Dubuffet's anti-art cult of art brut) brought the Smithsons into contact in the early 1950s with the remarkable personalities of the photographer Nigel Henderson and the sculptor Eduardo Paolozzi, from both of whom brutalism derived much of its existential character.

The years 1951–54 were crucial to the architectural formation of this sensibility. Already heavily involved with the realization of their Palladian-cum-Miesian school designed for Hunstanton in Norfolk in 1949 and completed some five years later, the Smithsons followed their early success with a sequence of highly original competition entries—projects which, as Reyner Banham has remarked, can only be seen as attempts to invent a totally "other" kind of architecture. Indeed, what little Palladianism there is left in their projects of this period is heavily mediated, from their Coventry Cathedral of 1951 to their Golden Lane housing, London of 1952, or their equally remarkable Sheffield University extension of the following year. If anything, these projects are "constructivist" in their affinities, although their restrained structural rhetoric seems in retrospect to have been of Japanese rather than Russian persuasion. That

the failure to realize any of these designs was a loss to English architectural culture may be judged from the absolute banality of the structures that were eventually erected in their place.

The underlying ethos of the original brutalist sensibility —the cryptic element that transcended its Palladianism —first came to public notice with the Parallel of Life and Art exhibition, staged at the Institute of Contemporary Arts, London, in 1953. This show comprised a didactic collection of photographs assembled and annotated by Henderson, Paolozzi, and the Smithsons. Drawn from news photos and arcane archeological, anthropological, and zoological sources, many of these images "offered scenes of violence and distorted or anti-aesthetic views of the human figure, and all had a coarse grainy texture which was clearly regarded by the collaborators as one of their main virtues." There was something decidedly existential about an exhibition that insisted on viewing the world as a landscape laid waste by war, decay, and disease—beneath whose ashen layers one could still find traces of life, albeit microscopic, pulsating within the ruins. Henderson, writing of his work in this period, stated: "I feel happiest among discarded things, vituperative fragments, cast casually from life, with the fizz of vitality still about them. There is an irony in this and it forms at least a partial symbol for an artist's activity."

That this was the underlying motivation of brutalism in the 1950s was not lost on the visitors to This Is Tomorrow, a show staged in 1956 at the Whitechapel Art Gallery. For this exhibition, the Smithsons, once again in collaboration with Henderson and Paolozzi, designed a symbolic temenos—a metaphorical shed in an equally metaphorical backyard, an ironic reinterpretation of Laugier's primitive hut of 1753 in terms of the backyard reality of Bethnal Green. About this installation Reyner Banham remarked:

One could not help feeling that this particular garden shed with its rusted bicycle wheels, a battered trumpet and other homely junk, had been excavated after an atomic holocaust, and discovered to be part of a

European tradition of site planning that went back to archaic Greece and beyond.

But this gesture was by no means entirely retrospective, for within this cryptic and almost casual metaphor of the shed the distant past and the immediate future fused into one. Thus the pavilion patio was furnished not only with an old wheel and a toy aeroplane but also with a television set. In brief, within a decayed and ravaged (i.e., bombed out) urban fabric, the "affluence" of a mobile consumerism was already being envisaged, and moreover welcomed, as the life substance of a new industrial vernacular. Richard Hamilton's ironic collage for this exhibition, entitled *Just what is it that makes today's homes so different, so appealing?,* not only inaugurated pop culture but also crystallized the domestic image of the brutalist sensibility. The Smithsons' "House of the Future," exhibited at the *Daily Mail Ideal Home Exhibition* in 1956, was evidently intended as the ideal home for Hamilton's muscle-bound, "punch-bag" natural man and his curvaceous companion.

Split between a sympathy for old-fashioned working-class solidarity and the promise of consumerism, the Smithsons were ensnared in the intrinsic ambivalence of an assumed populism. Throughout the second half of the 1950s they moved away from their initial sympathy for the life style of the proletariat toward more middle-class ideals that depended for their appeal on both conspicuous consumption and mass ownership of the automobile. At the same time, they remained far from sanguine about the evident potential for such new-found "mobility" to destroy both the structure and the density of the traditional city. In their London Roads Study of 1956 they attempted to resolve this dilemma by projecting the elevated freeway as the new urban fix. Meanwhile, on the domestic scale they continued to regard the chromium consumer product in the crumbling tenement or the plastic interior as the ultimate liberating icon of their conciliatory style.

Up to the mid-1950s truth to materials remained an essential precept of brutalist architecture, manifesting initially in an obsessive concern for the expressive articu-

Installation views of *Patio and Pavilion* at *This Is Tomorrow,* 1956. Architectural design by Alison and Peter Smithson, sculpture by Eduardo Paolozzi, and collages by Nigel Henderson.

lation of mechanical and structural elements, as in the Smithsons' Hunstanton school, and reasserting itself in a more normative but nonetheless anti-aesthetic manner in the small Soho house projected by the Smithsons in 1952. Designed to be built in brick, with exposed concrete lintels and an unplastered interior, this four-story box made numerous references to the British warehouse vernacular of the late nineteenth century, antedating by a year the publication of the equally brutal *avant project* for Le Corbusier's Maisons Jaoul, Paris, and anticipating the various projects for village infill housing designed by James Stirling, William Howell, and the Smithsons themselves, and exhibited at the CIAM Aix-en-Provence Congress of 1953.

The mid-1950s clearly saw an extension of the Brutalist base beyond the hermetic preoccupations of the Smithsons, Henderson, and Paolozzi. By 1955 both Howell and Stirling were part of a Brutalist formation, although Stirling has since denied that he ever thought of himself as such. While his Sheffield University entry of 1953 was indeed Tectonesque, his house project of the same year returned Stirling to the utilitarian brick aesthetic of the 19th century, though this work remained removed, in its neo-plastic-influenced composition of interlocking squares, from the brutal anti-art aura of the Smithsons' Soho house. Meanwhile, within the LCC, architects such as Colquhoun, Carter, Howell, and John Killick had begun to realize a number of Corbusian housing schemes culminating in that parody of the "radiant city," the Alton East Estate built at Roehampton in 1958.

Peter and Alison Smithson standing in the *Patio and Pavilion* at *This Is Tomorrow*, 1956.

Despite the fact that Mies's IIT campus had been the initial influence in shaping the Smithsons' first building, the subsequent development of the brutalist style found much of its vocabulary in the late work of Le Corbusier. His revitalization of the Mediterranean vernacular, manifest in his 1948 Roq et Rob project, proved seminal to the formation of the brutalist sensibility, and the Smithsons followed their enthusiasm for Mies with a subtle reworking of Le Corbusier's *béton brut* manner: as they put it in 1959, "Mies is great but Corb communicates." Similarly the shock first experienced by Stirling on visiting the Maisons Jaoul in 1955 was soon outweighed by

the enthusiasm with which he followed its example. The close correspondence between the syntax of the Maisons Jaoul and the style of Stirling's Ham Common housing of 1955 can hardly be disputed, although load-bearing cross walls were used in the two cases to entirely different architectural ends.

The ultimate integration of the British brutalist aesthetic—the fusion of its contradictory "formalist" and "populist" aspects into a glass and brick 'vernacular' drawn from the industrial structures of the 19th century—came with the works of Stirling and his partner James Gowan in 1959, their dormitory project for Selwyn College, Cambridge, and their Engineering Building for Leicester University. Some acknowledgment must be made here of the work of the late Edward Reynolds, whose structurally expressive (not to say expressionist) designs, which he made while still a student, exerted a decisive influence on the development of brutalism, most notably in the Howell and Killick entry for Churchill College, Cambridge, of 1958, and then in Stirling's Leicester project of the following year.

By now brutalism was beginning to lose its cross-channel existential base. As far as the Smithsons were concerned, the gritty post-occupation ethos of the Left Bank, of Jean-Paul Sartre and Juliette Greco, of Aldo Van Eyck, the Dutch Cobra Group, and Alberto Giacometti, began to give way to the rising star of the Pax Americana, to abstract expressionism, Buckminster Fuller, Elia Kazan, and the sleek, automotive, sheet-metal styling of the car designer Harvey Earl. This decisive shift in sensibility seems to occur in 1956, the year of the Suez Crisis, when the French and English are forced to back down by John Foster Dulles. This is the moment in which the incipient consumerism of the so-called Open Society confronts the brutalist spirit of resistance, as was still evident in Paolozzi's homage to the bombed-out East End of London, his film *Together,* made with Lorenza Mazzetti in 1956. Nothing could be further from the Bethnal Green garden shed and patio, designed for *This Is Tomorrow* by the Smithsons (in collaboration with Paolozzi and Henderson), than the Smithsons' "House of the Future," designed alone, and

exhibited in the *Daily Mail Ideal Home Exhibition* of the same year. As Reyner Banham was to put it, the latter was a pop art patio house that depended for its stream-lined organic appearance on a system of double plastic shell construction, which, as Banham observes, "was conceived as the equivalent of the paneling of a car body. Thus, no single panel was interchangeable with any other in the same house, only with its twin in another house. This situation, long since accepted in the construction of industrially produced shells (such as car bodies, aircraft fuselages, etc.) of course runs exactly counter to ideas of prefabrication current in architectural circles (e.g., all the various prefabricating projects associated with the names Gropius and Wachsmann), where the attempt has always been to work towards a single universal element that can fulfill any role the structure requires . . ."

Except in so far as it was still a cavelike house, little of the early brutalist troglodyte ethos remains in this work save, perhaps, the plastic idiosyncrasies of its introspective elevations and for the casual, technically inexplicable irregularity of some of the curves that delimit the roughly orthogonal perimeter of its form. The bidet-cum-sitzbad, let into the floor, the cylindrical shower stall, with its curved transparent retractable door, the equally retractable hexagonal table that was to descend noiselessly, by remote control, into the floor, all of this went along perfectly with the snap-on, gasketed, car-body joints and with the chromium-plated American kitchen gadgetry of the period, with which the Smithsons, subject to the continual influence of Paolozzi and Hamilton, were so evidently obsessed. In the end, this prefabricated, injection-molded, all-too-literally-Taylorized *machine-à-habiter* failed to take off, for the market and the mortgage companies had something else in mind, namely, the by-pass dream of the stockbroker's Tudor house, which has long been the English petit bourgeois version of home.

This essay is based on an extract from the author's Modern Architecture: A Critical History *(revised edition), published by Thames and Hudson, London, 1985.*

Nigel Henderson. *Newstand in Bethnal Green,* c. 1952. Photograph, 10 x 8 in. (25.4 x 20.3 cm). Estate of the artist.

Alison and Peter Smithson

But Today We Collect Ads

Traditionally the fine arts depend on the popular arts for their vitality, and the popular arts depend on the fine arts for their respectability. It has been said that things hardly "exist" before the fine artist has made use of them, they are simply part of the unclassified background material against which we pass our lives. The transformation from everyday object to fine art manifestation happens in many ways; the object can be discovered—*objet trouvé* or *l'art brut*—the object itself remaining the same; a literary or folk myth can arise, and again the object itself remains unchanged; or, the object can be used as a jumping-off point and is itself transformed.

Le Corbusier in Volume 1 of his *Oeuvre Complète* describes how the "architectural mechanism" of the Maison Citrohan (1920) evolved. Two popular art devices—the arrangement of a small zinc bar at the rear of the café, with a large window to the street, and the close vertical patent-glazing of the suburban factory—were combined and transformed into a fine art aesthetic. The same architectural mechanism produced ultimately the Unité d'Habitation.

The Unité d'Habitation demonstrates the complexity of an art manifestation, for its genesis involves popular art stimuli, historic art seen as a pattern of social organization, not as a stylistic source (observed at the Chartreuse D'Ema, 1907), and ideas of social reform and technical revolution patiently worked out over forty years, during which time the social and technological set-up, partly as a result of his own activities, met Le Corbusier half-way.

Why certain folk art objects, historical styles, or industrial artifacts and methods become important at a particular moment cannot easily be explained.

Gropius wrote a book on grain silos,
Le Corbusier one on aeroplanes,
And Charlotte Periand brought a new
object to the office every morning;
But today we collect ads.

Advertising has caused a revolution in the popular art field. Advertising has become respectable in its own right and is beating the fine arts at their old game. We cannot ignore the fact that one of the traditional functions of fine art, the definition of what is fine and desirable for the ruling class, and therefore ultimately that which is desired by all society, has now been taken over by the ad-man.

To understand the advertisements which appear in the *New Yorker* or *Gentry* one must have taken a course in Dublin literature, read a *Time* popularizing article on cybernetics, and have majored in Higher Chinese Philosophy and Cosmetics. Such ads are packed with information—data of a way of life and a standard of living which they are simultaneously inventing and documenting. Ads which do not try to sell you the product except as a natural accessory of a way of life. They are good "images" and their technical virtuosity is almost magical. Many have involved as much effort for one page as goes into the building of a coffee bar. And this transient thing is making a bigger contribution to our visual climate than any of the traditional fine arts.

The fine artist is often unaware that his patron, or more often his patron's wife who leafs through the magazines, is living in a different visual world from his own. The pop art of today, the equivalent of the Dutch fruit and flower arrangement, the pictures of second rank of all Renaissance schools, and the plates that first presented to the public the Wonder of the Machine Age and the New Territories, is to be found in today's glossies—bound up with the throw-away object.

As far as architecture is concerned, the influence on mass standards and mass aspirations of advertising is now infinitely stronger than the pace setting of *avant-garde* architects, and it is taking over the functions of social reformers and politicians. Already the mass production industries have revolutionized half the house—kitchen, bathroom, utility room, and garage—without the intervention of the architect, and the curtain wall and the modular prefabricated building are causing us to revise our attitude to the relationship between architect and industrial production.

By fine-art standards the modular prefabricated building, which of its nature can only approximate the ideal shape for which it is intended, must be a bad building. Yet, generally speaking, the schools and garages which have been built with systems or prefabrication lick the pants off the fine-art architects operating in the same field. They are especially successful in their modesty. The ease with which they fit into the built hierarchy of a community.

By the same standards the curtain wall too cannot be successful. With this system the building is wrapped

Alison and Peter Smithson: Axiometric view of *House of the Future*, 1956.

Installation view of *House of the Future*, 1956, interior.

round with a screen whose dimensions are unrelated to its form and organization. But the best postwar office block in London is one which is virtually all curtain wall. As this building has no other quality apart from its curtain wall, how is it that it puts to shame other office buildings which have been elaborately worked over by respected architects and by the Royal Fine Arts Commission?

To the architects of the twenties, "Japan" was the Japanese house of prints and paintings, the house with its roof off, the plane bound together by thin black lines. (To quote Gropius, "the whole country looks like one gigantic basic design course.") In the thirties Japan meant gardens, the garden entering the house, the tokonoma.

For us it would be the objects on the beaches, the piece of paper blowing about the street, the throw-away object and the pop-package.

For today we collect ads.

Ordinary life is receiving powerful impulses from a new source. Where thirty years ago architects found in the field of the popular arts techniques and formal stimuli, today we are being edged out of our traditional role by the new phenomenon of the popular arts—advertising.

Mass-production advertising is establishing our whole pattern of life—principles, morals, aims, aspirations, and standard of living. We must somehow get the measure of this intervention if we are to match its powerful and exciting impulses with our own.

Reprinted from Ark. no. 18 (November 1956).

Richard Hamilton

Persuading Image

The fifties have seen many changes in the human situation; not least among them are the new attitudes towards commodities that most directly affect the individual way of life—consumer goods. It is now accepted that saucepans, refrigerators, cars, vacuum cleaners, suitcases, radios, washing machines—all the paraphernalia of mid-century existence—should be designed by a specialist in the look of things. Of course, the high-powered virtuoso industrial designer is not a new phenomenon—Raymond Loewy and Walter Dorwin Teague have been at it for a good many years. William Morris and Walter Gropius realized the potential. What is new is the increased number of exponents, their power and influence upon our economic and cultural life. Design is established and training for the profession is widespread.

The student designer is taught to respect his job, to be interested in the form of the object for its own sake as a solution to given engineering and design problems—but he must soon learn that in the wider context of an industrial economy this is a reversal of the real values of present-day society. Arthur Drexler has said of the automobile: "Not only is its appearance and its usefulness unimportant . . . What is important is to sustain production and consumption." The conclusion he draws is that "if an industrialized economy values the process by which things are made more than it values the thing, the designer ought to have the training and inclinations of a psychoanalyst. Failing this he ought, at least, to have the instincts of a reporter, or, more useful, of an editor."[1]

The image of the fifties shown here is the image familiar to readers of the glossy magazines—"America entering the age of everyday elegance"; the image of *Life*

and *Look, Esquire* and the *New Yorker;* the image of the fifties as it was known and molded by the most successful editors and publicists of the era, and the ad-men who sustained them—"the fabulous fifties" as *Look* has named them. Being "plush at popular prices" is a prerogative that awaits us all. Whether we like it or not, the designed image of our present society is being realized now in the pages of the American glossies by people who can do it best—those who have the skill and imagination to create the image that sells, and the wit to respond humanly to their own achievements.

The present situation has not arrived without some pangs of conscience. Many designers have fought against the values which are the only ones that seem to work to the economic good of the American population. There is still a hangover from the fortyish regret that things do not measure up to the aesthetic standards of pure design; the kind of attitude expressed in 1947 by George Nelson when he wrote: "I marvel at the extent of the knowledge needed to design, say, the *Buick* or the new *Hudson*—but I am also struck by my inability to get the slightest pleasure out of the result."[2] There has since been a change of heart on both sides; on the part of the designers, the men who establish the visual criteria, towards a new respect for the ability of big business to raise living standards—and an appreciation, by big business, of the part that design has to play in sales promotion. What is new and unique about the fifties is a willingness to accept a new situation and to custom build the standards for it.

There is not, of course, a general acceptance of this point of view. Some designers, especially on this side of the Atlantic, hold on to their old values and are pre-

[1] Arthur Drexler in a lecture at the Chicago Institute of Design. Reprinted in George Nelson, *Problems of Design*.
[2] George Nelson, *Problems of Design* (London: Whitney Publications).

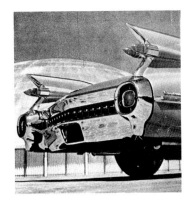

pared to walk backwards to do so. Misha Black goes so far as to suggest that advanced design is incompatible with quantity production when he says: "If the designer's inclination is to produce forward-looking designs, ahead of their acceptability by large numbers of people, then he must be content to work for those manufacturers whose economic production quantities are relatively small."[3] While Professor Black was consoling the rearguard for being too advanced, Lawrence Alloway was stressing the fact that "every person who works for the public in a creative manner is face-to-face with the problem of a mass society."[4] It is just this-coming-to-terms with a mass society that has been the aim and the achievement of industrial design in America. The task of orientation towards a mass society required a rethink of what was, so convincingly, an ideal formula. Function is a rational yardstick, and when it was realized in the twenties that all designed objects could be measured by it, everyone felt not only artistic but right and good. The trouble is that consumer goods function in many ways; looked at from the point of view of the business man, design has one function—to increase sales. If a design for industry does not sell in the quantities for which it was designed to be manufactured then it is not functioning properly.

The element in the American attitude to production that worries the European most is the cheerful acceptance of obsolescence; American society is committed to a rapid quest for mass, mechanized luxury because this way of life satisfies the needs of the American industrial economy. By the early fifties it had become clear in America that production was no problem. The difficulty lay in consuming at the rate which suited production, and this rate is not high—it must accelerate. The philosophy of obsolescence, involving as it does the creation of short-term solutions, designs that do not last, has had its drawbacks for the designer—the moralities of the craftsman just do not fit when the product's greatest virtue is impermanence. But some designers have been able to see in obsolescence a useful tool for raising living standards. George Nelson, in his book *Problems of Design*, states the case very forcibly: "Obsolescence as a process is wealth-producing, not wasteful. It

leads to constant renewal of the industrial establishment at higher levels, and it provides a way of getting a maximum of good to a maximum of people." His conclusion is: "What we need is more obsolescence, not less." Mr. Nelson's forward-looking attitude squarely faced the fact that design must function in industry to assist rapid technological development; we know that this can be done by designing for high production rates of goods that will have to be renewed at frequent intervals.

The responsibility of maintaining the desire to consume, which alone permits high production rates, is a heavy one, and industry has been cross-checking. With a view to the logical operation of design, American business utilized techniques which were intended to secure the stability of its production. In the late forties and early fifties an effort was made, through market research, to ensure that sales expected of a given product would, in fact, be available to it. Months of interrogation by an army of researchers formed the basis for the design of the Edsel, a project which involved the largest investment of capital made by American business in postwar years. This was not prompted by a spirit of adventure— rather it was an example of the extreme conservatism of American business at the time. It was not looking to the designer for inspiration but to the public, seeking for a composite image in the hope that this would mean preacceptance in gratitude for wish-fulfilment. American business simply wanted the dead cert. It came as something of a shock when the dead cert came home last. The Edsel proved that it took so long to plan and produce an automobile that it was no good asking the customer what he wanted—the customer was not the same person by the time the car was available. Industry needed something more than a promise of purchase—it needed an accurate prophecy about purchasers of the future. Motivation research, by a deeper probe into the subconscious of possible consumers, prepared itself to give the answer.

It had been realized that the dynamic of industrial production was creating an equal dynamic in the consumer, for there is no ideal in design, no predetermined consumer, only a market in a constant state of flux. Every new product and every new marketing technique affects this changing situation. For example, it has long been understood that the status aspect of car purchasing is of fundamental importance to production. Maintaining status requires constant renewal of the goods that bestow it. As *Industrial Design* has said: "Postwar values were made manifest in chrome and steel."[5] But the widespread realization of aspirations has meant that gratification through automobile ownership has become less effective. Other outlets, home ownership and the greater differentiation possible through furnishing and domestic appliances, have taken on more significance. Company policy has to take many such factors into account. Decisions about the relationship of a company to society as a whole often do more to form the image than the creative talent of the individual designer. Each of the big manufacturers has a design staff capable of turning out hundreds of designs every year, covering many possible solutions. Design is now a selective process, the goods that go into production being those that motivation research suggests the consumer will want.

Most of the major producers in America now find it necessary to employ a motivation staff, and many employ outside consultants in addition. The design consultants of America have also had to comply with the trend to motivation research, and *Industrial Design* reports[6] that most now have their own research staffs. This direction of design by consumer research has led many designers to complain of the limitation of their contribution. The designer cannot see himself just as a cog in the machine which turns consumer motivations into form—he feels that he is a creative artist. Aaron Fleischmann last year, in the same *Industrial Design* article, expressed these doubts: "In the final analysis, however, the designer has to fall back on his own creative insights in order to create products that work best for the consumer; for it is an axiom of professional experience that the consumer cannot design—he can only accept or reject." His attitude underrates the creative power of the yes/no decision. It presupposes the need to reserve the formative binary response to a single individual in-

[3]Misha Black in the Percy Wells Memorial Lecture at the Technical College for the Furnishing Trades (Shoreditch, 1958).
[4]Lawrence Alloway, "The Arts and the Mass Media," *Architectural Design* 28, no. 2 (February 1958):84.
[5]*Industrial Design* (February 1959): 79.
[6]*Industrial Design* (February 1958): 34–43.

stead of a corporate society. But certainly it is worth-
while to consider the possibility that the individual and
trained response may be the speediest and most
efficient technique.

Design in the fifties has been dominated by consumer
research. A decade of mass psychoanalysis has shown
that, while society as a whole displays many of the
symptoms of individual case histories, analysis of which
makes it possible to make shrewd deductions about the
response of large groups of people to an image, the re-
searcher is no more capable of creating the image than
the consumer. The mass arts, or pop arts, are not popu-
lar arts in the old sense of art arising from the masses.
They stem from a professional group with a highly de-
veloped cultural sensibility. As in any art, the most val-
ued products will be those which emerge from a strong
personal conviction and these are often the products
which succeed in a competitive market. During the last
ten years market and motivation research have been the
most vital influence on leading industrialists' approach
to design. They have gone to research for the answers
rather than to the designer—his role, in this period, has
been a submissive one, obscuring the creative contribu-
tion which he can best make. He has, of course, gained
benefits from this research into the consumers' response
to images—in package design, particularly, techniques
of perception study are of fundamental importance.
But a more efficient collaboration between design and
research is necessary. The most important function of
motivation studies may be in aiding control of motiva-
tions—to use the discoveries of motivation research to
promote acceptance of a product when the principles
and sentiments have been developed by the designer.
Industry needs greater control of the consumer—a capi-
talist society needs this as much as a Marxist society.
The emphasis of the last ten years on giving the con-
sumer what he thinks he wants is a ludicrous exaggera-
tion of democracy; propaganda techniques could be ex-
ploited more systematically by industry to mold the
consumer to its own needs.

This is not a new concept. Consumer requirements and
desires—the consumer's image of himself—are being

modified continually now; the machinery of motivation control is already established. At present this control operates through the intuitions of advertising men, editors of opinion- and taste-forming mass circulation magazines, and the journalists who feed them. But these techniques are too haphazard, too uncertain—fashion is subject to whims and divergencies, to personal eccentricities which squander the means of control. As monopolistic tendencies increase we can expect a more systematic application of control techniques with greater power to instil the craving to consume. It will take longer to breed desire for possession when the objects to be possessed have sprung not directly from the subconscious of the consumer himself, but from the creative consciousness of an artistic sensibility—but the time lag will have distinct advantages for industry.

An industry programed five years and more ahead of production has to think big and far-out. Product design, probing into future and unknown markets, must be venturesome and, to be certain of success, stylistically and technically valid. As the situation stands at the moment it is anybody's guess (some guessers shrewder than others) which images and symbols will mean most to the public in 1965. It is like someone in 1945 trying to forecast a specific description of Marilyn Monroe. New solutions in product design need to be as inherently likeable and efficient as MM, and as capably presented to the public by star propagandists. Many successful products attain high sales after several years of low production rates. The market is made by the virtues of the object: the Eames chair and the Volkswagen, best-sellers in recent years, are concepts which date back to the thirties. Detroit cannot wait that long and this impatience is a clue to what we can expect in all the consumer industries. New products need market preparation to close the gap. Industry, and with it the designer, will have to rely increasingly on the media which modify the mass audience—the publicists who not only understand public motivations but who play a large part in directing public response to imagery. They should be the designers' closest allies, perhaps more important in the team than researchers or sales managers. Ad-man, copywriter, and feature editor need to be working together

For '61
Buick brings you
THE CLEAN LOOK of action!

Now!
Full size living in 2
new-size surprises

TURN THE PAGE AND SEE WHY '61 IS BUICK'S YEAR!

HUGS THE RUG CLOSER HERE!

MORE DIRT GOES IN HERE!

with the designer at the initiation of a program instead of as a separated group with the task of finding the market for a completed product. The time lag can be used to design a consumer to the product and he can be ''manufactured'' during the production span. Then producers should not feel inhibited, need not be disturbed by doubts about the reception of their products from an audience they do not trust; the consumer can come from the same drawing board.

Within this framework the designer can maintain a respect for the job and himself while satisfying a mass audience; his responsibility to that amorphous body is more important than his estimation of the intrinsic value of the product itself—design has learned this lesson in the fifties. The next phase should consolidate that understanding of the essential service he is providing for industry and consumer, and extend the use of new psychological techniques as part of the designer's equipment in finding more precise solutions to the needs of society.

Reprinted from Design, *no. 134 (February 1960).*

THE
SUNDAY
TIMES COLOUR SECTION

HOW AMERICAN ARE WE?

Reyner Banham

Vehicles of Desire

The new brutalists, pace-makers and phrase-makers of the anti-academic line-up, having delivered a smart KO to the Land Rover some months back, have now followed it with a pop-eyed OK for the Cadillac convertible, and automobile aesthetics are back on the table for the first time since the twenties. The next time an open Caddy wambles past you, its front chrome-hung like a pearl-roped dowager, its long top level with the ground at a steady thirty inches save where the two tailfins cock up to carry the rear lights, reflect what a change has been wrought since the last time any architect expressed himself forcibly on the subject of the automobile.

That was in the twenties when Le Corbusier confronted the Parthenon and the Bignan-Sport, and from then to the new brutalists the Greek Doric motorcar with its upright lines, square styling, mahogany fascia, and yellowing nickel trim has remained the *beau ideal* of world aesthetes from Chicago to Chelsea Polytechnic. So great has been the aesthetic self-aggrandizement of architects, so great the public's Ruskin-powered terror of them that when Le Corbusier spoke, no-one dared to argue, and it has been placidly assumed ever since that all artifacts should be designed architect-wise, and that later automobiles which deviated from the Doric norm of the twenties were badly designed. But what nonsense this is. Far from being *uomini universali,* architects are by training, aesthetics, and pyschological predisposition narrowly committed to the design of big, permament single structures, and their efforts are directed merely to focusing big, permanent human values on unrepeatable works of unique art.

The automobile is not big—few are even mantelpiece high—it is not permanent—the average world scrapping period has lately risen, repeat risen, to fifteen years—and they certainly are not unique. The effective, time-base against which the impermanence of the automobile should be reckoned is less than even fifteen years, because the average resale period—the measure of social obsolescene—is only three to six years, while technical obsolescence is already acute after eight to ten years. And as to uniqueness, even relatively unpopular cars have a bigger annual output than all but the most sought-after, prefabricated, serially produced buildings. This is a field where the architect is rarely qualified to work, or to pass judgment, and automobiles designed by architects are notoriously old-fashioned, even where—like Walter Gropius's Adler coupés—they introduce marginal novelties such as reclining seats.

The technical history of the automobile in a free market is a rugged rat-race of detail modifications and improvements, many of them irrelevant, but any of the essential ones lethal enough to kill off a manufacturer who misses it by more than a couple of years. The "classic" automobiles whose "timeless" qualities are admired by aesthetes are nowadays the product of abnormal sales conditions—the slump-crazy market on which Citroen's *traction-avant* was launched was as freakish as the commercially and ideolgically protected one on which Dr. Porsche launched the Volkswagen. On the open market, where competition is real, it is the cunningly programed minor changes that give one manufacturer an edge over another, and the aesthetics of body styling are an integral part of the battle for margins. Under these circumstances we should be neither surprised nor shocked to find that styling runs the same way as engineering development, and in any case there can be no

norms of formal composition while the automobile remains an artifact in evolution, even though particular models are stabilized.

In fact it is a great deal more than an artifact in evolution as a concept while standarized in any passing type; it is also numerous as a possession while expendable as an individual example, a vehicle of popular desire and a dream that money can just about buy. This is a situation with which no preindustrial aesthetic ever had to cope; even Plato's side-swipe at the ceramic trade in the *Philebus* falls a long way short of our current interpretative needs, for the Greek pot, though numerous and standardized, had long given up evolving and was not conspicuously expendable. But we are still making do with Plato because in aesthetics, as in most other things, we still have no formulated intellectual attitudes for living in a throw-away economy. We eagerly consume noisy ephemeridae, here with a bang today, gone without a whimper tomorrow—movies, beachwear, pulp magazines, this morning's headlines and tomorrow's TV programs—yet we insist on aesthetic and moral standards hitched to permanency, durability, and perennity.

The repertoire of hooded headlamps, bumper-bombs, sporty nave-plates, ventilators, intakes, incipient tailfins, speed-streaks and chromium spears, protruding exhaust pipes, cineramic windscreens—these give tone and social connotation to the body envelope; the profiling of wheel-arches, the humping of mudguards, the angling of roof-posts—these control the sense of speed; the grouping of the main masses, the quality of the main curves of the panels—these balance the sense of masculine power and feminine luxury. It is a thick ripe stream of loaded symbols—that are apt to go off in the face of those who don't know how to handle them.

The stylist knows how, because he is continually sampling the public response to dream-car protoypes, fantasy vehicles like Ford's fabulous Futura, but other people must be more careful. As the New York magazine *Industrial Design* said, when reviewing the 1954 cars, "The most successful company in the history of the world makes automobiles; in 1953 General Motors'

Cadillac presents
the greatest advancements it has ever achieved
in motor car styling and engineering!

The Sixty-Two Convertible French embroidery from the Brooklyn Museum · Jeweled "V" and Crest created by Van Cleef and Arpels

The Cadillac car is so soundly designed and so carefully crafted that its very name has become a synonym for quality.

CADILLAC MOTOR CAR DIVISION, GENERAL MOTORS CORPORATION

Eduardo Paolozzi, *The Ultimate Planet*, 1952,
detail Collage on paper, 9⅞ x 15 in.
(25.1 x 38.1 cm). The Trustees of the Tate Gallery.

Eduardo Paolozzi. *Yours Till the Boys Come Home*, 1951. Collage on
paper, 14¼ x 9¾ in. (362 x 248 mm). The Trustees of the Tate Gallery.

Robby the Robot with Anne Francis.

sales totaled $10,028,000,000, an unheard of sum. Under the circumstances, passing judgement on a new crop of cars is like passing judgment on a nation's soul."

But coupled with this admirable caution, *Industrial Design* also possesses a shame-faced, but invaluable, ability to write automobile-critique of almost Berensonian sensibility. In its pages, fenced about with routine kow-tows to the big permanent values, one will find passages like "the Buick . . . is perpetually floating on currents that are permanently built into the design. The designers put the greatest weight over the front wheels, where the engine is, which is natural enough. The heavy bumper helps to pull the weight forward; the dip in the body and the chrome spear express how the thrust is dissipated in turbulence toward the rear. Just behind the strong shoulder of the car a sturdy post lifts up the roof, which trails off like a banner in the air. The driver sits in the dead calm at the center of all this motion— hers is a lush situation."

This is the stuff of which the aesthetics of expendability will eventually be made. It carries the sense and the dynamism of that extraordinary continuum of emotional-engineering-by-public-consent which enables the automobile industry to create vehicles of palpably fulfilled desire. Can architecture or any other twentieth-century art claim to have done as much? And, if not, have they any real right to carp?

All right then, *hypocrite lecteur,* where are you now with the automobile? As an expendable, replaceable vehicle of popular desires, it clearly belongs with the other dreams that money can buy, with *Galaxy, The Seven-Year Itch, Rock, Rattle 'n' Roll,* and *Midweek Reveille,* the world of expendable art so brilliantly characterized by Leslie Fiedler in the August issue of *Encounter.* The motor car is not as expendable as they are, but it clearly belongs nearer to them than to the Parthenon, and it exhibits the same creative thumbprints—finish, fantasy, punch, professionalism, swagger. A good job of body styling should come across like a good musical—no fussing after big, timeless abstract virtues, but maximum glitter and maximum impact.

The top body stylists—they are the anonymous heads of anonymous teams—aim to give their creations qualities of apparent speed, power, brutalism, luxury, snob-appeal, exoticism, and plain common-or-garden sex. The means at their disposal are symbolic iconographies, whose ultimate power lies in their firm grounding in popular taste and the innate traditions of the product, while the actual symbols are drawn from science fiction, movies, earth-moving equipment, supersonic aircraft, racing cars, heraldry, and certain deep-seated mental dispositions about the great outdoors and the kinship between technology and sex. Arbiter and interpreter between the industry and the consumer, the body stylist deploys, not a farrago of meaningless ornament, as fine-art critics insist, but a means of saying something of breathless, but unverbalizable, consequence to the live culture of the Technological Century.

Reprinted from Art, no. 1 (September 1, 1955).

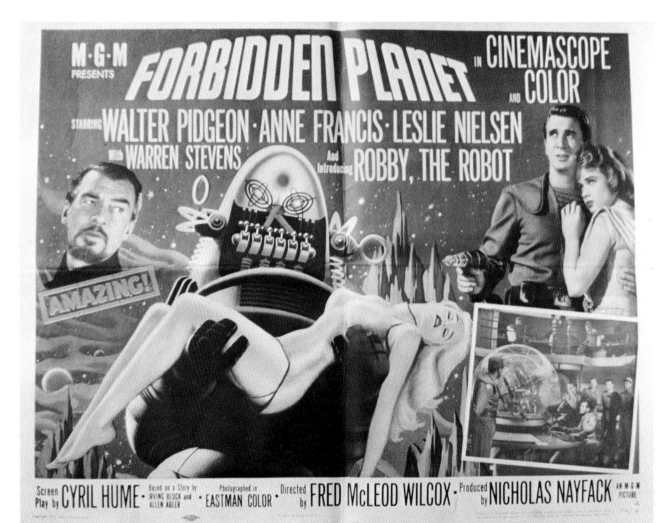

Poster for *Forbidden Planet* (M-G-M, 1956).

Eugenie Tsai

The Sci-Fi Connection: the IG, J.G. Ballard, and Robert Smithson

The robot can symbolise bland acceptance of machines or fears of a violent sexual nature. Common to both extremes is the retention of the human image. At a time when many artists are looking for iconographies with which to express 'the times' with a high degree of accessibility, the popular arts have it.
Lawrence Alloway[1]

Science fiction fascinated Independent Group (IG) members as a genre that was particularly in touch with the radical technological changes that were underway in postwar culture. Opposed to the dominant "high art" outlook of Herbert Read, president of the Institute of Contemporary Arts, the IG felt that popular culture produced iconography most truly representative of contemporary society. In fact, the admiration for science fiction can be traced back to the very first IG meeting in 1952, when Eduardo Paolozzi projected his favorite mass media images, including covers from science fiction "pulps" such as *Amazing Stories, Science Fantasy,* and *Thrilling Wonder Stories.* The most lurid of these featured sexually-charged confrontations between masculine robots and voluptuous women. Two years later, in January 1954, Lawrence Alloway lectured at the ICA on "Science Fiction," and in October 1958, he gave a "Mass Communications" session on "Monster Engineering." This examined the uses of monsters in the mass media, including the "ergonomic approach" found in technically slanted science fiction.

Of course, the best-known example of the IG's interest in science fiction appeared in the futuristic exhibition, *This Is Tomorrow,* (1956) at the Whitechapel Art Gallery. Richard Hamilton, John Voelcker, and John McHale collaborated on an environment that included a four-

teen-foot-high billboard cut-out of Robby the Robot, a charming automaton from the recently released American movie *Forbidden Planet.* This provocative image of a "mechanical man" abducting a beautiful young woman (a scene that did not appear in the movie) had been used for publicity during the movie's London run. Alloway felt that: "Robby . . . symbolises the machine age in its vivid, superstitious, and current forms."[2] Certainly Robby's presence at the exhibition was timely; the man-machine relationship was an important issue in the fifties and many robot stories written during this period reveal an ambivalence towards machines.[3] This ambivalence is clearly evident in *Forbidden Planet,* which combines a sense of the potential of technological advancement with a stern message that machines are only as virtuous as their human makers. The movie is a wild pseudo-Freudian adventure based loosely upon *The Tempest* and set in outer space.

When *This Is Tomorrow* opened in August 1956, J.G. Ballard was a newcomer to the world of science fiction. Four months later, "Escapement" and "Prima Belladonna," two of the twenty-six-year-old author's earliest stories, appeared in the magazines *Science Fantasy* and *New Worlds.* At this time, Ballard was already familiar with the IG:

They [the IG] were interested in a fresh look at the consumer goods and media landscape of the day, regarded it as a proper subject matter for the painter. I felt their approach had a certain kinship with that of science fiction (in which they were all extremely interested) and I went along to the "This is Tomorrow" exhibition at the Whitechapel Gallery in '56.[4]

[1] Lawrence Alloway, "The Robot & the Arts," *Art News and Review* 8, no. 16 (September 1, 1956): 1,6.
[2] Alloway, "The Robot & the Arts," p. 1.
[3] Peter Nicholls, ed. *The Science Fiction Encyclopedia* (New York: Doubleday, 1979), p. 504.
[4] J.G. Ballard, "From Shanghai to Shepperton," *RE/SEARCH,* no. 8/9 (1984): 121.

Although the IG's interest in science fiction may initially have attracted Ballard to *This Is Tomorrow*, the environment created by Hamilton, Voelcker, and McHale caused him to seriously reconsider the traditional conventions of the genre. Nearly thirty years after the exhibition, Ballard was able to recall the impact that environment had on his thinking:

Richard Hamilton had on show his famous little painting . . . And there were a lot of other Pop artifacts there, which impressed me a great deal. It struck me that these were the sorts of concerns that the SF writer should be interested in. Science fiction should be concerned with the here and now, not with the far future but with the present, not with alien planets but with what was going on in the world in the mid-'50s.[5]

Appropriately enough, through his association with *New Worlds*, Ballard later became friends with IG members Paolozzi, Hamilton, and Banham.

In addition to making Ballard reconsider the conventions of science fiction, *This Is Tomorrow* seems to have reinforced his inclination to examine the connection between man and his surroundings. The two parts of the environment constructed by Hamilton, Voelcker, and McHale underscored the relationship between overloaded perception and the plethora of imagery common to a technological mass media environment. However, while Ballard admired the IG's approach to popular culture, he scorned the sort of science fiction sources they employed. Ballard's psychological approach was a reaction against the futuristic, outer-space-oriented science fiction the IG knew. For example, his "Terminal Beach," 1964, takes place in the late twentieth century on Earth, in contrast to *Forbidden Planet*, which is set in the twenty-third century on the fictional planet of Altair IV. Ballard's vision of the future excludes high-tech hardware such as robots, spaceships, and laser blasters. His story revolves around a lone anti-hero, Traven, who seeks out the the deserted nuclear testing ground called Eniwetok. The gradually deteriorating "synthetic landscape" of this island is echoed by Traven's growing physical and psychic enervation. Ballard's entropic out-

[5]Ballard, "From Shanghai to Shepperton," p. 121.

John McHale, *Untitled*, 1956

look directly contradicts that of *Forbidden Planet,* which represents the future as a time in which machines enable man to conquer all aspects of the physical universe. Rather than fantasize about technological innovations, Ballard speculates about the effects a technologically altered environment might have on the human psyche. His protagonists are almost always completely impotent in the face of apocalyptic physical change. Ballard's work marks a shift from traditional science fiction adventures in outer space to the "discovery of inner space." His stories, which focus on entropy, environment, and altered states of consciousness, exemplify the "new wave" science fiction that came to critical attention in the mid-sixties. Ballard has since become something of a cult figure, largely on the basis of later publications: *The Atrocity Exhibition* (1970), *Crash* (1973), and *Concrete Island* (1974). While it remained tied to traditional science fiction, *This Is Tomorrow* contributed to the formation of the more critical and cynical "new wave" through its influence on Ballard.

Robert Smithson, like the IG, used science fiction, including the work of Ballard, to formulate a more expansive theory of art. Interesting parallels can be drawn between the situation he faced in the early sixties and that faced by the IG. Smithson felt that art criticism was dominated by a stifling force: the Greenbergian school. The idealist outlook of this faction was remarkably similar to that of the IG's nemesis, Herbert Read. Greenberg and his followers regarded art as self-referential, universal, and timeless, and concerned themselves with making aesthetic and qualitative judgments. Smithson, like the IG, challenged this narrow definition of art and turned to extra-artistic sources, including science fiction, to develop a broader alternative. Other sources he examined were contempory literature, film, linguistics, philosophy, anthropology, and, of course, the natural sciences.

Science fiction imagery appealed to Smithson throughout his career. Spacemen, rocketships, and B.E.M.s (bug-eyed monsters) populate his untitled collages from 1961–64. However, in the mid-sixties, he departed from representational paintings and collages and moved

Filmstill from *Spaceways,* 1954, starring Howard Duff and Eve Bartor.

X-ray decompression of Faith Domergue and Rex Reason in science-fiction film *This Island Earth,* 1954.

Robert Smithson. *Untitled,* 1966. Photostat 8½ x 12 in. (22 x 30 cm). Estate of the artist. Courtesy John Weber Gallery.

to abstract sculpture. This move corresponded to a shift in his science fiction sources from those propagating a traditional anthropomorphic worldview to a Ballardian vision of the desolate post-apocalyptic landscape. Now Smithson drew his imagery from visionary landscapes and settings. In fact, his essays used descriptions of architectural monuments to place the minimalist sculpture of his contemporaries in a futuristic context. Compare, for example, Donald Judd's "Specific Objects," Robert Morris's "Notes on Sculpture I," and Smithson's 1966 "Entropy and the New Monuments." While Judd and Morris discuss the abstract structures in formalist terms, Smithson opens his essay with an evocative passage from John Taine's science fiction classic *The Time Stream*:

On rising to my feet, and peering across the green glow on the Desert, I perceived that the monument against which I had slept was but one of thousands. Before me stretched long parallel avenues, clear to the far horizon of similar broad, low pillars.[6]

This was juxtaposed with a photo of Ronald Bladen's monolithic sculptures. Smithson points out that "many architectural concepts found in science fiction . . . suggest a new kind of monumentality which has much in common with the aims of some of today's artists."[7] He had in mind, among others, Judd, Morris, LeWitt, and Flavin. In addition, Smithson notes that the work of these artists "have provided a visible analog for the Second Law of Thermodynamics, which extrapolates the range of entropy . . . "[8]—a view consistent with that of Ballard. By discussing entropy, Smithson introduced the concept of time into art, running counter to the Greenbergian view of art as suspended in a timeless void. Smithson visualized geometric monuments and their surreal landscape surroundings in an untitled photostat of 1966. His later site-specific work, such as *Spiral Jetty* (1970), correspond even more closely to Ballard's notion of the future landscape "de-evolving" to the prehistoric past.

Smithson also opened his unpublished "The Artist as Site-Seer or a Dintorphic Essay" with a quote about monuments, this time from Ballard's *Terminal Beach*. In this passage, the landscape functions as an objective correlative for state of mind:

The system of megaliths now provided a complete substitute for the functions of his mind which gave to it its sense of the sustained rational order of time and space[9]

In addition, Smithson chose to discuss an excerpt in which Ballard focuses on the communicative function of megaliths:

The idea of the megalith appears in several of Ballard's science-fiction stories, but in The Waiting Grounds, *we find many references to codes that are "chiselled" onto the "five stone rectangles." They are "strings of meaningless ciphers . . . intricate cuneiform glyphics . . . minute carved symbols . . . odd cross-hatched symbols that seemed to be numerals . . . "*[10]

Smithson later asks: "Is language at the root of these megaliths, the way mathematics is at the root of geometry?"[11] In this way, Smithson uses Ballard to suggest that, contrary to Greenbergian dogma, art is a system of communication, not an object of contemplation.

[6] Robert Smithson, "Entropy and the New Monuments," *Artforum* 5, no. 10 (June 1966): 26. Reprinted in *The Writings of Robert Smithson* Nancy Holt, ed. (New York: New York University Press, 1979), p. 9–18.
[7] Robert Smithson, "Entropy and the New Monuments," p. 26.
[8] Ibid.
[9] Robert Smithson, "The Artist as Site-Seer. A Dintorphic Essay," p. 1. Robert Smithson Papers. Archives of American Art/Smithsonian Institution, microfilm roll 3834, frame no. 331.
[10] Robert Smithson, "The Artist as Site-Seer. A Dintorphic Essay," p. 2, roll 3834, frame no. 332.
[11] Ibid.

Eduardo Paolozzi. *It's a Psychological Fact Pleasure Helps Your Disposition,* 1948. Collage on paper, 14½ x 9½ in. (36.2 x 24.4 cm.)

Dick Hebdige

In Poor Taste:
Notes on Pop

Pop was meant as a cultural break, signifying the firing squad without mercy or reprieve, for the kind of people who believed in the Loeb classics, holidays in Tuscany, drawings by Augustus John, signed pieces of French furniture, leading articles in the Daily Telegraph and very good clothes that lasted forever . . .
Reyner Banham

One thing I dislike more than being taken too lightly is being taken too seriously.
Billy Wilder

Pop's contribution to "cultural politics" lies precisely in the manner in which it serves to problematize the terms "culture" and "politics" by abandoning the tone (of solemnity, of "seriousness") in which any "radical" proposal in bourgeois art and art criticism—avant-garde or otherwise—is conventionally presented. Pop encapsulates several cultural themes I want to touch on here:

(i) What might be described as pop's deictic function—the way in which it can be used to point up the complicity between aesthetic taste, and economic and symbolic power.
(ii) Pop as an inspired move in the Culture Game, the object of which is to fix the shifting line between "sensation" and "spirit," "low" and "high," "art" and "non-art"—categories which Pierre Bourdieu has shown to be coterminous.
(iii) Pop art as a strategy in another "taste war" (the same war, in fact, fought along a different front) between the Old and New Worlds, between an America which, as Leslie Fiedler puts it, *has had to be invented as well as discovered,*[1] and a Europe with its long literary and aesthetic traditions, its complex codings of class

and status—between two continents and a history, between two symbolic blocs: "Europe" and "America."
(iv) Finally, less grandly but no less seriously, pop as a discourse on fashion, consumption, and fine art: pop as a discourse on what Lawrence Alloway called in 1959, "the drama of possessions":[2] pop as a new suit of clothes.

A detailed exposition of the full history of British pop is neither necessary nor possible here. Suffice it to say that it's generally agreed that the development of British pop art falls into three approximate phases. The first is associated with the work of the Independent Group at the ICA and spans the years 1952–55. This is generally understood as the period of pop's underground gestation during which the members of the Group and most especially Eduardo Paolozzi and Richard Hamilton developed many of the obsessional motifs and representational techniques which were later to surface to such sensational effect, though in a slightly different form, within the Royal College of Art during the second and third phases. The second phase is usually dated from 1957–59 and is associated with the early work of Peter Blake and Richard Smith.

The third stage during which British pop is seen to emerge as a distinct, more or less coherent "movement" (though it is often conceded that pop was, in fact, never much more than an ad hoc grouping together of Young Contemporaries) is generally held to incorporate at least some of the early work of Derek Boshier, Patrick Caulfield, David Hockney, Allen Jones, Ronald Kitaj, and Peter Philips. It was during this phase that pop attracted an enormous amount of publicity, thanks partly to the exposure afforded by the annual Young

[1] Leslie Fielder,
[2] Lawrence Alloway, "The Long Front of Culture," *Cambridge Opinion*, no. 17 (1959): 25 26. (Reprinted in this catalogue, see pp. 30 33.)

Contemporaries exhibitions and by the Ken Russell TV documentary, *Pop Goes the Easel,* which was broadcast in 1962. This film helped to establish the stereotype of the young, iconoclastic and highly sexed male pop artist whose "lifestyle" (to use another sixties keyword) was conspicuously in the Swinging London mode. The program also helped to fix pop art in the public imagination as the corollary in the visual arts to the British beat and fashion booms which were beginning to gather a similar momentum at about the same time.

By the mid-sixties, the word "pop," like its sister words "mod," "beat," and "permissive," had become so thoroughly devalued by over-usage that it tended to serve as a kind of loose, linguistic genuflexion made ritualistically by members of the press towards work which was vaguely contemporary in tone and/or figurative in manner, which leaned heavily towards the primary end of the color range, and which could be linked—however tenuously—to the "swinging" milieu.

Today, pop art in Britain has become so thoroughly absorbed into the language of commerical art and packaging—dictating, for instance, the peculiarly ironic tone of so much "quality" British advertising—that we are in danger of losing sight of the radical nature of its original proposal: that popular culture and mass-produced imagery are worthy of consideration *in their own right* and, in addition, *almost incidentally* provide a rich iconographical resource to be tapped by those working within the fine arts. It is easy to forget, for instance, that when it first appeared in this country in the 1950s pop presented itself, and was widely construed in critical circles, as a form of symbolic aggression,and that it fell into an awkward, unexplored space somewhere between fine art and graphics. It fell between—to use the critical oppositions of the time—on the one hand, fine art: the validated, the creative, the pure; and on the other, graphics: the despicable, the commercial, the compromised. The assumed incompatibility of art and commerce is clearly registered in some of the protests which greeted pop's emergence. For instance, in an article entitled "Anti-Sensibility Painting," which appeared in *Artforum* in 1963, Ivan Karp wrote:

The formulations of the commercial artist are deeply antagonistic to the fine arts. In his manipulation of significant form, the tricky commerical conventions accrue. These conventions are a despoliation of inspired invention . . .[3]

During the late fifties and early sixties, the arts field was still being scanned continuously by self-appointed defenders of "good taste," determined to "maintain standards." Points of potential "crossover" and "breakdown" were particularly susceptible to this kind of monitoring. Trespassers could be prosecuted. When Janey Ironside, using William Morris wallpaper blocks, transferred the bold designs to her textiles in 1960, the William Morris Society lodged a complaint with the Royal College authorities.[4] As the prolonged austerity of the forties and early fifties gave way to a period of relative affluence, the official tastemaking bodies sought new ways to extend their paternalistic influence over popular tastes. The BBC, presumably in an attempt to arrest the cultural decline with which commercial television was commonly equated amongst the BBC hierarchy, set out to "educate" the new consumers. According to John McHale:

[There was] a calculated co-operation between the BBC and the Council for Industrial Design . . . Around mid-1956, a fire was written into the script of The Grove Family *television series—so that the "family" could refurnish their "home" through the Design Centre.*[5]

Pop challenged the legitimacy of validated distinctions between the arts and the lingering authority of prewar taste formations. The "lessons" inscribed in pop's chosen objects—Americana, "slick graphics," pop music, etc.—matched BBC didacticism point-for-point and turned it upside down. Where the BBC counseled discrimination and sobriety, pop recommended excess and aspiration.

Pop tends to fare so badly, or at least indifferently, within the existing canons of art history, and is so consistently rejected, disapproved of, or condoned with strong reservations, that one begins to wonder what

Nigel Henderson. *Veteran*, Bethnal Green, c. 1952. Photograph, 10 x 8 in. (25.4 x 20.3 cm) Estate of the artist.

else is at stake here. Pop tends to be reified within art history as a particular moment, a distinct school of painting, sculpture, and printmaking which falls within a discrete historical period, i.e., roughly from 1953 to 1969, and is defined simply as that-which-was-exhibited-as-pop. Alternatively, pop is interpreted as a kind of internal putsch, as a reaction occurring more or less exclusively within the confines of the art world. From this viewpoint, pop is regarded as a more or less conscious move on the part of a group of ambitious young Turks, intent on displacing an older group of already established Academy painters and sculptors—in Britain, Henry Moore, Stanley Spencer, Graham Sutherland, *et al.*; in the U.S., Jackson Pollock and the abstract expressionists. Here pop is conceived of as a struggle conducted at the point where the Art Game meets the Generation Game. Or—and this is a slight variation—pop is seen as a term in a more general dialectic of pictorial styles—a dialectic which, in the late fifties, clearly dictated a move away from what was already there: abstraction and "kitchen sink realism": the work of John Bratby, Jack Smith, Edward Middleditch, etc. As Robert Indiana put it in 1963, "Pop is everything art hasn't been for the last two decades."[6]

There is some truth in both these interpretations. As Bourdieu points out, in order to create value and recognition in the art world, one must first create a *difference*. This, after all, provides the economic logic which governs most areas of cultural production. It is this logic which generates both change and small change within the art world, which creates the *value* (in both senses) of the art object and which also determines the literally outrageous form of so much avant-garde practice.

However, neither of these definitions permits an analysis of the extraordinary effectivity of pop as a visual idiom *outside* fine art; the sheer variety of poster and printmaking which pop helped to get consecrated as fine art. In other words, both definitions inhibit an investigation of pop's wider cultural currency. I would argue that the significance of pop lies beyond the scope of traditional art history, in the way in which it posed questions about the relationship between culture in its classical-

[3]Ivan Karp, "Anti-Sensibility Painting," *Artforum* 11, no. 3 (September 1963): 26–27.
[4]Paul Barker, "Art nouveau riche" in *Arts in Society,* Paul Barker, ed. (London: Fontana, 1977)
[5]John McHale, "The Fine Arts in the Mass Media," *Cambridge Opinion*, no. 17 (1959).
[6]Quoted in G.R. Swenson, "What is Pop Art? Answers from 8 painters (Part 1)," *Art News* 62, no. 7 (November 1963): 27 (Indiana). The next sentence is worth quoting too: "(Pop) is basically a U-turn back to representational usual communication, moving at a breakaway speed in several sharp late models . . . some young painters turn back to some less exalted things like coca cola, ice cream sodas, big hamburgers, supermarkets and EAT signs. They are eye hungry, they pop . . . (They are) not intellectual, social and artistic malcontents with furrowed brows and furlined skulls . . ."

conservative sense—culture as, in Matthew Arnold's words, "the best that has been thought and said in the world"—and culture in its anthropological sense: culture as the distinctive patterns, rituals, and expressive forms which together constitute the "whole way of life" of a community or social group.

We should remember, for instance, that the word "pop" was originally coined by Lawrence Alloway and was used to refer not to collages, prints, and later paintings produced by Hamilton and Paolozzi, but rather to the raw material for both these artists' work—the ads, comics, posters, packages, etc.—the scraps and traces of Americana which had been smuggled into the country by GI's, enterprising stationers, and John McHale—scraps and traces which spoke of yet another more affluent, more attractive popular culture which had, in the early fifties, yet to be properly established in Great Britain. The term, "pop," then, is itself riddled with ambiguity. It stands poised somewhere between the IG's present and some imagined future, between their artistic aspirations and their experience of cultural deprivation in Britain in the early fifties. And the early work of Paolozzi and the IG presentations and exhibitions—*Parallel of Life and Art* (1953), *Objects and Collages* (1954), and *This Is Tomorrow* (1956)—were motivated by a common pledge not only to produce a new kind of visual environment but also to analyze critically the fabric of everyday life and mass-produced imagery.

It should also be recalled that the tone of the early IG meetings at the ICA was self-consciously pitched toward a consideration of science and engineering rather than art, that cybernetics, Detroit car styling, and helicopter design figured amongst the early topics for discussion at those meetings, that Paolozzi professed a marked preference for science museums over art galleries, that he later wrote about the origins of pop that "there were other valid considerations about art beside the aesthetic ones, basically sociological anthropological . . ."[7] It should be remembered, too, that as early as 1959 Alloway was arguing for the development of a sociologically inflected, "audience-oriented model for understanding mass art"[8]—the beginnings of a recep-

tion-aesthetic which would seek to account for the variable significance of objects and images as they circulated in different consumer markets. In other words, pop formed up at the interface between the analysis of "popular culture" and the production of "art," on the turning point between those two opposing definitions of culture: culture as a standard of excellence, culture as a descriptive category. The questions pop art poses simply cannot be answered within the narrowly art historical framework which most of the critical research on pop art seems to inhabit.

It is difficult to recapture the austere visual and cultural context within which or rather against which British pop first emerged in the early fifties. The documents and recollections which have filtered down from IG meetings stress the sheer lack of visual stimulation which afflicted every aspect of daily life in Britain at the time. The paucity of visual material merely underlined the shortage of goods. Rationing was not fully lifted till 1954. Packaging was virtually nonexistent.

Against this were counterposed the exotic hyperboles of American design. These images and objects function in Paolozzi's scrapbooks as signs of "freedom" asserted against the economic and cultural constraints, as dreams, implicitly "subversive" *readymade metaphors*.[9]

I have argued elsewhere[10] that these signifiers were widely interpreted within the critical discourses of art and design and the broader streams of concerned, "responsible" commentary as harbingers of cultural decadence and the feminization of native traditions of discipline and self-denial. One example will suffice here. In an article which appeared in *Design* in 1959,[11] John Blake surveyed examples of contemporary product design for traces of American influence, contrasting the "restraint and delicacy" of the tasteful European Mercedes air vent with the "heavy, overrealistic" transposition of aircraft motifs to the air vent of the 1957 Pontiac. This curiously arbitrary logic—a perverted relic of the old modernist axiom that form should follow function—leads the author to conclude that the Italian-designed Lincoln Mercury is preferable to the vulgar and

bulbous forms of the U.S. Cadillac on the grounds that the former presents a more "*honest,*" more complete transplantation of airplane motifs.

These hysterical constructions of America as "enemy" were eventually to produce an "America" which could function for British pop artists in the fifties (as the unconscious had for the surrealists in the thirties and forties) as a repressed, potentially fertile realm invoked against the grain. Early pop imagery drew its transgressive power from the friction generated in the clash between "offical" and "unoffical" taste formations—a productive clash of opposing forces. The dialectic which gave pop its power and meaning and which defined its difference can be presented through juxtapositions:

Negative/official: Richard Hoggart intended to clinch his denunciation of cheap gangster fiction through the following analogy: "The authors are usually American or pseudo-American, after the manner of the American shirtshops in the Charing Cross Road."[12]

Positive/transgressive: Richard Hamilton, resorting to the cool mode, played back the language of the U.S. menswear ads.

Negative/official:Hoggart railed against the influence of Hollywood films on the "juke box boys." "They waggle one shoulder" he wrote, "as desperately as Humphrey Bogart . . . across the tubular chairs."[13]

Positive/transgressive: Alloway wrote approvingly in 1959 of the American cinema's "lessons in style (of clothes, of bearing) . . . Films dealing with American home-life, such as the brilliant women's films from Universal-International, are, in a similar way, lessons in the acquisition of objects, models for luxury, diagrams of bedroom arrangement."[14]

Negative/official: Hoggart wrote that "working people are exchanging their birthright for a mass of pin-ups."[15]

Positive/transgressive: Peter Blake poses above a locker *strewn* with pin-ups.

Uwe M. Schneede, *Paolozzi* (New York: Harry N. Abrams, 1970).
[8]Lawrence Alloway, "The Long Front of Culture," p. 26.
[9]Uwe M. Schneede, *Paolozzi*.
[10]Dick Hebdige, "Towards a Cartography of Taste, 1935-1962," *Block*, no. 4 (1981): 39–56.
[11]John Blake, "Space for Decoration," *Design*, no. 77 (May 1955): 9–23.
[12]Richard Hoggart, *The Uses of Literacy*, (London: Pelican, 1958).
[13]Richard Hoggart, *The Uses of Literacy*.
[14]Lawrence Alloway, "The Long Front of Culture," p. 25.
[15]Richard Hoggart, *The Uses of Literacy*.

Pop art drew its power, then, from underneath the authorized discourses of "good" taste and "good" design. Pop artists dressed up, like the teddy boys, in the anxieties of the period. They converted their youth and their appropriation of "America" into future-threat.

"This is Tomorrow," they said. This is Our Tomorrow.

The *content* of Tomorrow counted. The fact that Hamilton's *"Hommage à Chrysler"* used four different pictorial conventions to depict the shine on chromium was less important than the fact that the chromium on a Chrysler got depicted at all.

The *form* of Tomorrow counted: the blasphemy of reproduction. Screenprints, cut-ups, photographs from magazines, epidiascopes: the promiscuity of collage which pointedly suggested that the craft-based tradition of the artist as sole point of creation was being superseded by the techniques of mass production and mass reproduction, that, just as the national identity was about to drown in the welter of imported, popular culture, so British painting was about to sink beneath a flood of anonymous, mass-produced images.

This is Tomorrow, they said. This is Our Tomorrow.

By reconstructing the field of opposing forces, groups, tendencies, and taste formations on which early British pop was posited, one can begin to see the points at which its breaks and transgressions became meaningful and, in a strictly limited sense, "progressive." This kind of mapping indicates, if nothing else, the provisional, historically located nature of any radical proposal within art. Such "radicalism" is conditional and contingent upon a number of historical givens—the availability or non-availability, the appropriateness or inappropriateness of different kinds of oppositional discourse. Criticisms of the aggressive fetishization and sexualization of women in pop art, at least during this period, or those blanket dismissals of pop which take as their starting point the extent of American cultural and eonomic penetration of Britain's leisure industries in the fifties, tend to ignore these contingent factors. Similar objections might be raised to the accusation that early pop failed to "transcend . . . the ideology of affluence." The fixation of early pop artists like Hamilton on consumer goods and synthetic materials (" . . . the interplay of fleshy plastic and smooth, fleshier metal"[16] and his "search for what is epic in everyday objects and everyday attitudes"[17]) may now seem (dis)ingenuous and improbable, but seem less so when considered against the background of the real changes in consumption patterns which lay behind the rhetoric of the "new Golden Age." After all, the fifties did see a dramatic, unprecedented rise in living standards in Britain. No doubt the increases in spending power and rates of acquisition were not evenly distributed across all social classes, but the general improvement in material conditions was real enough.

Effect of high revolution as stimulated in a centrifuge. USAF photograph. Collection of Richard Hamilton.

As Christopher Booker puts it:

Between 1956 and the end of 1959 the country's hire purchase debt rose faster and by a greater amount overall, than at any other time before or since . . . Deep Freeze had arrived and TV Instant Dinners and Fish Fingers and Fabulour pink Camay. And with so many bright new packages on the shelves, so many new gadgets to be bought, so much new magic in the dreary air of industrial Britain, there was a feeling of modernity and adventure that would never be won so easily again. For never again would so many English families be buying their first car, installing their first refrigerator, taking their first continental holiday. Never again could such ubiquitous novelty be found as in that dawn of the age of affluence.[18]

After the Depression and Austerity, for artists to refuse to respond positively to such transformations (overstated as they may be here by Booker), could seem more like sour grapes than a transcendence of prevailing ideology.

"[Kitsch is] . . . vicarious experience and faked sensations . . . the epitome of all that is spurious in the life of our time."
Clement Greenberg

We come, finally, to the objections leveled within art criticism against pop. For those criticisms, like Greenberg's famous denunciation of kitsch, often revolve around pop's ambivalence towards its raw material, its parasitic relation to the genuinely popular arts. Pop, it is frequently suggested, was indulgent and decadent because it refused to adopt a morally consistent and responsible line on the commercially structured popular culture which it invades, plunders and helps to perpetuate. Its ambiguity is culpable because pop exploits its own contradictions instead of seeking to resolve them. It is morally reprehensible because it allows itself to be contained by the diminished possibilities that capitalism makes available. Clearly, for British pop artists in the late sixties, "Americanized" pictorial forms had come to stand—as "Americanized" science fiction had for post-Dadaist intellectuals in the thirties and fifties—as a hermeneutic: a cage full of codes and little else. But

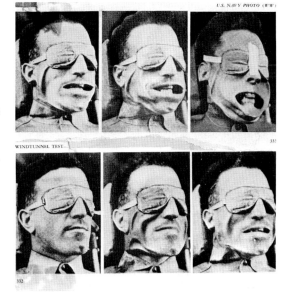

Eduardo Paolozzi. *Windtunnel Test*, 1950. Collage on paper. 9¾ x 14¾ in. (24.8 x 36.5 cm) The Tate Gallery, London.

whereas, in former modernist appropriations of popular culture, the coded nature of these fictional worlds could serve (as it did in Boris Vian's thrillers or Godard's *Alphaville*) as an analogy for a constricted and alienated experience, in pop art and kitsch the pull towards metaphor is arrested, the metaphors—where they exist at all—tend to be "distractions": jokey asides.[19] A vicarious and attenuated relation to "authentic" experience is . taken for granted, even welcomed for the possibilities it opens up for play, disguise, conceit. To use Paolozzi's words, "the unreality of the image generated by entirely mechanical means 'is commensurate with the' new real-

[16]Hamilton, quoted in *Pop Art in England. Beginnings of a New Figuration 1947-1963,* York Art Gallery, 1976.
[17]Richard Hamilton, "An Exposition of $he," *Architectural Design* 32, no. 10 (October 1962): 73.
Of course, there was still an adherence to fine art values even amongst the original proponents of Pop. In order to underline the fact that transformational work had indeed been performed upon the original subject matter, Hamilton in marked contrast to Warhol tended to stress just how elaborate the process of "cooking" had become, no matter how plain and simple the original ingredients: *One work began as an assemblage assisted with paint, was then photographed, the photograph modified and a final print made which was itself added to paint and collage.*
[18]Christopher Booker, *The Neophiliacs* (London: Collins, 1969).
[19]Gerard Cordesse, "The Impact of American Science Fiction" in *Europe in Superculture: American Popular Culture and Europe,* C.W.E. Bigsby and Paul Elek, eds.
[20]Uwe M. Schneede, *Paolozzi.*

ity with which we have lived for half a century but which has yet to make serious inroads on the established reality of art."[20]

Pop, then, refuses to deploy that potential for transcendence that Marcuse claimed characterizes the Great (European) Tradition. It refuses to abandon the ground of irony, to desert surface and style.

84
85
However, it is precisely here, on the reflective surfaces of pop, that I would argue its potentially critical and iconoclastic force can be located. For the "politics" of pop reside in the fact that it committed the cardinal sin in art by puncturing what Bourdieu calls the "high seriousness" upon which bourgeois art depends and through which it asserts its difference from the "debased" and "ephemeral" forms of "low" and "non"-art. (Even dada had its "statements," its slogans . . .) Pop's politics reside in the fact that it was witty, decorative, and had visible effects on the look of things, on the looking at things: in the way it opened up the range of critical and creative responses to popular culture availabe to those who possess a modicum of cultural capital. Its "politics" reside in the fact that, in its minimal transformations of the object, it worked to reduce or to problematize the distance which Bourdieu defines as being necessary for the maintenance of the "pure aesthetic gaze," the remote gaze, the pose of contemplation on the object rather than absorption in the object: that pure gaze which unites all elitist taste formations: "the theory of pure taste has its basis in a social relation: the antithesis between culture and corporeal pleasure (or nature if you will) and is rooted in the opposition between a cultivated bourgeoisie and the people . . ."[21]

Pop did not break down that opposition, far from it, but it did manage to smudge the line more effectively than most other modern art movements. For whereas pure taste identifies itself in the active "refusal of the vulgar, the popular, and the purely sensual," Pop reaches out to close those gaps in order to produce not "politics" opposed to "pleasure" but rather something new: a politics of pleasure.

Andy Warhol, *Elvis I*, 1964. Acrylic on canvas, 82 x 82 in. (209 x 209 cm) Collection Art Gallery of Toronto

Andy Warhol, *Wanted Men*, 1964 Oil on canvas. Each 48 x 39⅜ in. (122 x 100 cm) Collection Sonnabend Gallery

This is perhaps what guarantees pop's continued exile from those places where the serious critical business of analyzing both art and popular culture is conducted.

It is significant, for instance, that the references to pop art in the recently launched Open University course, *Popular Culture,* are confined solely to the covers . . . the cover more precisely of the final volume in the series. Presumably, Paolozzi, Hamilton, Banham and the rest were just not serious enough. And yet an embryonic study of popular culture focusing on the conflict between popular aspirations and entrenched interests (taste makers) and proposing a model of cultural consumption which stresses class and regional differences was already being developed—albeit somewhat intuitively—by Alloway, Hamilton, McHale, and the Smithsons during the mid to late fifties. For instance, as early as 1959, Alloway was arguing against the mass society thesis (which still haunted cultural studies "proper"—Hoggart *et al.*):

We speak for convenience about a mass audience but it is fiction. The audience today is numerically dense but highly diversified . . . Fear of the Amorphous Audience is fed by the word 'mass.' In fact, audiences are specialized by age, sex, hobby, occupation, mobility, contacts, etc. Although the interests of different audiences may not be rankable in the curriculum of the traditional educationalist, they reflect and influence the diversification which goes with increased industrialization.[22]

In the same article, Alloway quotes a reader's reaction to a science fiction magazine cover from the early fifties:

I'm sure Freud could have found much to comment, and write on, about it. Its symbolism, intentionally or not, is that of man, the victor; woman, the slave. Man the active, woman subjective; possessive man, submissive woman! . . . What are the views of other readers on this? Especially in relation with Luros' backdrop of destroyed cities and vanquished man?[23]

Alloway merely quotes this in order to suggest that there are possibilities for a *private and personal deep*

interpretation of the mass media beyond a purely sociological consideration of their functions. What is perhaps interesting for us (and so often repressed) is that a rudimentary home-grown semiotic—one poised to "demystify" "representations" of "gendered subjects"—appears to be developing here in the correspondence columns of *Science Fiction Quarterly* in 1953 without any assistance from French academics (Barthes' *Mythologies* remained untranslated until 1972).

However, that hardly matters, because the true legacy of pop is not located in painting or purely academic analysis at all, but rather in graphics, fashion, and popular music, in cultural and subcultural production . . .

For instance, the Sex Pistols' career, managed with a spectacular Warhol-like flair by Malcolm McLaren, another sixties art school product, offered precisely the same kind of parodic, mock-serious commentary on rock as a business that pop art in the sixties provided on the Art Game.

The principle of facetious quotation has been applied to subcultural fashion to produce what Vivienne Westwood used to call *"confrontation dressing,"* collage dressing, genre dressing: the sartorial insignia of that elite which Peter York calls *"Them."*

Facetious quotation applied to music has produced the art of musical pastiche, word salad, aural cut-ups, the art of sound quotation: the new musical genres, rap, dub, electronic, and "constructed sound" . . .

The final destination of pop art, pop imagery, and pop representational techniques lies not inside the gallery but rather in that return to the original material, that turning back towards the source which characterized so much of pop art's output in its "classic" phases. Its final destination lies, then, in the generation, regeneration not of art with a capital "A" but of popular culture with a small "pc" . . .

This article is a revised version of an essay previously published in *Block,* no. 8 (1983).

[21] Pierre Bourdieu, "The Aristocracy of Culture" in *Distinction: A Social Critique of the Judgment of Taste,* trans. Richard Nice (Cambridge, Mass: Harvard University Press, 1984).
[22] Lawrence Alloway, "The Long Front of Culture," p. 25.
[23] Quote of a reader's reaction to a science fiction magazine cover in Lawrence Alloway, "The Long Front of Culture," p. 26.

Poster for *Ciao! Manhattan*. Edie Sedgwick wearing a design by Betsey Johnson, c. 1968.

Leo Castelli, John Coplans, Alanna Heiss, Betsey Johnson, Roy Lichtenstein, and Claes Oldenburg

An Observed Conversation

This is Tomorrow Today, the installation and texts that comprise the first section of the four-part exhibition series *The Pop Project,* engendered a critical interest in the possible relationship between the collaborative investigations of the Independent Group in the London of the Eisenhower era and those American artists whose names are linked with the Pop Art "movement" that followed. In an attempt to establish or refute such a relationship, and to discover at source, with some of the key participants, attitudes concerning the development of Pop Art and the question of its continuing significance, an informal symposium took place at The Clocktower Gallery on December 7, 1987, in the midst of the Hamilton-McHale-Voelcker pavilion reconstruction discussed in the first essays of this publication.[1] The participants are the New York gallerist Leo Castelli, long associated with the artists of the American Pop Art phenomenon; John Coplans, the artist, critic, curator and former museum director who experienced first-hand the manifestations of popular culture in the art worlds of London, New York, and Los Angeles; Roy Lichtenstein and Claes Oldenburg, whose painting and sculpture are historically linked to the movement; the designer Betsey Johnson, a leading fashion innovator since the 1960s in New York; and Alanna Heiss, founder and Executive Director of The Institute for Contemporary Art, the Clocktower's parent institution. At the suggestion of Leo Castelli, Alanna Heiss invited the participants to discuss a number of issues suggested by current interest in the history and cultural implications of Pop Art. The following is a redaction of the transcribed conversations, prepared for The Institute by Edward Leffingwell.

John Coplans: The question of a difference between two approaches to popular culture is very simple. There's a confusion, and I had to sort out that confusion. Everyone thinks of Lawrence Alloway as the man who used the term "Pop Art" first, which is quite correct. But that was before any of you here at this table was operating in your characteristic *modus vivendi,* or made the discoveries and work that you have. Really, what we are talking about are two different things. You're talking about a regional movement called "Pop" which is about popular art and shifting taste on the one side, and on the other side you're talking about Pop Art, which is about altering the perception of art itself. I think they are quite different endeavors. And I thought they were quite different endeavors the minute I walked into Andy Warhol's show at the Ferus Gallery in Los Angeles in 1962.[2] Or saw anyone else's work. One set of things is sociological and anthropological, and the other is art.

Claes Oldenburg: It seems to me you're making a leap from this thing that happened back there, which was always more cultural and anthropological in direction than artistic, to me anyway, and you're making a huge leap over all of the things which it might have influenced in the Pop Art realm, to another kind of later art which is involved with culture and anthropology. I think it's an interesting idea. But it leaves us *under* the leap.

Alanna Heiss: There's a possibility that there may be a stronger connection between the two ideas than there seems to be. We might find a connection in a shared commitment to changing the exhibition format, to a unification of the art and the exhibition that might address a larger audience. You might think of it as a com-

[1] The Whitechapel Art Gallery exhibition, London, 1956, has been regarded as a primary source of the Pop phenomenon. See Brian Wallis' essay, pages 9–17.
[2] Warhol's first solo gallery exhibitions took place in 1962 at the Ferus Gallery, Los Angeles, and Stable Gallery, New York. He also participated in "My Country 'Tis of Thee" at the Dwan Gallery, Los Angeles, and "New Realists," Sidney Janis Gallery, New York in the same year. Lichtenstein appeared in the group exhibitions as well.

mon populist mission. And, perhaps, there are other common sources.

CO: There are a lot of sources for what I did, which have nothing to do with Lawrence Alloway and the English scene.

AH: Roy, when did you first come to terms with the problems of low culture, high culture?

Roy Lichtenstein: Sixty-one. Late.

AH: Had you any knowledge of what was going on in England at the time?

RL: Not in England. But I did know about Happenings and about Claes' work, and Jim Dine's and Lucas Samaras'. I knew something about Happenings, that there may be common objects that might be merchandise, that had an American, non-Cubist meaning. There were industrial things incorporated in the Happenings. I knew about Jasper Johns and Robert Rauschenberg and Larry Rivers. Rivers had done the paintings based on a Camel cigarette pack. There were many things that led me to think of the high and low art. Part of the style of the creation of a sensitive artwork could become a symbol of high art itself, like brushstrokes and sensitive modulations. One could eliminate the look of high art by discarding the sensitive line and modulation, for instance, and use neat unvarying lines or flat color areas usually associated with the production of low art, and through a sense of order put it in a high art context. That's one way of looking at it. But through history there's a vulgarizing of the subject, all the way from the first suppliant donor in a Renaissance painting through Daumier, Courbet, anybody. Picasso used commonplace objects in his collages. I don't want you to believe that I thought all this out before I began. I just thought pseudo-commercial art was a good idea.

AH: Did you have any higher mission as a young man? Were you politically or socially concerned?

RL: Very much so, but not in my art. Because you wouldn't take an actual cartoon or a depiction of a kitchen appliance as art. There was irony in its use. Because the merchandise was foisted on the public, its depiction made a social comment. That wasn't the most important part, to tweak capitalism. But irony plays a part.

JC: Roy just brought up something very important about what was in the air here at the time. There was a difference between England and the United States. Roy and Claes, two major artists, were dealing with the common object in their art already. There was a kind of potential or possibility in the air that had been generated by Johns' flags, that are derived from common objects and date from the period of the London activities of the Independent Group.[3] As a result there was a major shift of perception in art, resulting from the work of two artists present at this table, and one who is dead, Andy Warhol. That's the really important thing. As I've said, you have the anthropological significance of the London group, a brave endeavor, and you have the work of importance to the history of western art, a shift of perception that is of great consequence. It may be true that the two coincide at certain points, and you can't help but coincide if you live in a human situation, but the one activity is at a great difference from the other, while at another point they absolutely coincide. The British view is that the two absolutely coincide. My view is that they're entirely disparate, but there is a coincidence in the center, at the source. When you refer to Roy and Claes or Andy and George Segal, I think you can refer to Pop Art. And when you refer to specific artists in England who were making art objects you can say Pop Art. But the work represented by the Hamilton pavilion is not in the accepted terminology about art objects per se. They are a kind of assemblage of objects, some manufactured and others recovered, about an ideological stance. It's important to differentiate between the two endeavors. One has to be very cool about it. The British thing is Pop and the American thing is Pop Art. It's only Pop Art when you speak of art.

Leo Castelli: The English did not have the experience of Rauschenberg and Johns, something that played a very

[3] Johns' Flag, encaustic on newsprint over canvas mounted on plywood dates 1954–55.
[4] The Store, Dec. 1, 1961–Jan. 31, 1962, was located at 107 East Second Street, New York. It contained Oldenburg's sculptures of everyday commodities in plaster. Sales in this period totaled $1,655. Expenses, $368. No sales tax was computed.

important role in Roy's development. Claes' too, per-haps. Andy's certainly.

CO: We had the great advantage of getting the materi-al of popular culture first-hand, growing up with it. Johns has links to what you might call primitive art, folk art. His work seems to be very integrated in the Ameri-can landscape. Having that material makes a huge dif-ference, even if your attitude is objective and ironic. If you're not an abstract artist and you turn to your sur-roundings, you naturally use this kind of material.

JC: I've always felt that Americans invented their cul-ture. They didn't inherit it. The Europeans inherited their culture, went step by step. An effect of the Pop interest in London was the idea that the time was coming to move from that inheritance and turn to a culture that has invented itself. They began to deal with the idea of how things are invented.

CO: There were all kinds of movements going on. We had the Eisenhower era behind us, and we had the Beat era. We had all sorts of backgrounds. I had the idea that art was for everybody, for the masses. It was a commitment. At the time I came to New York in 1956, I was forced to go into the rather brutalized environment of the Lower East Side, experience, and share that. It's maybe ridiculous that an artist should then try to pre-sent that experience in an art exhibition. *The Store* was ironic and recognized the fact that you couldn't really do that sort of thing.[4]

RL: The masses were not going to buy it.

CO: The people who were going to buy it were Ileana Sonnabend and Leo Castelli. If you're dealing with transformation—transformed things—you are limiting your audience. If I went to Orchard Street and bought a lamp and exhibited it in my store window, someone might come in and buy it. But, if I took a lamp as a point of departure for a transformation, nobody would come in and buy it, except an art dealer or a collector. I think the issue is whether or not the transformation of an object has taken place. And I think you have to rec-

Andy Warhol, *Jackie (Blue),* 1964. Silkscreen on canvas, 20 × 16 in. Courtesy Leo Castelli Gallery, New York.

Andy Warhol, *Jackie '64*, 1964. Silkscreen on canvas, 20 × 48 in. Courtesy Leo Castelli Gallery, New York.

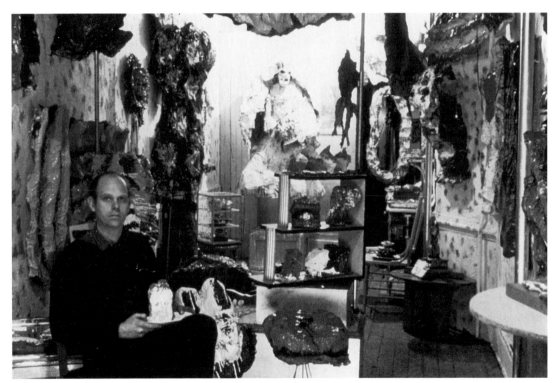

Claes Oldenburg in *The Store,* 107 E. 2nd Street, New York, c. December, 1961. Courtesy the artist.

ognize that the art is made by certain human beings who have a lot of other things on the agenda, like sculpture, painting, the history of art.

AH: Betsey, you deal with transformation in terms of fashion, and London was very important to fashion in America during the sixties. What impact did the radical change in the popular conception of fashion have on this period? And what influence, if any, did the Pop artists have on you?

Betsey Johnson: Well, for years, everyone thought I was English. The American answer to Mary Quant. That's what I felt I was here, on the same wavelength as she was. But, I probably got more inspiration from the short skirts of cheerleaders. Until I hit New York from Terryville, Connecticut, I knew nothing much more than cheerleading, orange and black. I did funnily enough end up in the Chelsea Hotel. And then at Max's Kansas City. And then the Velvet Underground needed some clothes to wear, and then there was Edie Sedgwick. Edie was the perfect idea of the little unisex boy-girl body, and she needed a little fitting work. I just fell into that clan of kids. I did feel a support system going on in London. I always felt the English came up with a kind of craziness out of nowhere. And, I felt the impact of Andy and Roy particularly. The soup can and the cartoon were really very much connected to a fashion cartoon of plastic theatricality, cellophane fakery going on in contrast to the Levi-marching-Vietnam. It was very strange, a high contrast between real fashion and pop fashion. It was unique, fashion in the sixties, and I doubt if it will ever repeat in my lifetime. The total blending of art, fashion, and music. Now you can separate clothes, and you can separate art, and you can separate music. But the strongest part about the period for me was the blend. You couldn't wear the clothes unless the right music was playing, unless you were in the right place. It was a connection that worked for the rich—Amanda Burden, Jacqueline Kennedy. I had customers at that time who were very hip to the idea that if they believed in the new art and the new music, they also had to wear these ridiculous new clothes. I think that for one strange time price did not matter. It was the look that

Andy Warhol in his studio, 231 E. 47th Street, New York, c. 1964.

counted, very unlike the status fashion that followed.

AH: There seems to be an interesting connection between the clients of fashion and the collectors of art. Leo, did you see a different kind of collector become interest in art when artists in your gallery began to use vernacular images?

LC: No. They were the same. There were really very few of them, and you can count them on the fingers of one hand. The ones who got interested in Rauschenberg and Johns and then after that Frank Stella, and Roy, Andy, and Claes, were the same people, absolutely the same people.

AH: So you're saying that it's a false idea that many of the great collectors of the period, like Robert and Ethel Scull, became interested in this art because it drew on images that were closer to what they'd seen in their everyday environment. You're saying the collecting of the work had nothing to do with image accessibility.

LC: I think it had to do with art, the way art evolved, progressed. There had been all kinds of movements before, abstract expressionism for instance, and Scull did collect Kline and Rothko. They were looking for something else coming along, and then Rauschenberg appeared, and Johns, and Cy Twombly and Stella. The collectors were hunting, as I did myself, one movement after the other, because of the fact that art was evolving very rapidly. When something new occurred, they simply rushed upon it.

CO: I think what happened, as Leo says, is that the first rank of collectors were collecting art because of the quality. But then you had collectors all over the country who picked up on what was called Pop Art and were definitely influenced by the content of it. It was standard at the time to accompany shows of Pop Art with a Pop Art party. Their lifestyle had gotten involved in the art. I think that had a lot to do with Pop Art's popularity. Maybe not with the first rank collectors but as it spread out.

[5]*London Knees 1966,* 1968, were produced in an edition of 120 in painted latex, packed in a case containing postcards, notes, drawings, and photographs as documentation. They are fifteen inches high.

92
93

Cindy Sherman, *Untitled,* 1980. Color photograph, 20 × 24 in. Courtesy Metro Pictures, New York.

Roy Lichtenstein, *I Love You, But . . .,* 1964. Oil and Magna on canvas, 48 × 48 in. Courtesy Leo Castelli Gallery, New York.

RL: There were all those parties, everything was there. It looked very bizarre.

BJ: The mix was bizarre. Women with diamonds and emeralds pouring off and bouffant Kenneth hairdos. They'd have a little forty dollar silver zip little jumpsuit of mine. It was nice; it didn't have that status thing about it. They just knew the look was right. And that's all they cared about.

LC: Andy was very influential in what you were doing. The others, Roy and Claes, were not very much involved in that scene.

CO: I tended to withdraw from that sort of thing.

BJ: But you were inspiring it. Were you interested in fashion then?

CO: I'm interested in clothes but not so much in fashion. I did get involved with Mary Quant's concept of the short skirt, which inspired some SOFT KNEES.[5]

BJ: Conceptually, in terms of transformation, what happened was that the shape of women changed. Pantyhose was invented and women went from a girdle-esque Hollywood points, tits and ass sort of fifties Monroe-esque adoration of woman, to a natural moving body in pantyhose. That was the biggest shift. Pantyhose and no bras.

AH: We've been talking about common objects and transformation. What about the place of realism in all this?

JC: The English movement was anti-realism. It was the left wing kitchen sink school, which was supported by the *New Statesman* as the new ultimate in painting, which had to be deadly serious about working-class living, and it had to be realistic. It was an attack against modernism and modern art, against the whole endeavor of modern art since Monet by semi-Marxist people who were interested in promoting realism in England as an alternative to the establishment, to Henry Moore and

Claes Oldenburg, *London Knees 1966*, 1968. Painted latex, height 15 in. Courtesy the artist.

Marilyn Monroe.

Barbara Hepworth. The situation was against the kind of realism embraced by what I've called Pop. Pop was against the dictatorship of the ideological, of political ideas about what had to constitute a work of art. There is a whole world, anthropologically, that has to be examined and dealt with and which cannot be constricted by narrow ideological terms.

CO: The illustrations of the Independent Group pavilion are basically photographs. I have trouble with works that deal entirely with photographs. Not photographs, but collaged photographs.

JC: Which is really graphic art. It's not really about photography. It's only incidentally about photography.

CO: Someone like Dennis Adams is on another plane, it's art about ideas.[6]

JC: But Cindy Sherman does connect in a certain kind of way. There is a definite post-Pop sensibility at play in her best work. But there's no direct link. She neither uses the media that you use nor the materials or images, but she has inherited instinctually something about examining the situation of her own generation of women, which is what her comment is always upon. Roy, your crying women, for example, are the closest thing I can give you to what Cindy Sherman was doing. Her crying woman is lying by the telephone waiting for the call that never came.[7] There's a kind of overplay that has no direct referential iconographical situation, yet clearly, she is terribly involved with certain aspects of what you were about. And, one could go on with a number of people and say that.

LC: Jeff Koons is closely connected with the inspiration of the Pop artists. Not so much Haim Steinbach, who seems to be more rigid and intellectual. But you have Koons' inflated rabbit cast in stainless steel or the Louis Quatorze bust. There is an element that is in the spirit of Roy and Claes. I don't see it very much in the others. As for photography, there is Clegg & Guttman for instance, who are quite interesting. There's something that makes their photographs more than photographs.[8]

RL: I don't see very much that isn't connected, somehow to Pop being done today. Naturally I'd see Pop anywhere I look.

JC: Pop Art.

RL: It doesn't have the apparent seriousness of abstract expressionism; it's something else. Maybe in Anselm Kiefer I would go so far as to say there's very little Pop Art. Almost everyone working today has some tinge. You can see it in Julian Schnabel. I definitely see it in David Salle.

JC: Salle's right out of James Rosenquist, isn't he?

RL: Yes. There is an influence. I even see Pop Art in the very abstract people today.

LC: Like Peter Halley for instance.[9]

RL: Yes, Halley. I mean here's an ironic stance. You can't think of his work as serious abstract painting. It has irony. If it isn't then, it's just a copy of Mondrian or something.

JC: But, the base use of materials, the glitz, and the glitter of color.

RL: There's been no serious challenge to Pop Art.

JC: I think that's a different issue.

CO: We're still within a period that seems to me began in the late sixties.

AH: A period of varying accessibility. Claes puts energy into making public works that a large number of people can see. And artists make prints as well, which in a way broke the museum audience down to the street audience.

RL: Outside of the Bauhaus, I don't think anyone ever had the serious idea of making art accessible to a greater public. But I think it is a complicated issue.

[6]Dennis Adams places site-related topical structures employing photographic images with implicit political comment, characteristically, bus shelters. See pages 110–117.
[7]Lichtenstein, Crying Girl, 1962. Enamel on metal, edition of five. Sherman, Untitled, 1981 (Metro Pictures Number 90). Color photo, edition of ten.
[8]Koons is best known for cast stainless steel figures derived from popular cultural sources. Steinbach, like Koons, is associated with art that has been regarded as a comment on the commodification of art. Clegg & Guttmann exhibit group portraiture in Cibachrome as well as serial landscape photographs.
[9]Halley paints reductive geometric abstractions said to be derived from circuitry diagrams.

Clegg & Guttman, *Our Production/The Production of Others*, 1986. Laminated Cibachrome, 120 × 120 in. Courtesy Jay Gorney Modern Art, New York.

Haim Steinbach, *"exuberant relative" version 1*, 1986. Mixed media construction, 25 × 56½ × 15 in. Courtesy Sonnabend Gallery, New York.

Jeff Koons, *Rabbit*, 1986. Stainless steel, 41 × 19 × 12 in. Courtesy Sonnabend Gallery, New York.

AH: In reference to the accessibility, we know you made inexpensive clothes, Betsey. Was that by desire or design?

BJ: That was my strength. My desire. There are often commercial implications. I see the return of the mini-skirt, for example, as an obvious business ploy. Long goes short, short goes long. New proportion needed out of boredom to be established. It's nothing to do with the sociological conditions of what short meant in the sixties. Short in the sixties was saying what you were all about. I'm trying to work the way I worked twenty-five years ago, trying to be that much of a child again, back to the sixties again, oppy-poppy. It was a chunk of years that was the most happy, the most inspiring for me. I like the visuals. It has years and years of life before it and had died so quickly that in terms of fashion it took twenty years to forget the losses and to respect the clean, modern, futuristic lines. I think that the modern approach to clothing and the materials used has just started. It's very black and white now.

RL: The Eames chair was designed for accessibility. Of course, no poor people ever bought an Eames chair. Do we believe in accessibility, or is it simply an attitude or style? Do you make prints to get your art to the public, or do you make prints to make money?

CO: Well, prints are probably a little different. I think when you speak about the public in sculpture, it really is an increased audience.

RL: It's seen by a lot of people, but do you really do it for that reason?

CO: Whether it actually registers is another thing. The motivation for doing it initially was to have it out of a museum and out of the collector's homes. Not the only motivation, but to be seen by a larger public was part of it. I mentioned earlier the notion that art should be for everybody. That is certainly a part of my work, and it may be an illusion. In *The Store,* it was really an illusion. But, in public art although you can't really question everybody about what they experience from the work,

you are at least out there on the street. And you're there every day.

AH: Our absent member, Andy Warhol, was terribly interested in accessibility, through magazines and movies.

RL: You don't think it was about promoting your own image, proliferating your own image and having more people see it? That's a little different from producing work as a way of doing good in the world by having the public see art. To promote your own view of the world is a different motivation. That would be my motivation. And that's what I think everybody's motivation is. The idea that it's good for people, and more people see it is a nice way of putting it. But I don't think that's what really happens.

CO: When Coosje and I do a project, we attempt to come to terms with the cultural context in that area.[10] It isn't only a question of placing a work in a formal relation to a site.

AH: Were you all trying to address a different audience?

BJ: I think I was just trying to be me. I think that had to do with Andy, wanting to show him and his friends, but it was just the opposite of my Eisenhower upbringing. I wanted to be the opposite.

RL: Which is not a populist notion. Andy is not anybody's idea of Mr. Average.

BJ: Well, I didn't want to be Ms. Average. I just wanted to make a place for me. To do what I wanted to do. And I found there was a place for me.

RL: I wasn't trying to address a different audience. I would like the audience to include everyone.

LC: Roy wanted to do those things for himself.

RL: That's art.

[10]Coosje van Bruggen is Oldenburg's partner and collaborator on large-scale projects.

Roy Lichtenstein, *Greene Street Mural,* 1983. Paint and collage on wall, 18 ft. × 95 ft. 8 in. Courtesy Leo Castelli Gallery, New York.

View of Betsey Johnson installation during the exhibition *Abstract Painting 1960–1969,* at P.S. 1, Long Island City, 1983.

LC: Absolutely.

CO: I think in my case, it might be a little different. It's not a question of only talking down to people or compromising in that sense; that's not the idea. The idea, the hope I guess, is that one would reach a larger audience. It's more a hope, because it would be terrible to force people to look at works of art.

RL: But, if you were doing abstractions or abstract expressionism, wouldn't you also hope that the audience would be as large as possible and include everyone? You didn't change your subject matter to appeal to an audience.

CO: It wasn't a question of compromising or trying to reach people by dealing with them on their own terms. It's a Whitmanian desire, with the emphasis on "mania," I guess, to involve everybody in your artwork. To believe that everybody's interested in what we're doing.

AH: Were these artists, Roy, Claes, Andy, responsible for, and effective in, reaching a larger audience than had existed in the fifties?

JC: Yes. But that wasn't their fault!

LC: Exactly.

RL: The audience just got bigger.

JC: The audience got bigger because of the increase in museums everywhere. Little art centers became museums and generated an audience and collectors, and then the collectors wanted to get on the International Council of The Museum of Modern Art. And in every town, you had somebody who wanted to be the big collector, and they pushed a museum and pushed exhibitions. Everything got distributed. Universities suddenly had many more art departments, and people teaching art criticism, and suddenly there were more magazines. Everything got larger, in every kind of way. It just happened. There was an explosion.

View of *Il Corso del Coltello* at the Arsenale, Venice, Italy, 1986, a collaboration of Claes Oldenburg, Coosje van Bruggen, and Frank O. Gehry. Courtesy Leo Castelli Gallery, New York.

RL: An education and population explosion.

BJ: Don't you think it was massive, like the pill, or landing on the moon?

JC: They say there are more people attending museums today than sports functions. It's a whole change in the American scene. And the artists got carried along in it. There was a pluralism in the scene, a wider range of artists for a larger audience. It all seemed to come together and cohere.

LC: Snobbery played a tremendous role as well. It became very fashionable to be involved in art. Much more in fashion to be in modern art than in baseball. And there are all the openings, everywhere, in the museums, in the galleries.

RL: There is more serious interest in art, and there is more serious interest in play also. I don't know why.

CO: Perhaps an art that uses recognizable images receives more attention in the press than one that does not.

JC: The press prefers something easy to write about.

LC: Actually I think the best work done through the years, starting with abstract expressionism, has been done in this country. There is no real competition either from England or France, or Germany for that matter. That sounds heretical because people adore Georg Baselitz or Kiefer, the German artists. But I'm a bit rabidly pro-American.

RL: The history of modern art plays off these concepts. From a Pop Art viewpoint, even the abstract expressionists, who were considered American, can be seen as European. We were more in touch with the vernacular art that's really here, and the architecture, not the ideal architecture of the Bauhaus or of formalism or abstract expressionism. I mean the images we really see are different from the images of the past, our real environment. Everything that isn't this is really the past. We're

talking about painting what is here now. It can be difficult for an artist to make this kind of change. It's very hard when all of your friends and comrades are abstract expressionists, and you suddenly decide to defy the whole thing. It's okay if you had no stake in it, as we didn't, I didn't, coming from the Midwest into an abstract expressionist environment in which I didn't really belong. I had no problem making a break; I had nothing to lose.

AH: You mention architecture. Is there a relationship in terms of form or utility in Pop Art?

RL: I think much new architecture came out of our art.

JC: I don't see how you can include architecture as art. Architecture is *architecture*. That's why we give it a different name.

RL: Architecture could be considered as art.

LC: Look at Frank Gehry.[11]

RL: Michelangelo did some architecture.

JC: He was an artist that did some architecture. That's different.

RL: I understand that it is, and I agree with you wholeheartedly. We could do terrific architecture, but nobody asks.

JC: Frank Gehry is a very good architect as an architect. I don't think he's a good architect because he's an artist.

CO: He's on his own terms.

JC: The last remnant of my Greenbergism is the Kantian notion that art is useless. It's not about anything functional, making chairs, or making clothes. It's just there for its own sake, not for anything else. That it is embodied in an object is irrelevant, yet relevant. But it's not about something useful in the sense that architecture has a necessary, dynamic, purposeful usefulness.

[11] A prominent Los Angeles-based architect, Gehry has collaborated with Oldenburg and van Bruggen on several projects, including the performance "Il Corso del Coltello" ("The Knife"), presented in Venice, Italy, 1985, in association with the critic/curator Germano Celant.

RL: I think you could make architecture or a chair that has the formal qualities of art.

JC: But, then it becomes sculpture. When John Chamberlain makes a vast foam coach, it's sculpture; it remains sculpture. As soon as an architect makes something that's entirely useless, then it's a work of art. It's not architecture anymore.

CO: Coosje and I are working on the Binoculars Building with Frank Gehry in Venice, California. Frank has designed the building with a huge entrance in the form of a pair of binoculars, which is our responsibility. It's a collaborative effort, but that doesn't make Frank exactly a Pop architect. There's an attempt to bring our approaches together.

JC: America is the greatest country in the world for vernacular architecture, architecture made by people in the streets, so to speak. A man owning a small business can say, "I want a huge hot dog. Make one for me." It's very much like Walter Hopps when he did *The New Painting of Common Objects*.[12] He had to do the poster, and he sat at his desk in his usual way, and he picked up the phone, and he looked in the *Yellow Pages,* and he looked under "silkscreen," and he dialed a number and said, "I want a poster." The guy said, "What kind of poster?" So he told him. He said, "What's to go on it?" And Walter told him. And he said, "How many colors?" And Walter said, "Three." And he said, "How else do you want it?" And Walter said, "Loud and clear." And he said, "When do you want it?" And Walter said, "Tomorrow." And up came the most wonderful poster. This country is rich and full of this kind of source material, and it has nothing to do with architects, it's got to do with vernacular, the popular art of commercial image-making with imagination.

I recall the retrospective I did at Pasadena for Andy, and 5,000 people turned up and jammed the museum. It was much later than the one with Roy, which was more modest, because it was years earlier. The museum was smaller.[13] But Andy's opening was a kind of event. No one could see the paintings; they came for the fun. It

[12]Pasadena Art Museum, Pasadena, California, 1962.
[13]The Warhol exhibition opened in 1970 at Pasadena. The Lichtenstein exhibition dates 1967.

Model for *Main Street/Chiat-Day Project,* a collaboration of Claes Oldenburg, Coosje van Bruggen and Frank O. Gehry in Venice, California. Courtesy Frank O. Gehry and Associates, Los Angeles.

wasn't very serious, whereas the people who came to see Roy's work were very serious about seeing it. Sometimes, people just came for the fun of coming, and others came for a very serious purpose.

AH: But that serious purpose involves the perception of humor or irony implicit in the work itself.

JC: Irony is a very broad thing. Everybody uses irony at some point or another, including your mother and all kinds of writers. Irony is a very easy thing to speak of because it doesn't really define anything except the broadest kind of category of comment, tart comment. The Hamilton pavilion for instance, in which we're seated, was received as an intensely serious and thoughtful effort by some very bright people, and it included some strange material. The Independent Group looked at everything that was available. To address the question of the role of irony and humor to Claes is to consider the same question. To take a plate of fried eggs and make it look like Jackson Pollack is one thing. There's a comment on the high seriousness through the use of these common objects.

CO: Sometimes if you make something larger, or smaller than it should be, it's funny. Sometimes when you make something soft, which is supposed to be hard, that's funny. When you frustrate expectations. But it's difficult to talk about humor. I have the feeling that now irony is noncommittal and somehow bad, but it certainly was an important thing at the time.

LC: Jeff Koons is an exception. There is irony and humor in his work.

CO: There are a lot of things that happen in my art that people think are funny but did not start out to be funny. They turned into funny things, because I was playing with nature. And nature has a way of being funny all by itself, which can happen when you go out into the landscape and see things that can make you laugh. Humor is a part of experience, and I wouldn't rule out its role in the making or perception of art.

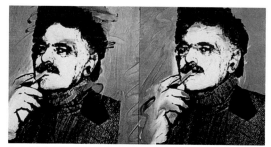

Andy Warhol, *Portrait of John Coplans*, 1974. Oil paint on canvas, 15 × 30 in. Collection of John Coplans, New York.

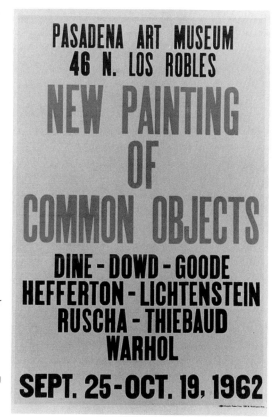

Poster for *New Painting of Common Objects*, 1962. Silkscreen, 42 × 28 in. Collection of Marjorie Harvey, Atlanta.

View of Roy Lichtenstein's *Brushstrokes in Flight,* 1984, at the Columbus, Ohio, airport. Fabricated and painted aluminum, height 25 ft. Courtesy Leo Castelli Gallery, New York.

RL: I think humor is an important and modern emotion and is coming into art more and more. In Picasso, in Miro, there's certainly humor. In Klee. Hilarious humor isn't there, but humor is. You present material that is unexpected in a high art context, as Claes says, it frustrates expectations. You don't expect Pop Art to be the art of the museums, and there's humor in that.

LC: The only two humorists among the artists who we're discussing are Claes and Roy. Andy was totally lacking in humor. And I suspect that Rosenquist has a totally different kind of humor, or no humor at all of the sort that Claes and Roy have.

JC: I was on a panel last night at the Whitney Museum. It was about Andy's legacy. I had my difficulty, because I don't know what Andy's legacy is, and I said I can't tell you what Andy's legacy is because it's mixed with a number of other artists. And until their legacy has been determined, how can one say? It's co-equal. You don't say that Degas is more important than Pissarro or more important than whoever you care to name. They're a group of artists who changed our perception of art, and I think there's a group of artists we are discussing who changed our perception of art, but it has to be defined and thought about and in some way be tested in a serious and high manner.

It wasn't to my mind a particularly bright audience. It was entirely misunderstood, because for them, for many people in the audience, everything was co-equal with Andy, his movies or his books or his films, and various things like that. It's hard to get them to sort out that there is a history of western culture that art relates to, and that if you want to talk about Andy's language or music you've got to relate it to the history of music and language and so on, each endeavor. But from my point of view there's only one central core to his work, and that's his painting, and I dismiss everything else as second rate-because I don't think it's relevant in the terms I'm employing. In all these things we've addressed, you have to make some points of demarcation in the interest of history.

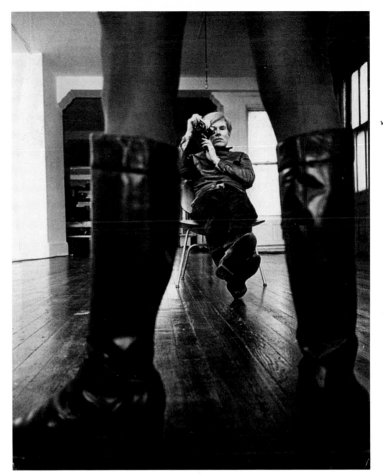

Andy Warhol at The Factory, 33 Union Square West, New York, c. 1968.

Andy Warhol, *Nineteen Cents*, 1960. Oil on canvas, 71¾ × 53¾ in. Courtesy Leo Castelli Gallery, New York.

Claes Oldenburg. Courtesy Archive Pictures Inc., New York.

Claes Oldenburg

I am for an art that is political-erotical-mystical, that does something other than sit on its ass in a museum.

I am for an art that grows up not knowing it is art at all, an art given the chance of having a starting point of zero.

I am for an art that embroils itself with the everyday crap & still comes out on top.

I am for an art that imitates the human, that is comic, if necessary, or violent, or whatever is necessary.

I am for an art that takes its form from the lines of life itself, that twists and extends and accumulates and spits and drips, and is heavy and coarse and blunt and sweet and stupid as life itself.

I am for an artist who vanishes, turning up in a white cap painting signs or hallways.

I am for art that comes out of a chimney like black hair and scatters in the sky.

I am for art that spills out of an old man's purse when he is bounced off a passing fender.

I am for the art out of a doggy's mouth, falling five stories from the roof.

I am for the art that a kid licks, after peeling away the wrapper.

I am for an art that joggles like everyones knees, when the bus traverses an excavation.

I am for art that is smoked, like a cigarette, smells, like a pair of shoes.

I am for art that flaps like a flag, or helps blow noses, like a handkerchief.

I am for art that is put on and taken off, like pants, which develops holes, like socks, which is eaten, like a piece of pie, or abandoned with great contempt, like a piece of shit.

I am for art covered with bandages. I am for art that limps and rolls and runs and jumps. I am for art that comes in a can or washes up on the shore.

I am for art that coils and grunts like a wrestler. I am for art that sheds hair.

I am for art you can sit on. I am for art you can pick your nose with or stub your toes on.

I am for art from a pocket, from deep channels of the ear, from the edge of a knife, from the corners of the mouth, stuck in the eye or worn on the wrist.

I am for art under the skirts, and the art of pinching cockroaches.

I am for the art of conversation between the sidewalk and a blind mans metal stick.

I am for the art that grows in a pot, that comes down out of the skies at night, like lightning, that hides in the clouds and growls. I am for art that is flipped on and off with a switch.

I am for art that unfolds like a map, that you can squeeze, like your sweetys arm, or kiss, like a pet dog. Which expands and squeaks, like an accordion, which you can spill your dinner on, like an old tablecloth.

I am for an art that you can hammer with, stitch with, sew with, paste with, file with.

I am for an art that tells you the time of day, or where such and such a street is.

I am for an art that helps old ladies across the street.

I am for the art of the washing machine. I am for the art of a government check. I am for the art of last wars raincoat.

I am for the art that comes up in fogs from sewerholes in winter. I am for the art that splits when you step on a frozen puddle. I am for the worms art inside

Tom Wesselman. Courtesy Archive Pictures Inc., New York.

the apple. I am for the art of sweat that develops between crossed legs.

I am for the art of neck-hair and caked tea-cups, for the art between the tines of restaurant forks, for the odor of boiling dishwater.

I am for the art of sailing on Sunday, and the art of red and white gasoline pumps.

I am for the art of bright blue factory columns and blinking biscuit signs.

I am for the art of cheap plaster and enamel. I am for the art of worn marble and smashed slate. I am for the art of rolling cobblestones and sliding sand. I am for the art of slag and black coal. I am for the art of dead birds.

I am for the art of scratchings in the asphalt, daubing at the walls. I am for the art of bending and kicking metal and breaking glass, and pulling at things to make them fall down.

I am for the art of punching and skinned knees and sat-on bananas. I am for the art of kids' smells. I am for the art of mama-babble.

I am for the art of bar-babble, tooth-picking, beerdrinking, egg-salting, in-sulting. I am for the art of falling off a barstool.

I am for the art of underwear and the art of taxicabs. I am for the art of ice-cream cones dropped on concrete.

I am for the majestic art of dog-turds, rising like cathedrals.

I am for the blinking arts, lighting up the night. I am for art falling, splashing, wiggling, jumping, going on and off.

I am for the art of fat truck-tires and black eyes.

I am for Kool-art, 7-UP art, Pepsi-art, Sunshine art, 39 cents art, 15 cents art, Vatronol art, Dro-bomb art, Vam art, Menthol art, L&M art, Ex-lax art, Venida art, Heaven Hill art, Pamryl art, San-o-med art, Rx art, 9.99 art, Now art, New art, How art, Fire sale art, Last Chance art, Only art, Diamond art, Tomorrow art, Franks art, Ducks art, Meat-o-rama art.

James Rosenquist. Courtesy Archive Pictures Inc., New York.

Roy Lichtenstein. Courtesy Archive Pictures Inc., New York.

I am for the art of bread wet by rain. I am for the rats' dance between floors. I am for the art of flies walking on a slick pear in the electric light. I am for the art of soggy onions and firm green shoots. I am for the art of clicking among the nuts when the roaches come and go. I am for the brown sad art of rotting apples.

I am for the art of meowls and clatter of cats and for the art of their dumb electric eyes.

I am for the white art of refrigerators and their muscular openings and closings.

I am for the art of rust and mold. I am for the art of hearts, funeral hearts or sweetheart hearts, full of nougat. I am for the art of of worn meathooks and singing barrels of red, white, blue and yellow meat.

I am for the art of things lost or thrown away, coming home from school. I am for the art of cock-and-ball trees and flying cows and the noise of rectangles and squares. I am for the art of crayons and weak grey pencil-lead, and grainy wash and sticky oil paint, and the art of windshield wipers and the art of the finger on a cold window, on dusty steel or in the bubbles on the sides of a bathtub.

I am for the art of teddy-bears and guns and decapitated rabbits, exploded umbrellas, raped beds, chairs with their brown bones broken, burning trees, firecracker ends, chicken bones, pigeon bones and boxes with men sleeping in them.

I am for the art of slightly rotten funeral flowers, hung bloody rabbits and wrinkly yellow chickens, bass drums & tambourines, and plastic phonographs.

I am for the art of abandoned boxes, tied like pharaohs.

I am for an art of watertanks and speeding clouds and flapping shades.

I am for U.S. Government Inspected Art, Grade A art, Regular Price art, Yellow Ripe art, Extra Fancy art, Ready-to-eat art, Best-for-less art, Ready-to-cook art, Fully cleaned art, Spend Less art, Eat Better art, Ham art, pork art, chicken art, tomato art, banana art, apple art, turkey art, cake art, cookie art.

Robert C. Scull with Warhol boxes. Courtesy Archive Pictures Inc., New York.

add

 Im for an art that is combed down, that is hung
from each ear, that is laid on the lips and under the
eyes, that is shaved from the legs, that is brushed on
the teeth, that is fixed on the thighs, that is slipped on
the foot.

square which becomes blobby

Reprinted from *Store Days*. Documents selected by
Claes Oldenburg and Emmett Williams. Something Else
Press, Inc., New York/Villefrance-sur-mer/ Frankfurt am
Main, 1967.

View of opening, Stable Gallery, New York, 1964. Courtesy Archive Pictures Inc., New York.

Art meets fashion. Courtesy Archive Pictures
Inc., New York.

Krzysztof Wodiczko, *Projection on the Memorial Arch,* Brooklyn, Grand Army Plaza, New Year's Eve, 1985. Projected image on monument. Courtesy Hal Bromm Gallery, New York.

View of *A Podium for Dissent,* 1985. Dennis Adams and Nicholas Goldsmith for a performance by Ann Magnuson, Battery Park City Landfill, New York, during the Creative Time production *Art on the Beach.* Cable extensions, aluminum, steel, wood, enamel, and photography, 288 × 225 × 192 in. Courtesy Dennis Adams.

Tom Finkelpearl

Public Image: Homeless Projects by Krzysztof Wodiczko and Dennis Adams

While Dennis Adams and Krzysztof Wodiczko both employ politically charged photographic images in the creation of site-specific public art, their goals and methods differ. In the fall of 1986, Adams constructed *Bus Shelter II* on Fourteenth Street near Third Avenue, under the auspices of the Public Art Fund and with the full approval of the local community board. Soon after its completion, the *Daily News* and the *New York Post* ran editorials protesting the sculpture's photographic images of Julius and Ethel Rosenberg. Both the *News* and the *Post* assumed that the shelter was a celebration of the couple, and, hence, communism, though the *News* acknowledged Adams' use of the right-wing lawyer Roy Cohn in his Lincoln Center shelter. (How could an artist celebrate both accused communists *and* a notorious commie hunter? This question was not addressed.) The headlines read, "Spies Shouldn't Deface the City's Streets"[1] and "Protest Rosenberg 'Art.' "[2] Clearly, the Rosenbergs' execution is a chapter of American history the *News* and the *Post* would prefer to ignore, and their only suggestion is, "Let's Take It [the shelter] Down" (*Post*). Adams' sculpture forces the viewer to confront the Rosenberg case and all that it means in American politics. Whether it is the Rosenbergs, Bertolt Brecht, Roy Cohn, or Klaus Barbie, Adams insists upon employing controversial, recognizable political figures whom many would prefer to forget, and he presents them in a public context. Consequently, Adams fights the intentional amnesia of our political/media culture.

In an interview in *October #38*—the sociological and political opposite of the *New York Post*—Krzysztof Wodiczko describes the audience for his New Year's Eve *Grand Army Plaza Projection:*

Most of the people who came to the event were from the black and hispanic community in Brooklyn, many of whom were school children. They were people who had no place else to go to celebrate New Year's Eve. Some members of the cultural intelligentsia, as well as some junior high school students who had seen photographs of my projections shown at the New Museum at the time, made an effort to be there.[3]
And he describes the response:

I wanted the people to see various possibilities. But since everyone was interested in convincing others of his or her own reading, only a few seemed to realize that various readings were all simultaneously possible. One reading was that the missiles were two phallic symbols. Another was that the projection was about disarmament, the nuclear freeze, the liberal position. A third group spoke of the interdependence of the superpowers, the fact that they are locked together, that they cannot exist without each other, and that there is a frightening similarity between them. . . ."[4]

Wodiczko's account shows that the projection was a potent image, that the diverse group in attendance felt equipped to discuss the images, ones they knew from the mass media. It also reveals Wodiczko's great trust in the ability of a general audience to understand his work. Without condescending, he speaks to commonly recognized topics. By employing familiar images, Wodiczko, like Adams, creates a politically-charged atmosphere in a public context, even if people cannot agree upon the exact meaning.

While Richard Serra's *Tilted Arc* has also created a charged atmosphere about the integrity of public art,

[1] "Spies Shouldn't Deface City's Streets," *New York Post*, December 1, 1986.
[2] "Protest Rosenberg 'Art,' " *Daily News*, November 20, 1986.
[3] "A Conversation with Krzysztof Wodiczko," Douglas Crimp, Rosalyn Deutsch, and Ewa Lajer-Burcharth, *October #38*, p. 25
[4] *Ibid*, p. 27.

the debate has been between two sides that speak different languages. With Adams' and Wodiczko's work, the discussion tends to focus upon issues like freedom of speech or superpower diplomacy rather than on unfocused anger, on the one side, and an attempt to create a theoretical public context for minimalism on the other. While Adams and Wodiczko do not give the viewer answers, they ask questions with a common vocabulary.

There is a clear distinction in the kind of images that Wodiczko and Adams employ. Where Adams generally uses wire service photos of the key figures in political events, Wodiczko focuses upon the material means to power and repression: missiles, tanks, a clip of bullets, a homeless person's cart. In addition, Wodiczko's images are related to a specific site. Adams' structures are somewhat site-specific: a bus shelter for a bus stop. But, his images are only generally related to the actual location: the Rosenbergs in New York, Klaus Barbie in Munster, Germany. Wodiczko's projections, on the other hand, are concerned with the political history of the monument or architecture that becomes his screen. Through a change in context, an image may take on a new social, political, or economic meaning. It is the context of display that Adams and Wodiczko insist upon controlling. A brief look at the history of the use of popular imagery demonstrates how important control is to their work.

While many see Pop Art as the first sign of Modernism's demise, artistic interest in low culture was present long before Postmodernism. In her book *Realism,* Linda Nochlin argues that the need to depict contemporary society was at the very center of nineteenth-century realism. She identifies Daumier's statement, ''Il faut être de son temps'' (It is necessary to be of one's times) as the rallying cry of the group of militant realists centered around Courbet.[5] Of course, paintings celebrating contemporary achievements, or depicting contemporary society, were not new, as seen in triumphal arches or Dutch genre painting. However, Nochlin points to a new dissonance in several mid-nineteenth-century works that comment upon contemporary society. A

Krzysztof Wodiczko, *Projection on the Lutherkirche,* Kassel, Germany, during *Documenta 8,* 1987. Projected image on building. Courtesy Hal Bromm Gallery, New York.

humorous example is Piero Magni's *Monument to Commemorate the Cutting of the Suez Canal*. In this marble sculpture, we see a set of scantily clad allegorical figures cut in a classical style. As Nochlin points out, the artist forces ''classical nymphs and deities to bear the unaccustomed and uncomfortable weight of the message of modern progress.''[6] The classical form is at odds with the technological feat being commemorated. The realists, then, turned away from this sort of pompous stance and toward the depiction of actual modern experience, including the depiction of the urban and rural underclass, the urban middle class, and the modern city.[7] These depictions had a distinctly modern feel, with the use of classical forms to celebrate recent achievements or the use of traditional power symbols to elevate the new. It was this interest in modern everyday life and low culture that was the seed for the Pop sensibility: the reaction against the prevailing modes of representation would repeat itself in the Pop movement.

The Greenbergian view of modernism is of a steady progression away from the real world toward art for art's sake. How could a movement that originated in the need to depict modern experience, whether we start with Courbet or Manet, be so divorced from that experience? In his essay, ''Modernism and Mass Culture in the Visual Arts,'' Thomas Crow presents a revisionist view of Modernism as a constant cycle representing high and low culture. He speaks, for example, of Manet's *Olympia* in terms of the ''flattened pictorial economy of the cheap sign'' and the ''pose and allegories of contemporary pornography,'' mixed, of course, with Titian's *Venus of Urbino*.[8] Crow traces this high/low culture dialectic through Impressionism to Synthetic Cubism. He defines how the phenomenon has ''repeated itself most vividly in the paintings, assemblages, and happenings of the artists who arrived on the heels of the New York School: Johns, Rauschenberg, Oldenburg, and Warhol.''[9]

This interest in low cultural forms and issues seems to re-surface in a cyclical pattern, usually beginning as a group of artists moves toward the representation of contemporary society in response to a dominant estab-

[5]Linda Nochlin, *Realism*, Baltimore: Penguin Books, 1971, p. 103.
[6]*Ibid.* p. 111.
[7]*Ibid.*
[8]Thomas Crow, ''Modernism and Mass Culture in the Visual Arts,'' in *Pollock and After*. New York: Harper and Row, 1985, p. 233.
[9]*Ibid.* p. 234.

Dennis Adams, *Bus Shelter I*, 1983. Broadway and 66th Street, New York. Aluminum, steel, plexiglass, wood, enamel, fluorescent light, Duratrans, 86 × 142 × 103 in. Sponsored by the Public Art Fund, Inc. Courtesy the artist.

lishment that disregards low culture. In order for their political message of disaffection to be productive, the context must be marginal, detached from the certification of the museum or the institution that would make art into a luxury commodity. Crow argues:

Managed concensus depends upon a compensating balance between submission and negotiated resistance within leisure—Marcuse's 'repressive de-sublimation.' But once that zone of permitted 'freedom' exists, it can be seized by groups which articulate for themselves a counter-consensual identity, an implicit message of rupture and discontinuity. From the official point of view, these groups are defined as deviant or delinquent; we can call them, following contemporary sociological usage, resistant subcultures.[10]

The Independent Group, working in England, like the Realists and the Impressionists started as just such a "resistant subculture" in opposition to the contemporary dominant ideology represented by Herbert Read. They made low culture, science fiction, and advertising topics of serious anthropological study in a series of meetings, articles, and exhibitions including "Parallel of Art and Life," "Man, Machine, and Motion," and "This is Tomorrow." Even a quick look at these titles reveals a new interest in the astoundingly modern post-war present and its futuristic feel. Very little of commercial value came out of these investigations of the commercial world.

American Pop also started as a resistant subculture, a street-oriented and democratic response to abstract expressionism. Allan Kaprow, Robert Rauschenberg, Jim Dine, Claes Oldenburg, and others made work that was collected from, or responded to, the street. In 1960, Dine's *The House* and Oldenburg's *The Street* were signs that the "real" world was making a comeback in the American gallery environment. Like Eduardo Paolozzi, Nigel Henderson, and Alison and Peter Smithson in their *Patio and Pavilion,* these nascent Pop artists became junk scavengers—literally bringing the street into the gallery. As in England, the Pop movement was soon absorbed into the mainstream of the commercial art market, reaching new heights of popularity in the fash-

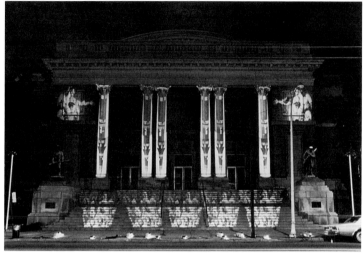

Krzysztof Wodiczko, *Projection on Memorial Hall,* Dayton, Ohio, 1983. Projected image on building. Courtesy Hal Bromm Gallery, New York.

ion, design, and music worlds. This "real" world, or realist aesthetic, is the common ground Adams and Wodiczko share with Pop.

The difficult question of commercial simulation, evident in highly publicized gallery exhibitions, is opposed to the public discourse of Adams' and Wodiczko's art. Commercial simulation presents itself as subversive. Even within Crow's argument, there is room for an art of opposition that exists within commodity culture: "To accept Modernism's oppositional claims, we need not assume that it somehow transcends the culture of the commodity; we can see it rather as exploiting to critical purpose contradictions within and between distinct sectors of that culture."[11] This critical position is the place the simulationists would like to occupy, and it is the position that the American Pop artists occupied. However, Crow sees this critique as coming from a subculture, not from the position of acceptance and museum certification. As in the case of fifties and sixties Pop, the critique of media is accepted by the media and the elite. Its status as a resistant subculture then becomes questionable. Crow identifies this cycle from outside to inside the power structure:

The avant-garde group itself enacts this engagement in an intensification of collective cooperation and interchange, individual works of art figuring in a concentrated group dialogue over means and criteria. But in each instance, this movement is followed by retreat—from specific description, from formal rigor, from group life, and from the fringes of commodity culture to its center. And this pattern marks for us the inherent limitations of the resistant subculture as a solution to the problematic experience of a marginalized and disaffected group.[12]

Crow addresses the issues of audience, impact, and political status. As a style or movement is drawn into the mainstream, it comes to rely on the patronage of the elite and the museum establishment. The group, criticized by the "resistant subculture," becomes its benefactor. Crow describes how the Impressionists' depiction of commercial culture quickly became an advertisement for that culture in the work of Toulouse-Lautrec,[13] and to some extent in Monet.[14] This does not mean that artistic exploration and invention is over once commercial success is achieved. It simply points to the political and sociological status of the art.

In "The Work of Art in the Age of Mechanical Reproduction," Walter Benjamin argues that painting, the form of the past, is intimately tied to a small select audience. He writes:

A painting has always had an excellent chance to be viewed by one person or few. The simultaneous contemplation of paintings by a large public, such as developed in the nineteenth-century, is an early symptom of the crisis in painting, a crisis which was by no means occasioned exclusively by photography, but rather in a relatively independent manner by the appeal of art works to the masses.[15]

Benjamin argues that movies and photography are the appropriate mass media for the new mass audience. This text of Benjamin's, sacred to the appropriationists, reveals a contradiction. While the appropriationists are certainly conscious of working within a photographic culture, criticizing the notions of authenticity and orginality, they continue, in most cases, to create unique objects, as in the case of Sherrie Levine or Richard Prince. Many artists create large photographic images that cannot be easily reproduced and are not produced in multiples. Even straight photographers are insistent upon authenticity, sometimes destroying negatives after a limited edition. While these artists may examine mass reproduction on a theoretical basis, their work is marketed as unique. Benjamin writes that "The instant the criterion of authenticity ceases to be applicable to artistic production, the total function of art is reversed. Instead of being based on ritual, it begins to be based on another practice—politics."[16] The question is how to determine whether a work has transcended the "criterion of authenticity." Do we trust the artists' stated intention, consult the critical discourse, or examine the work's function in the marketplace? If we look to the latter, there is little question that most simulation and appropriation is functioning as unique and precious.

[10]*Ibid.*, p. 246.
[11]*Ibid.*, p. 250
[12]*Ibid.*, p. 253.
[13]*Ibid.*, p. 257.
[14]*Ibid.*, p. 253–4.
[15]Walter Benjamin, *Illuminations*, ed. Hannah Arendt. New York: Schocken Books, 1969, p. 234.
[16]*Ibid.* p. 224.

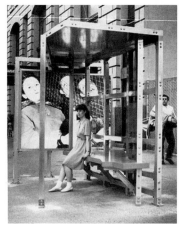

Dennis Adams, *Bus Shelter II*, 1986, 14th Street
and Third Ave., New York. Aluminum, steel,
plexiglass, wood, enamel, fluorescent light,
Duratrans, 96 × 138 × 96 in. Sponsored by
the Public Art Fund, Inc. Courtesy the artist.

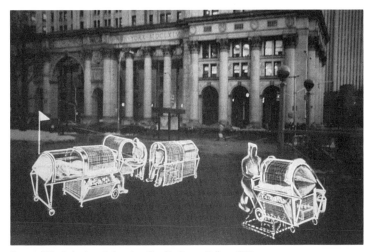

Krzysztof Wodiczko. Installation view, The Clocktower Gallery, 1988.

Dennis Adams. Installation view, The Clocktower Gallery, 1988.

However, the art of Dennis Adams and Krzysztof Wodiczko *is* oppositional and manages to remain so as these artists gain recognition. The context they have chosen for their art, the sociological location, precludes easy absorption into the commodity market. They stand outside the inevitable cycle of absorption by using a more direct relationship with the audience. It is important to note that Wodiczko actually listened to what the crowd had to say at the Grand Army Plaza Projection, that he actually trusts them to interpret his work, accepting a variety of interpretations. The democracy of Wodiczko's attitude does not diminish the depth of meaning of his work. Many of the simulationists seem to rely upon a dense critical vocabulary that is essentially elitist and exclusive, and this elitism is reflected in the popular imagery they employ. Instead of the Independent Group's fascination with all that was Pop, today we see a sincere distaste for low cultural material. This distaste is presented as critique by the use of that material. The critique is readily understood by the initiated, an obscurity that still permits considerable commercial success.

Wodiczko's "Homeless Vehicle" is a functional product, as are Adams' shelters. Perhaps, this is another reason the artworks function outside the theoretical ivory tower. They cross the line into function, just as they break the barriers that separate high art from the masses. Benjamin anticipated for photography a new relationship with a mass audience. Perhaps this new out-of-the-gallery art can create the permanent avant-garde that Benjamin predicted, a resistant subculture that has a chance to remain outside the center of the commodity culture.

Freud teaches us that understanding our past and acknowledging our current problems can lead to a healthy mind, free of unhealthy repression. This is similar to the ambition that Wodiczko and Adams share. By showing our society to itself, by re-opening chapters that have been closed by institutional amnesia and repression, these artists help us to understand ourselves. The possibility of such awareness may, in the end, result in a kind of cultural healing by changing the way we perceive the world in which we live.

Dennis Adams, *ReHearst*, 1978–79. Black and white photographs, each 16 × 20 in. Courtesy the artist.

Las Vegas research photograph from the archives of Venturi, Rauch and Scott Brown. Courtesy the architects.

Patricia Phillips

Why Is Pop So Unpopular?

"Since it is believed in some circles that any revolution or upheaval in the pure arts must, of some historical necessity, be followed by an equivalent upset in architecture, it is anticipated that the cordon-sanitaire between Pop Art and architecture is about to be breached like a metropolitan green belt, and a Pop architecture emerge about 1966."[1]
Reyner Banham, 1962

With this prediction, Reyner Banham was almost right—and a little wrong. The upset occurred, but the emergence was modest and manifold, and that strange chasm between art and architecture was not successfully spanned. It would be a stretch of the imagination to say that Pop architecture is thriving in the late 1980s. In fact, to suggest that it is, or was, a serious movement at all raises the most skeptical and suspicious rejoinders. If, in fact, the purpose of this exhibition is to examine the idea of Pop architecture, its emergence over twenty years ago, and its residual effects, it is not its mission to force a notion about Pop's continued vitality and provocative influence on architectural thought and practice today. It is extremely tempting to present an exhibition as a genesis of a new idea or as the resurrection of an old one, but this requires incredible fabrication, a great sense of authority, and missionary zeal. Pop architecture is not a postulate—something that must be taken for granted—but instead is presented as a hypothesis to develop a particular focus for discovery and dialogue in contemporary architecture.

The whole idea of Pop architecture is to permit and encourage questions, and to allow the "complexity and contradiction"[2] of life and architecture to emerge. In spite of its often aggressive and obvious visual charac-teristics, Pop is not a style. It is a proposition that challenges the idea of style and its continued relevance in an age of accelerated transformations in architecture. The identifiable peculiarities, the rich iconography, and the shared inquiries of most Pop architecture are finally a form of camouflage; they do not coalesce into a style (although Pop images are frequently appropriated by architects who remain interested in style), and their ferocity and vulgarity conceal the more contemplative nature of the beast. These quick characteristics of Pop are the trail markers—instantly visible and frequently misapprehended—that have sent the architectural search in the wrong direction. The brash imagery has verified the plausability of something called "Pop architecture" while silencing discussion and research of its real significance. It is this strange irony that makes an understanding of Pop so elusive and has diminished its impact on architectural ideology. It has, at the same time, seemed too simple to get, too difficult to comprehend, and finally, too easy to dismiss.

If Pop is not a style and, in fact, is a critique of architectural style, then it should be examined as an idea about contemporary architecture. In the most general and pervasive sense, Pop is about the coincidence of architecture and popular culture, about "extending esthetic attention to the mass media and in absorbing mass media material within the context of fine art. It [is] an expansionist esthetics, . . ."[3] In unpredicated ways, cataclysmic changes in the culture and questions about the form and content of architecture in a fragmented and disrupted environment have combined to cause small eruptions, if not major quakes. It is this exceptional set of circumstances that created the idea of Pop and destined its problematic relationship with architecture.

[1] Reyner Banham, "Towards a Pop Architecture." (1962) *Design by Choice.* New York. Rizzoli International Publications, Inc. 1981, p. 61
[2] Robert Venturi, *Complexity and Contradiction in Architecture.* New York. The Museum of Modern Art. 1966.
[3] Lawrence Alloway, "POP ART: The Words." (1962) *Topics in American Art Since 1945.* New York. W. W. Norton & Company, Inc. 1975, p. 119.

Illustration for *Archigram 4*, 1964. Courtesy Archigram.

The boldness and directness of Pop's iconography has always obscured its essential ambivalence, as well as the constructive nature of its critique. Art has always provided access, insights, and commentary in every age on the circumstances of its productions, and on the passions of its creators. Pop brought a new tenacity to these timeless dynamics. Through the appropriation of the most literal and conspicuous images of mid-twentieth-century mass media and technological power, art and popular culture began to share a common language and syntax. The differences occurred in the attitudes brought to observation and appropriation and in the meanings that were constructed. This congruence of imagery in art, architecture, styling, advertising, and media often obscured the critique that Pop provided. The immediacy of the humor, the intensity of the banality, and the enormous scale of some of the fantasies never quite transmitted the critical persistence of the work. Pop was not an embrace of contemporary culture, nor was it an acquiescence to its potentially leveling and insidious effects. It was an acceptance of the present with an eye to the future through a receptivity to sources both difficult and occasionally repugnant. These sources were not sanctioned by art, by history, or by virtually anyone, for that matter. Pop artists and architects looked to the world, as others have before, but they had the audacity to look at the wrong things, and perhaps at the wrong time.

For the past fifteen years, architectural dialogue has slumbered between the perceived restraints and ambitious failures of Modernism and the overblown mannerisms and self-righteousness of Postmodernism. This has become an old and directionless debate, where information and ideas have been sacrificed to zealotries in both camps. In this climate, Pop architecture offers important ideas that illuminate the misguided and superficial nature of the current architectural debate and the reasons for its fast-moving demise to empty rhetoric. The Modern-Postmodern dialectic has focused on the perception of architectural history—on whether it is an opening or an obstacle to creative invention and communication. The central argument appears to be about who really understands the meaning and consequences

Section drawing of *Interchange* project, 1963, by Ron Herron and Warren Chalk, published in *Living City* magazine, used as the catalogue for *Living City,* an exhibition at the Institute of Contemporary Arts, London. Courtesy Archigram.

Views and components, Archigram's *Living City Exhibition,* Institute of Contemporary Arts, London, 1963. Courtesy the architects.

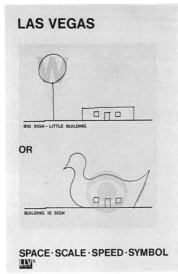

Drawing and analysis for Las Vegas research, Venturi, Rauch and Scott Brown, 1968. Courtesy the architects.

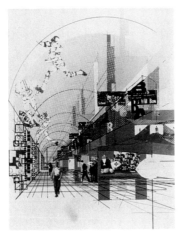

Interior view, National Football Hall of Fame competition entry. Drawing by Gerod Clark and Robert Venturi. Courtesy Venturi, Rauch and Scott Brown.

of this history, about who has broken the desired notion of continued progress, and about history as a literal source or as an intellectual idea. Modernists are attacked for the fissure they have wrought in historical continuity through their virtuous and utopic visions. Postmodernists are under fire for their nostalgic sentimentality and for their applied approach to history. Reportedly, the Modernists have chosen not to remember at all, and the Postmodernists have chosen to remember in a highly subjective, selective, and idiosyncratic manner. What is frequently overlooked by both Modernists and Postmodernists is history as a flexible concept that is in a constant state of invention and revision. History moves with the culture; it is not an independent fact but a mutable idea. Historian Howard Zinn examines and advocates for the subjectivity of history. "I am for value-laden historiography. For those who still rebel at this—despite my argument that it does not determine answers, only questions; despite my plea that aesthetic work, done for pleasure, should always have its place; despite my insistence that our work is value-laden whether we choose or not . . ."[4] In their embattled enthusiasms, both Modernists and Postmodernists have forgotten the most significant lesson of history—that it is also "aesthetic work." The past and the future are both consequences of invention; one implies action occurred and the other suggests speculation in progress. No matter how history is sliced, it does not support narrow segregation. "The fascinating progression of a past historical event can have greater effect on us than some cool, logical discourse . . . if only for one reason, because we learn the end of that story."[5] The importance of a shared history is in the liberties it allows.

Pop architecture is about this conundrum of history, about the liberties of interpretation, and about the new critique it provided of the thinness of architectural hegemony. At its inception in the early 1960s it provided a prescient vision into the futility of Modern-Postmodern debate. Pop architecture was an aggressive commitment to the present. This preoccupation with the contemporary created a climate that opened and expanded the use of extra-artistic sources. The interest in the present was neither an assault on the past nor a glorifica-

[4]Howard Zinn. "What is Radical History?" *The Politics of History.* New York. Beacon Press. 1970, p. 35.
[5] *Ibid.,* p. 36.

tion of the future; Pop was about a new autonomy. As Modernists and Postmodernists alike claimed inspired access to the relevant lessons of history, the horizon of vision was shortened to include only architecture as the source and application. The resulting hermeticism on both sides is no surprise. The closed set inevitably limits the possible solutions. But Pop was an open set; as the variables for consideration extended into large philosophical, social, and cultural questions, the precious egg of architecture broke open. And, of course, once the shell is cracked, it cannot be reassembled. There is no point of return; only change is possible. This is why Pop architecture has been so unpopular—especially with architects. The real site of the rupture was not in history or with a Modernist notion of progress, but at the new location of pertinent information. Pop challenged what had always been considered acceptable sources for architectural inspiration. It looked outside of the shell to issues of contemporaneity and confirmed that history could offer neither protection nor justification for an architectural inquiry that sought limitations rather than possibilities.

The beginnings of Pop at the Institute of Contemporary Arts in London were interdisciplinary. Artists, architects, and critics assembled to explore a shared curiosity about the peculiarities, and particularly the ironies, of a new society influenced by mass media and complex technologies. The late 1950s and early 1960s were years of desires fulfilled and fears fuelled. The overwhelming abundance of consumer products, the possession of which was a channel to improved status, and mass media and advertisements used to create expectations out of thin air, expanded the already distended appetites of the growing middle class. These inflated wishes for both objects and stimuli offered ironic potential for the artist as social observer. At the same time that there was a growing fascination for space travel, for the expansive fanatsies and cautions of science fiction, and for the variety and quantity of consumer commodities, there was a crystallization of the insular, protective conformities of suburbia and middle-class domesticity. The home became a sanctum from a world of excesses and constant saturation. With the enlargement of prospects for

prosperity there came a desperate climate of suspicion. Communism, for example, and any kind of "other" represented a threat to these bright promises. Pop was a way to explore this simultaneous participation in and retreat from the world. The ideas willfully and subliminally communicated in popular culture and its artifacts were far more compelling than the traditional notion of art as a personal quest for meaning. Popular culture provided unmined meaning—perhaps too much meaning. This abundance offers some explanation for the many expressions and manifestations of Pop ideas.

The Independent Group at ICA discovered that the inroad to collaboration and cross-disciplinary work was found in the ubiquitous. Architects Alison and Peter Smithson and architectural historian and writer Reyner Banham brought architecture to this Pop investigation of art and contemporary culture, and then had the audacity to bring the results of their research back to the provincial domain of architecture. It was not an easy or entirely fruitful reciprocity. In fact, the Smithsons' challenging and provocative projects and proposals are testaments to architecture's resistance to change, especially when challenged by ideas from non-architectural sources. As originators, the Smithsons chose to work within the established territory of architectural convention. The triumphs were modest and gradual, and frequently underestimated, but their work raised important questions about the planning process, the participatory dimension of architecture, and the relationship of Pop and Brutalism in contemporary architecture. The Smithsons took ideas from popular phenomena in order to empower the users of architecture. Unlike many of their followers, the Smithsons chose to be both builders and theoreticians. Their work represents the inconsistent nature of theoretical innovation and its built manifestation. Architecture is recalcitrant; theory is fluid. It is not always a graceful *pas de deux*.

Following the inception of Pop in Europe with the discussions, writing, exhibitions, and various productions of the Independent Group, a young group of English architects centered around the Architectural Association School of Architecture in London began to publish a ca-

cophonous series of drawings and research. Archigram avoided the difficult relationship of theory and built form to concentrate on writing, visionary drawings, and brazen speculations about what Pop architecture could offer the world and the profession of architecture. Archigram had no intention to promote a style or a formula, but offered new substance for consideration and proposed speculative architecture as an instrument for critique. Their work implied a radical potential for the future.

Peter Cook, Michael Webb, Ron Herron, David Greene, and other architects associated with Archigram—which was also the title of a publication originated in 1961 to disseminate the work of this group—embraced a variety of themes and strategies to present ideas about architecture and Pop culture. Their drawings embraced issues of technology, mass production, temporality, and utopianism. The work was, at once, exploratory, critical, and propagandistic. But the conviction that they all shared was a radical reassessment of architecture. In spite of the glib, outrageous, and wicked quality of the drawings, there was an earnest review involved. Popular culture provided an access for looking at architecture from a distant and independent vantage point. Pop is an idea about art and its acceptable parameters, but it is also about a way of looking at the world. It provided these architects with a perspective which enabled them to see architecture with objectivity, with novelty, and with frankness. At a moment when architecture was suffering the consequences of diminished possibilities and architects themselves were tightening the restraints, Archigram began to open a door. The irony is that the use of available phenomena, as the genesis for aggressive images used in conjunction with unresolved architectural forms, often made the work inscrutable or appear unconcerned with the human consequences of its speculations. It was either too whimsical, too winsome, or too wicked to invite genuine scrutiny. There was probably great relief that Archigram's proposals could not be built, and that also became a censure used against the work. If it couldn't be constructed, why should it be taken seriously as architecture?

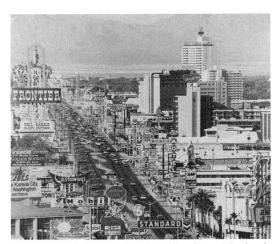

Las Vegas research photograph from the archives of Venturi, Rauch and Scott Brown. Courtesy the architects.

Las Vegas research photograph from the archives of Venturi, Rauch and Scott Brown. Courtesy the architects.

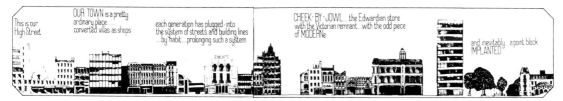

Detail from ''The Metamorphosis of an English town,'' 1970, by Peter Cook, revised from an earlier version in *Archigram Nine.* Courtesy Archigram.

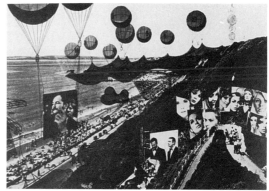

Peter Cook, *Instant City at Bournemouth,* 1969. Courtesy Archigram.

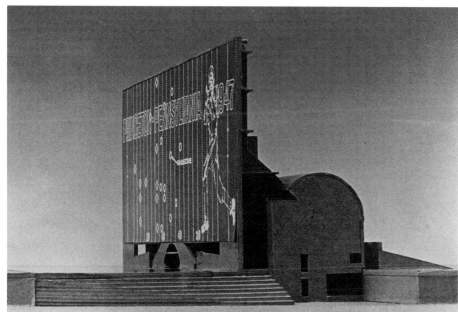

Model view, *Bil-Ding Board,* National Football Hall of Fame competition entry, 1967. Robert Venturi with Gerod Clark and Frank Kawasaki. Courtesy Venturi, Rauch and Scott Brown.

Haus-Rucker-Inc., model for *Rooftop Oasis*, 1973. Courtesy the architects.

At the same time that Archigram was drawing a future of technological utopias, plug-in and instant cities, moveable buildings, vast structural systems, and sci-fi fantasies, American architect Robert Venturi was experiencing a bit of restlessness of his own. Whereas Archigram looked to the extraordinary in popular culture, Venturi focused his eyes on the more ordinary qualities of contemporary life—on what you might see anywhere rather than find nowhere. Archigram offered skepticism, cynicism, and acerbic wit in their speculative work. Venturi found a more compassionate, less sensational route for his research. As an alternative to the strident, narrow, and self-obsessed qualities of Modern architecture, Venturi, in his writings and buildings, proposed a reconceptualization of architecture through the obvious, the ordinary, the ugly, and a vernacular building issuing from traditional construction techniques and from media, consumer, highway, and suburban apparitions. Like Archigram, Venturi and his firm, including partner Denise Scott Brown who participated in the Pop dialogue from its beginnings in both England and the United States, used the idea of Pop to challenge the exclusivity of contemporary architecture and its nearsighted vision. Archigram's work encouraged people to think critically about twentieth-century culture and its impact on architecture, on the quality of life, and on the future. Venturi's books, drawings, and buildings enabled people to perceive with receptivity the world invented by the quick legibility of capitalist economy. Archigram asked people to think about architecture, and Venturi, Rauch and Scott Brown encouraged people to look at it. In the best of worlds, thinking leads to seeing and seeing leads to thinking, and both offer an intellectual access and an enhanced perspective for understanding the world as it is.

Venturi's book, *Complexity and Contradiction in Architecture*, was published five years after the first issue of *Archigram* appeared (1966). It was presented as a "gentle manifesto" offering a non-doctrinaire alternative for architecture. It is, of course, seen as the introduction of Postmodernism to the American culture. It was also a brilliant summation of the meaning of Pop in the United States. From these foundations of Pop archi-

SITE Projects, *Ghost Parking Lot,* Hamden Plaza Shopping Center, Connecticut. Courtesy Ronald Feldman Gallery, New York, and the architects.

SITE Projects, competition drawing for Frankfurt Museum of Modern Art, 1983, by James Wines. Courtesy the architects.

SITE Projects, *High-Rise of Homes,* 1981. Pen and ink on Mylar, 42 × 42 in. Courtesy the architects.

SITE Projects, *High-Rise of Homes,* 1981. Pen and ink on Mylar, 42 × 42 in. Courtesy the architects.

tecture, one in England and the other in the United States, the profound differences of the idea and interpretation of Pop is evident. Archigram reviewed technology and the systemic phenomena of modern life. Their desire was not to glorify technology or to use it to create more and more, but to employ its powers to simulate architecture and environments of absolute flexibility. For Archigram, the promise of Pop was in the enhanced, mutable, and manipulable options for architecture provided by complex technologies. Venturi's early investigations of architecture—vernacular sources, roadside buildings, and signage—were more concerned with the existing, uncensored manifestations of large systems and architecture as communication rather than obsessive flexibility. Working like archaeologists or anthropologists, Venturi and his colleagues focused on the artifacts of the culture in order to disclose the operations of the culture. Theirs was a more small-scale, tactile, and immediate research compared to the vast premonitions and abstractions of Archigram. The differences become more evident as the students and contemporaries of Archigram and Venturi, Rauch and Scott Brown have built. On the one hand are Richard Rogers, Renzo Piano, and Norman Foster in Europe who have all used technology as iconography. Michael Graves, Robert A.M. Stern, and Charles Moore in the United States, on the other hand, suppress technology behind historicist and humorous facades generated from many sources. All of these architects use collage, but to different ends—to achieve disruption or conciliation.

Clearly, the only thing that is formulaic about Pop is its persistent iconoclasm. As seductive as much of the imagery is, it does not coalesce into a style or genre. For Pop is not simply about the look of things, but a proposition of how they came to be that way. It opened opportunities for the artist and architect to be social observers and to take this data to the easel, the studio, and the drafting table. In spite of its radical content, many believe that Pop is without critical edge, without rigor, and short on content. Pop began as an interdisciplinary idea, and the painters and sculptors were able to take the idea and generate an important and resonant body of work. Pop art is still looked at with enthusiasm,

with interest, with a certain consensus about its significance following the mute metaphysics of abstract expressionism. Pop architecture was a partial retort to the stillness of Modernist architecture, but it never implanted itself in the center of architectural discourse. It has always been seen as a fringe—and as an idiosyncratic and slightly self-indulgent one, at best.

Architecture simply could not deal with the radicalism of Pop. Pop architecture was easy to dismiss because so few Pop-inspired buildings have been constructed, and those that have been mimic characteristics rather than examine issues. Pop architecture is also, like International Style architecture, particularly susceptible to bad knock-offs. The glass and steel buildings of corporate imperialism are mimetic by design and intention; they are intended for standardization, for a formula approach. Pop iconography, while not axiomatic, was superficially obvious and easily recapitulated by message mongers. If there is anything most middle-of-road Modernists and Postmodernists share, it is a healthy disdain for Pop. Pop is trivial. Pop is facile. Pop was fashionable. Architecture does not welcome any marginal idea or untried inclination.

In spite of a general rejection of Pop in the architecture profession, its influence, though diluted and changed, is discernable. Postmodernism extracted from both Archigram and Venturi those qualities and charactertistics which, when composed in just the wrong way, become platitudinous, or heroic and rhetorical. Archigram's obsessive technology has fostered a new iconography for corporate architecture which employs the forms and their implied flexibility to a specific building type. Postmodernists who focused their gazes on the vernacular landscape, the genteel qualities of suburbia, and the cozy images of a highly selective history, looked to Venturi for inspiration. They simply took all of the fat and little of the meat. Whether they chose to look ahead, around, or behind, Pop architects offered rare insights and the permission to look at anything. Pop struggled to change not just the look of architecture, but the very premise of what it is in the late twentieth-century. The strong anti-stylistic position has become the blueprint

for the most stylish architecture of the century. This is Pop's greatest irony; in its rejection of architectural style it looked to the manipulation of style in popular culture, and conceived another style for exploitation.

Venturi and his partner Scott Brown, the Archigram group (now dispersed), Superstudio and Archizoom in Italy, and Haus-Rucker-Co in Germany constitute a first generation of Pop architects. They began the exploration of this new frontier and their breakthroughs gave others courage. There is a second generation of practitioners who are working with the residual ideas of Pop. But their work is not mimetic. In most cases, they want to build, or, at the very least, to take their conceptual work to other forums of social observation. Their investigations are more subtle and perhaps more focused, and the iconography does not instantly read "Pop." They are architects whose work is strongly tied to the idea of site—not as a locus of observable activity—but as a semaphore for the culture. Their architecture offers an interpretation of a popular culture that has changed quickly and sometimes overwhelmingly in the past twenty years.

For much of this more recent work the idea of Pop has expanded to include questions of psychology, sociology, media influence, information, and disinformation. It attempts to take non-visual phenomena and translate them into visible form. Early Pop was visceral, tactile— the stuff of life in all of its messy vitality and troublesome irony. The popular culture of today still includes all of these things and more. It is the more and the less that is the new focus of popular culture. Pop-inspired architecture today is about the silence rather than the noise, about the absence rather than the presence.

One of the most telling transformations that has occurred in the past twenty-five years has to do with the diminishment of the image. The Smithsons' essay, "But Today We Collect Ads," had to do with the transparency and plethora of information and advertising (see pages 53–55). The vividness of the images left no question about desires, expectations, or the message. There was a directness and enthusiasm, in spite of a limited

SITE Projects, *Indeterminate Facade Showroom*, 1975, for Best Products Co., Inc. at Houston, Texas. Courtesy the architects.

depiction of the desired model. The dream was clear, and when things looked a certain way, the dream had been achieved. The cause and effect were not circuitous. In the 1980s infatuation with the image has not diminished, but the clarity of the message has. With two decades of saturation behind us, the image has less and less residual impact. So images have become more fleeting, more ephemeral, and more duplicitous. With the complication of roles in the past two decades, it is not so clear what everybody wants; it is only clear that everybody wants something—often for very different reasons. The image has had to accommodate this enhanced recognition of motivation and objective; it has become more layered and more calculated in its inscrutability. Even nostalgia, the most enduring sensation of all, must embrace the more transitory qualities of this new media age. Popular culture is about a new invisibility.

The new generation of Pop architects, all of whom would take exception to being identified in this way, have directed their inquiry to the ideas circulating in the culture. These ideas frequently do not have a visual representation. The Pop inquiry has moved from ''the stuff'' of popular culture to more ambient ideas. The projects of SITE, fiercely independent and yet indebted to Venturi and others, suggest this new or post-Pop orientation. SITE's work looks beyond observable phenomena to the ideas that permeate and affect the culture. Like Venturi, they have chosen to be builders as well as theoreticians, and have taken the Pop vocabulary to narrative structure and idiosyncratic pursuits. But like early Pop architects, the critique that SITE proposes is not just about the culture, but is about architecture as well. Michael Webb represents what is old and new about Pop. As one of the original Archigram members he imagined and drew exuberant and wry buildings. His recent work is concerned with viewpoint, with ways of seeing. The new drawings are precise mathematical analyses of visualization. But a house that he is planning to build for himself in upstate New York proposes a garage entrance for the family car. Once in the house, the automobile would be raised on a platform into the living room above ground. This singular and potent icon of Pop will be the absolute focal point of the domestic environment.

To explore Pop architecture is to examine time. This exhibition is about the new access and liberties of the Pop sensibility, about the viability and necessity of cultural phenomena and ambient ideas for architectural inspiration, and about the relativity of history. But most of all, it is about time, and how ideas develop, grow, and propagate—and how they change. The intersection of architecture and popular culture challenged the notion of a fixed architecture, of style, and perhaps of the possibility of an architectural movement at all. Pop did these things without compromising its own critique, but the irony is that the commentary it provided was never as affecting as the actual productions of popular culture. Pop architecture remained mutable, flexible, open, non-hierarchical, non-commercial—and fundamentally unpopular.

New York City, Duane Michals, c. 1968.

The Necessity of Walls:
The Impact of Television on
Architecture

Edward Leffingwell: The pervasive influence of television on everyday life seems an accomplished fact of our culture. As a student and critic of architecture, what do you think about the role television plays in the understanding and practice of architecture?

Glenn Weiss: I'm interested in the formal aspects and the narrative aspects of television as it creates architecture. Historically, you can see the impact, the ramifications of television on architecture somewhere around the mid-sixties. Earlier, with people like Peter Smithson, you start to see the impact of electronic media, the telephone and radio.[1] Smithson and his colleagues are not part of the television generation, but they are part of the telephone generation, something that has other implications. I'm also tremendously interested in the sociological impact of television and how it affects architecture, how it transforms the notion of public and private, from an idea that has to do with visual enclosure or physical enclosure, to one that has to do with information. On the other hand, I'm not interested in a television that endangers or takes away from architecture completely. I'm not interested in the nay-sayers of destruction regarding the influence of television.

EL: Do the images conveyed by television have a direct impact on architecture, or is it a matter of narrative structure?

GW: The images themselves propose two directions. One is how television is actually made, the way editing proceeds, and the way information is arranged in sequence. It has to do with the clumping of information, with making a list, rather than the presence of an enlightened rational system where you create cause and effect, where you think about the structure of how something's going to proceed, where it's going to go, where it's going to end, how you make a holistic element out of the process. Television tends to put things in sequence. Everything is of the present. There's a lot of responsiveness to television. Television responds to the next thing that happens until it gets to the end, which is probably based on one simple narrative idea. The case of the sit-com is one thing. But the soap opera never has an end; it is a perpetual present. And we see that effect on architecture. It can be seen in that light, but I also see the relationship as more positive, putting things together rather than deconstructing them.

That's one side of the argument. The other argument is that television makes architecture into a situation rather than into a place. The narrative structure of television creates an architecture which is about relationships between people who are involved in a given circumstance and their response to that circumstance, rather than focusing on the architecture that makes it happen or is the physical location of the circumstance. Architecture ceases to be identified with walls, as the making of a square, or a circle, or a bowl, or a system of columns that embraces a place and becomes a situation, a place where action occurs. You, as a person, respond to the action in this place. And your memory is geared by your personal response. Television is all about personal response.

EL: What are the architectural devices that would cause this to happen?

GW: If you're an architect working on a situation, you would not be concerned with the actual formal struc-

[1]See pages 47–51, 53–55.

ture of the neoclassical position, making a center room and various smaller rooms going off that, responding to a hieratical concept. And you wouldn't assume a Modernist position of making a grid of space which maintains a continuum, or be interested in the events that occur within that continuum. You don't need the structure at all. What you need are events within a particular location. A ceiling can vibrate independently, for instance, in rapid patterns of light. The ceiling might very likely have some lights that flash on some other point, so there is an energized interrelationship between the ceiling and the wall of the space. The architect's concern is with the interrelationship between the user and the activity. Coop Himmelblau, who work in Vienna, claim they just do a kind of scribble on paper, this energy line that presents the relationship and composes or allows various events.[2] You see a lot of what is being called fragmentation.[3] But on the other hand, there is another kind of unity, and I think that unity is being caused by a generation of people who have grown up watching television.

EL: Are you saying that the devices used in the construction of an interior space may be actually activated in some kind of sequential way in some television-like program, that lighting would be timed to change or interact in some way?

GW: Yes. In discotheques. I'm talking about the actual ability to manipulate and try to change the building and the structure to your taste. I don't think it's clearly understood now, but it has to do with the rejection of the concept of structure.

GW: People like Zaha Hadid, Rem Koolhaas, Coop Himmelblau have rejected structure in the way we understood it in the past, as clear, visible patterns.[4] They've replaced the patterns with a sense of energy, of things operating against each other as they create a situation. The situation is very animated, full of energy. Television causes this to continue. It's part of the cultural phenomenon that causes us to empathize with buildings, put ourselves into something and make a judgment based on ourselves and our action.

EL: Not so much in terms of function but as creative expression?

GW: More in terms of creative expression. Functioning pertains in terms of the expressive use of lighting, for instance, but the concern is not the dogma of the Modern movement, the interest in the economy of use. This is about expressive use.

EL: You brought up the notion of classical and Modernist deployment of walls and rooms. Will you describe the effects of television on architecture in terms of rooms, how they would connect and relate to the user?

GW: The concept of the room is not a particularly important one for the television people we're discussing. The concept is event and what goes on. You don't need a complete room to make an event happen. And you don't even need walls to make privacy happen. Postmodernism is based on a desperate reactionary attempt to figure out what to do when you're faced with the fact that the whole history of architecture is beginning to look unnecessary, when walls no longer make privacy, when walls no longer make divisions. It is the sense of the protection of information that was becoming crucial. I think the Postmodernists buried their collective head and ignored the problem. Except in the case of Leon Krier, who attempted to say that we don't just live in the world of Einstein and electronic images; we actually live in another world which is our city also, and which basically has the same rules as Sir Isaac Newton's world in how we relate to the city.[5] Krier makes a fantasy out of the Modernist's idea of making a good city or place based on its functions and habits within the culture. He makes a situation so that modern urban planning is a kind of Disneyland, not a pragmatic pattern. And in fact that's happened. There is a demand for public places that fulfill our television-derived understanding of what they should be. The nice little urban area as an experience is the historic district—it's a nice little urban area experience which the user enters, and the architecture responds in a way that makes the stage

[2] Architects practicing in Vienna since the mid-sixties.
[3] The separation and recombination of architectural elements with the intent to dramatize the original meaning of the elements.
[4] Hadid is a theoretical architect, teaching at the Architectural Association, London. She is known for drawings of buildings derived from Russian Constructivist architecture. Koolhaas practices architecture in Rotterdam.
[5] Krier is a theoretical and "reactionary" architect who hypothesizes the reconstruction of European cities on the models of Gothic or neoclassical town planning.

VIDEO PROJECTION OUTSIDE HOME (1978)

A large ADVENT video projection screen is placed on the front lawn, facing
pedestrians on the sidewalk. It shows an image of whatever TV program is
being watched by the family on their TV set within the house. When the set
is off, the video projector is off; when the channels are being changed, this
is seen on the enlarged public screen outside the house.

Dan Graham, *Video Projection Outside of Home,* 1978. Collage, 20 × 30 in. Courtesy the artist.

Richard Artschwager, *Tract Home,* 1964. Acrylic on celotex, 42 × 43 in.
Courtesy Leo Castelli Gallery.

set for that experience. I know that the Mom and Pop store that used to be there is not there, but I'll accept what has come to be there as credible within my circumstances. It doesn't make any sense in terms of Modernist thinking, the striving for an integration of the parts to the whole. This new generation of architects doesn't demand that integration. Zaha Hadid's buildings are not flying into outer space. We know in fact that they are anchored on the ground; they are never going to move anywhere. Hadid's buildings are not really the edge of an urban block flying off. They're going to be there. And we accept it as a kind of credible stage set. Architecture always exists in the realm of Newton no matter how much advancement we make into space.

GW: I mean that a seat is always a place where you sit down. It's always going to have the feeling of sitting down, no matter how much Einstein may tell us that we are in fact moving through space at some unimaginable speed. We remain in a static relationship with the floor which is beside us, and we are travelling at the same velocity as the floor, with the sensation that we are sitting down and at rest. The world of Newton will continue to dominate, because we are aware of space as static rather than electric. There will always be this tension between what's going on socially, the breakdown of the necessity of walls, and the possibilities of communication, because we have the telephone, we have the radio, we have television. Our need to sit down and be static remains a reality. No matter how much you may go into the theoretical to discuss it, you always have to come back to this real world. Or some of us do. The Pop artists never had to come back. They could remain in play with their public and their art and themselves. But the architect always has to come back to a public, one that was never part of the intellectual game.

EL: Is there something that lends itself to a metaphorical conception, that has to do with things like the problem of identity, the difficulty of placing oneself in a location of architectural diversity?

GW: It may have something to do with adjustment.

Zaha Hadid. Rear perspective, Kurfurstendam, 70, Berlin, 1986–877. Gouache on paper, 8½ × 11⅝ in. Courtesy Max Protetch Gallery, New York.

There's a project by Reyner Banham from about 1965.[6]
He makes a plastic bubble and puts himself and a
friend inside, without any clothes on, and with a televi-
sion set and a stereo system. It was what Banham
deemed the reality of architecture at the time. Within
this bubble you have a perfectly controlled environ-
ment, very simple, and you are extremely exposed to
public view in every way. The wall has become mean-
ingless, and what becomes important is the focus of at-
tention in that protected space. So you focus on the
stereo or television, or whatever electronic gadgetry
completes the mind-expansion necessity. This is the real
effect of the actual circumstance of billions of people
watching television. I also feel that television and infor-
mation have made a major change in our understand-
ing of what is public and what is private. That sense is
one of the major theoretical premises behind architec-
ture and how it's made: why you make spaces to pro-
tect certain things from each other, to isolate things,
keep them separate from each other. Spaces start to
look not so much like in the Renaissance, when there
were actual rooms holding things together, but more
like the tent of an Arab sheik where everything is under
one tent roof. We realize that the man is not going to
enter the woman's side of the space, although there is
no barrier. It is culturally presumed that you will not en-
ter that space, and you will not listen to what's going on
within that space.

The wall starts to break down. It becomes clearly a soci-
ological phenomenon, an activity and the agreement
between people about what is private and where a pri-
vate place begins. The telephone, the radio, and the tele-
vision bring the ability to access other private lives and
carry them into the home. You can see that in Dan
Graham's suburban lawn project.[7] He puts a television
on the front yard to show what the people inside are
viewing. He is making clear that what is private about
the house is what is going on inside, and that is visible
through the plate glass windows. The private nature of
what the resident is watching on the television is re-
vealed as Graham brings it outside and sets it on the
grass, thereby making even that personal information
technology public to the world.

[6]See pages 65–69.
[7]Graham is a New
York conceptual art-
ist and cultural critic.

Alan Belcher, *Condo-87*, 1987. Color photographs with Velcro attached to concrete blocks,
48 × 100 × 42 in. Courtesy Josh Baer Gallery, New York.

Alexander Brodsky and Ilya Utkin, *Dwelling House of Winnie-the-Pooh in a Large City*. Courtesy Constantin Boym and Modo.

EL: What does this suggest about identity, privacy, and the individual?

GW: The notion of the individual becomes more and more like pieces of memory, stacked into your brain—that history of experience, the place where you find yourself in the web of communications at a particular moment. And I don't know about the ability to manipulate the web, or manipulate the information, but the expression of this information serves to give others the feeling of individuality as well. I think we will always have this tie to physical expression, which depends on the reaction of human beings and their control of physical presence. We have something like forty years of decent audio recordings, fifty years of film, and almost nothing of television. Over a period of hundreds of years, with this kind of information and storage of information, it should be possible to put together a personal history with elements of information that become quite broad again. Ours is a very physical existence, a grounding in the substantial power of the earth. And this analysis of the impact of the electronic media is merely an exaggeration of circumstances in order to be able to talk about them.

EL: How does the physical expression of architectural materials change if our sense of identity is changing?

GW: The use of cheap, readily available building materials will maintain a kind of connection with the past. In spite of the use of traditional materials, they will be put together in a different way. Building will respond to a sense of personal invention, in response to peer pressures. In order to be considered a member of the suburban culture, for example, you will choose certain kinds of architectural elements for the home. The choices may include the den, the playroom, bedrooms for children rather than alcoves, and the carport. These are appropriate choices in a specific situation. The problem is the Wittgensteins who say that these architectural elements or symbols change and mutate, and there is no guarantee what a carport will come to mean.[8] There are debates over the viability of Postmodernism, but Postmodernism does work because we're not connected with

8 Ludwig Wittgenstein, the Austrian philosopher, is of interest here for the expression of his language theories.

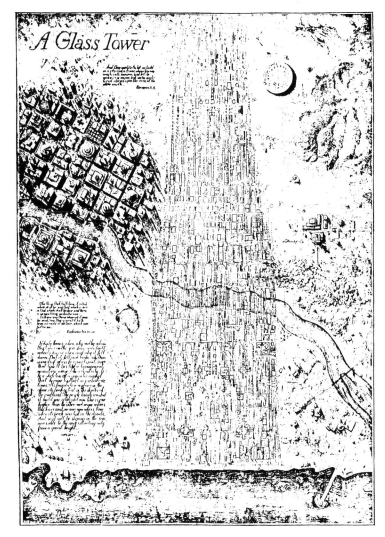

Alexander Brodsky and Ilya Utkin, A Glass Tower. Courtesy Constantin Boym and Modo.

Alexander Brodsky and Ilya Utkin, *Crystal Palace*, 1982. Courtesy Constantin Boym and Modo.

the long-term effect of reading the symbols. We're only concerned with the effect of creating a situation for ourselves for a moment. That's a television age kind of effect.

[9]See pages 47–51.
[10]Tschumi, a Swiss architect residing in New York, is the chief architect for Parc de la Villette, a cultural center in Paris.

EL: So our choice of building materials is a means to the construction of a transitory, appropriate theatrical set.

GW: People like Ken Frampton want to posit the need to work our way backward, that we must go back to the adobe brick.[9] I think it's an illusion on his part. He's forcing the issue so there'll be some kind of reconciliation again. Frampton advocates a return to a phenomenological architecture, an architecture that produces a spatial experience very close to how the architect interprets materials. If a set of stairs is made of steel it should spring in a way that steel springs and the way wood stairs do not. This use can be seen as a call for the return of a physicality of touch through the interpretation of materials and their use. If Frampton is referring to something it's not to the stage-setness alone, but to the participatory nature of the architecture that results. It's like an amusement park. The problem with Bernard Tschumi's work at la Villette lies in his refusal to acknowledge that he has created an amusement park rather than an architectural discourse.[10] Tschumi's stage set is based on pheonomenology: you have a giant slide or ramp that you work your way around. What is there will in a sense be continually reinvented by people, because there's no symbolic necessity for it. Running down a ramp is always running down a ramp. It has a certain existence which is probably fairly permanent.

Bernard Tschumi, *View: Folly J7,* 1985. Project for Parc de la Villette, Paris. Courtesy Max Protetch Gallery, New York.

Bernard Tschumi, *P6,* 1985. Project for Parc de la Villette. Courtesy Max Protetch Gallery, New York.

EL: There seems to be a great deal of interest in architectural renderings and photographs on the part of the public. It's how we grasp projects like la Villette that many of us may never see.

GW: It seems that one of the problems for the intellectual in our time is the overwhelming amount of material that is made by the non-intellectual, and we see the impact of this production on many things. There is a mass of information going out to the general public about

architecture, what it looks like, how it's made. Architects hope to see their own work reach the general public. This is a huge change in the twentieth century, for an intellectual to care that his work be read and experienced by millions of people. Because of this easy access through television to any level of intelligence, there is a new tension going on between the designer and the architect who knows his building will be seen on television or in a publication. Before Robert Venturi, buildings were always photographed in motion, in movement, as we experience them. After Venturi, the static photograph began to represent the building, rather than dealing with the edge, the movement, the line in motion. Venturi took blatantly static photographs of the front of his mother's house in which nothing is moving. You are suddenly able to see that he has made a center on the building, and one window too big on one side, the other too small on the other side. This perception would never have been revealed in earlier architectural photography. Venturi starts an entire generation of architects designing for the photograph. I heard Robert Stern say in a class at Columbia not to worry about your buildings the day after you photograph them. It's a kind of amoral position which can be seen consistently today, a desire on the part of the architect to create circumstances which are effectively captured in the color photograph. The color photograph is clearly part of the drama and excitement of Postmodernism in architecture. You get Michael Graves coming up with work in response to color photography, because he wants to communicate more broadly, and he realizes the strength of attractiveness in communication.

EL: How do these concerns relate to television's influence on architecture?

GW: Television communicates architecture as fragments. The window, for instance, has to be well-realized because, most likely, there'll be a person standing in front of that window. The window has to be clear as an element. Some architects continue to focus their energies more and more upon elements of the buildings themselves, just pieces of them. I think the Postmodernists, responding directly to television colors, have intro-

Rem Koolhaas, *Rotterdam Summation*, 1982. Silkscreen, 48 × 87 in. Courtesy Max Protech Gallery, New York.

duced that palette through the desire to have their work photographed, rather than through any kind of phenomenological approach. I'm more interested personally in television's role in the creation of a situation rather than in the composition of a building. The architects who interest me are not employing centuries of logic in their work. They are trying to create a circumstance, a situation, a place, based upon what happens in that place. I'm thinking of Coop Himmelblau in Vienna, Brodsky and Utkin in the Soviet Union.[11]

EL: So we're seeing these architects who are in some way midwifing something familiar to us as users of television, and the work is recognizable and perhaps somehow comfortable in its familiarity. I know you're describing what you've observed and that you're interested in the phenomenon, but do you feel the work is adequate to the needs of the time?

GW: I'm trying to avoid my true moral position on all of this. You want my true moral position? We have to fight dramatically for a phenomenological return. But we have to recognize that a problem exists. The Postmodernists refuse to take any kind of position about what's good, what is usable, why you would use it. They've taken a perhaps silly approach, an approach that can be seen as demeaning to the intelligence. They know that we've seen neoclassical western buildings for a long time, and that's what we like, and that's what we're going to get. I think our approach to building has to be more sophisticated than that. It has to be about what the individual who's composing the building really believes in deeply. What is important is the making of value judgments about what is relevant to the narrative in the creation of a situation out of architecture. The importance rests on choice, the selection of specific tools and materials, and applications from a practically unlimited range of possibilities. I'm concerned with a discourse about what people are choosing, what they are saying is valuable. Brodsky and Utkin, for example, don't really draw building in any way. They draw circumstances that are very complex and heartfelt, in a kind of cartoon. They've designed a glass cathedral for the edge of Moscow. The sense you get is that there is

no cathedral. It's only the illusion of cathedral, the desire for it, something on the edge of the city, something not part of real life. I'm interested in the complexity of emotional response, the sense of a world with good and bad attributes that requires decisions about values.

EL: You're calling for a responsibility, a commitment to the user by the architect, to commit to building programs that might be legible to the community while remaining engaged in some greater plan.

GW: Yes. And for a real respect for someone who uses that architecture. A respect for the intelligence and a respect for the sensitivity. But I'm also an advocate of style and am not announcing a return to any sort of puritanism, any sort of return to minimal needs expressed in an architectonic way exclusively. I like play as an element. We should feel we have the power to express ourselves, and that expression can come through physical form in the building or the decoration of the building. I don't want to steal that energy. That's one of the things I like about Postmodernism, the joy of it. It may be a kind of pointless joy in certain cases, but at least joy is in the making. I get most infuriated with the architects I respect the most. If someone like Michael Graves, who has a fine mind and a great hand, chooses to use his abilities in a less than responsible intellectual fashion, then that's who infuriates me. These are the people I'm looking for to make the hard choices. We may be seeing better architecture out of eastern Europe, where it's been much more difficult. These architects have had to respond to a more insular intellectual environment, rather than being obsessed with a passion that their work go out everywhere, through the media, through television. I think the issue of the architect wanting to be popular is a difficult one. I have a desire to return to complexity. I'm beginning to react to television by acknowledging that the world is hard and difficult in some ways, but it is not a melodrama. We need to see new intellectuals who turn to a history that we've ignored, a kind of excellence we've ignored. We cannot allow our architecture to be broadcast through the television media at the level of a sixth grade education. I don't know who has the guts to do it.

[11] The Soviet architects are frequent winners of the *Japan Architect* magazine competitions.

Michael Graves, the Humana Building, Louisville, 1982. View from Main Street. Courtesy the architect.

Michael Graves, Clos Pegase Winery, Calistoga, Napa Valley, California, 1984. Detail of south entrance. Courtesy the architect and Otto Baitz.

Michael Graves, Plocek House, Warren, New Jersey, 1979. Street facade. Courtesy the architect.

Gilbert and George, *Day-Time*, 1986. 95 × 119¼ in. Courtesy Sonnabend Gallery, New York.

A Brokerage of Desire

Howard Halle

History is bunk. Henry Ford

*The promise of America
is opportunities not guarantees.*
T.V. commercial for First Jersey Securities,
a venture capitalist lender

I. Canons of Irreality

As the geographic locus for corporate cultural hegemony, America has engendered the breakdown of nation-state identity and ideological distinctions by sublimating historical models to the purposes of consumerism.
In other words, America's manifest destiny has been ahistorical rather than historical. In American (read corporate hegemonic) culture, the reassurance of the recognizable has displaced the uncertainty of the real. Current federal politics, which under normal historical models would be labeled "reactionary," have instead been rendered, by the exegesis of a telegenic presidency, to be emblematic of consumption. Art practice has in turn been displaced by product placement: ". . . This economy performs a similar operation on all cultural expressions, whereby the specific, ambivalent content of an expression . . . is first abstracted as a general, equivalent style . . . and then circulated as so many commodity signs . . ."[1]

"American" history has a view-of-itself as a culmination of Western achievement, a system of value signs transcending the circumstances of ordinary human conflict. In a similar fashion "art" (specifically Modernist) history views itself as transcendent. Both are examples of an inexorable progression from the real to the hyperreal to a possible irreal space emptied of all signs (such reification—for example in art history—could proceed some-

thing like this: nature into landscape, landscape into abstraction, abstraction into sign for abstraction).

This upwardly spiralling order of signification is motivated by *internalized* and *externalized* mechanisms, both having less to do with the rational than they have with the emotional. In terms of the former, desires attempt to recuperate some aspect of that which is lost in the face of an ever receding procession of signs (nostalgia). In terms of the latter, such desires become the basis of a meta-language of consumption (advertising). Whether internally motived or externally manipulated, however, such nostalgic desire has a mirror opposite in the tendency to project culturally that which is to be (progress). Although admittedly a more recent development in historical terms, "progress" shares with "nostalgia" the distinction of being the basis for developing both models of history and of consumption.

It seems interesting to me that at the same time that the ruin re-enters the field of contemporary art, there is an attempt to grasp the coming of a new historical consciousness.[2] Phillipe Junod

. . . and for the first time with a sudden shiver came the clear knowledge of what the meat I had seen might be! These Eloi were mere fatted cattle which the Morlocks preserved and preyed upon.[3]
H.G. Wells

II. The Anticipated Ruin

In viewing how internally motivated desires for nostalgia or for progress can be projected onto historical models, two specific examples located within the culture of the eighteenth and nineteenth centuries respectively should

[1] Hal Foster, "Signs Taken for Wonder," *Art in America* June 1986, p. 86.
[2] Phillipe Junod, "Future in the Past," *Oppositions* 26 New York: Rizzoli, 1984, p. 53.
[3] H.G. Wells, *The Time Machine*.

be considered. One is the architectural "folly" of which Phillipe Junod further writes: "The artificial ruins that multiplied in the gardens of the eighteenth century are already 'anticipated' ruins because the quality of becoming old was given to them from the beginning."[4] These simulacra of antiquity are on the one hand an evocation of nostalgic longing. On the other hand, however, they reflect a specific methodology of history, in which the models of the objects of the past can at will be moved through the matrix of time. The second and similar methodology underlies the genre of science fiction, the roots of which functioned as a kind of prescient literature surrounding ruinistic permutations in art and architecture (e.g. Ensor's 1880 work "My Portrait in 1960"). In fact ruinism and science fiction occurred at an important juncture in western art: the shift in the value of art production away from "conformity to a tradition" towards a "consecration projected into the future."[5] That moment is the birth of Modernism.

146
147

The ruins Junod describes are not an imitation of antiquarian form conforming to tradition. Rather, they are an acceleration of that form into the terms in which it would have existed in the eighteenth century present and beyond. That entire history, by virtue of being shifted to the plane of signs, becomes an object of consumption.

In spite of a shared methodology, an important distinction exists between ruinism and science fiction. It could be argued that ruinism's object-of-consumption, the history-of-itself projected by the ruin, is a known quantity, whereas science fiction deals with the unknown: the future. But, in fact, their relationship is more dialectical. Science fiction is always predicated on the contemporary conditions within which it originates. For ruinism, the ruin of the past is articulated in terms of the future that the present obtains. Junod's ruins are, in a sense, travellers in time—not unlike H.G. Wells' protagonist in *The Time Machine*. For Wells, however, the anticipated ruin is not an image from the past—a Doric temple or a Gothic cathedral. Instead he foresees the conflation of the Marxism and Darwinism of his times: a vision of the future in which the means of production

Ashley Bickerton, *Me Portrait #1 (Wildcat)*, 1987. Acrylic aniline dye, bronzing powder, and lacquer on plywood with anodized aluminum and steel, 58 × 48 × 41½ in. Courtesy Sonnabend Gallery, New York.

Alan Belcher, *ERA*, 1986. Color photograph, 30 × 40 in. Courtesy Josh Baer Gallery, New York.

have reverted to the evolutionary descendants of a pro-
letariat governed by an economy of cannibalism.

The history of Modernism, by definition, presumes that
the value of art is consecrated in the future. Within the
strictures of its practice, a degree of science fiction ex-
ists, where mimesis is accelerated to its inevitable oblivi-
on. This record opposes, at the point of its origin, the
ruinism of history painting. And this history, in turn, at
the approach of another *fin de siècle,* has become the
anticipated ruin: the object of consumption of a new
and radical historicism.

Postmodernism, like Modernism, construes itself as a
rupture with history, and in that respect is not a revival
conforming to tradition. Like ruinism, it locates its mod-
el in the past. But is Postmodernism a new ruinism? The
model it temporally relocates is rooted in the future. By
its codification of Modernism, Postmodernism succeeds
in transposing the ruin of the future into the present. In
this sense Postmodernism raises the question: if the fu-
ture has become our past in the present, where do we
go from here? The bulk of Postmodern production has
chosen to beg this question. Instead, for an expanded
audience acclimatized by print, film, and television—
''the extension of what Malraux calls 'our imaginary
museum' ''[6]—Postmodernism has concerned itself
chiefly with a re-mystification of art practice.

By its nature concerned with the present and future
tenses, advertising has no historical memory. Cycles in
art and copy styles reappear with new names to be
greeted as innovations. Among observers of the Ameri-
can scene, discussions of advertising in our national life
always lack a historical dimension.[7]
Stephen Fox

III. A Brokerage of Desire
A will-to-history as demonstrated by the anticipated
ruin can be seen as an emotional response operating
within the spectrum of signs for the past and signs for
the future. Re-ordering these signs along invented
models (such as is the case with ruinism or science fic-
tion) certainly can confuse the cultural chronology of

[4]Junod, p. 55.
[5]*Ibid.,* p. 48.
[6]*Ibid.,* p. 49.
[7]Stephen Fox, *The Mir-*
ror Makers: A History
of American Advertis-
ing and Its Creators.
New York: Vintage
Books/Random House,
1984, p. 306.

Meyer Vaisman, *The Whole Public Thing,* 1986. Process inks on canvas with toilet seats,
18 × 70 × 70 in. Courtesy Sonnabend Gallery, New York.

Richard Prince, *Untitled* (jewelry), 1978–79.
Ektacolor print, 20 × 24 in. *Untitled* (watch),
1978–79. Ektacolor print, 20 × 24 in. *Untitled*,
1978–79. Ektacolor print, 20 × 24 in. Courtesy
Barbara Gladstone Gallery, New York.

[8]Jean Baudrillard, "Simulations," *Semiotexte* New York, 1983.
[9]Fox: 47.
[10]*Ibid.*, 48.

"real" history, but these changes do not destroy the essence of history itself. A very different effect occurs, however, when such signs are re-ordered not for the purposes of cultural configuring but of stimulating consumption. Consumption as a function of ensuring fulfillment is very much located in the here and now, and within the mechanism which engenders consumption (advertising). All cultural signs are given an equivalent commodity value—shifting them, as it were, from the plane of history to the trading floor of a brokerage of desire.

Visual technologies of dissemination—photography, film, television—are of paramount importance to this codification process. Indeed Jean Baudrillard in defining the hyperreal describes it as "that which is always already reproduced."[8] Yet the exchange of historical for commodity value which operates within advertising has less to do with the availability of specific technologies than it has, perhaps, with an innate preference for hyperrealization within human behavior. Human longing itself is the capital transacted within the brokerage of desire—often with results not anticipated by the brokers themselves.

As an example of this, Stephen Fox cites an advertising campaign for *Force* breakfast cereal in 1902. Utilizing a "trade character"—Sunny Jim—and jingles that appeared exclusively in print (in newspapers, on cable cars and other public places), the campaign proceeded without the benefit of saturation media such as radio or television. "Sunny Jim" became so successful that: "songs, musical comedies and vaudeville skits were written about him. Anybody with a cheery personality and the name of James risked being called Sunny Jim. A prominent judge cited him in rendering a decision. A *Force* Society was organized. 'No current novel or play is so universally familiar,' *Printers Ink* (a trade publication) commented. 'He is as well known as President Roosevelt or J. Pierpont Morgan.' "[9] Yet as the campaign's creator Earnest Calkins admitted, "the advertising absolutely sold "Sunny Jim" to the public, but it did not sell *Force*."[10]

The ostensible end of the transactions of signs which occur within advertising leads toward locating a tangible product or service as an object of consumption. Yet as the example of "Sunny Jim" demonstrates, often the process of hyperrealization itself supersedes the product. And this phenomenon recurs time and again in the development of advertising even within economies based on the distribution of hard goods. With the rise of an information-based economy, process has increasingly displaced product as the deliverer of fulfillment. This is a result not only of the externally manipulated shift of cultural signs to the plane of the hyperreal. More to the point it is the result of a palpable mass expression—a will to ahistoricity.

The degree to which this expression has been felt in recent art practice is reflected by the extent to which art's traditional arena of codification—the museum—has itself become a brokerage of desire. In the sense of the "real" museum, increased dependence on corporate largesse has transformed that institution into a venture for articulating the veneer of humanism so essential to the successful operation of contemporary capital. The traditional relationship of the museum audience to the transcendent history of objects on display has often been subsumed by that audience's desire for the transcendence of corporate-sponsored exhibition-as-spectacle (the blockbuster). The deliberately downplayed role of traditional patronage has been replaced by the high profile appendage of corporate identity onto culture (the logo-ization of culture). At the same time, the museum in Malraux's "imaginary" sense ("the corpus of available visual documents"[11]) has been similarly transformed. As a result of capital's circulation of all cultural signs within the ahistoricity of media, distinctions between art and mass culture have been rendered nil.

Art practice has always located its product as an object of desire. At a physical remove, codified by elite individuals and institutions, this object of desire has nonetheless made its impact felt on culture at large through a transcendent myth of its own making. But in the face of an onslaught of ahistoricizing tendencies, such hierarchical orderings are crumbling. Increasingly, art practice

has shifted its focus from the object itself to the brokerage where art is transacted.

Reprinted from *A Brokerage of Desire*. Catalogue essay by Howard Halle. Otis Art Institute of Parsons School of Design Exhibition Center, Los Angeles, 1986.

Nancy Dwyer, *Coming Up Next*, 1986. Acrylic on canvas, 60 × 75 in. Courtesy Josh Baer Gallery, New York.

[11] Junod: 49.

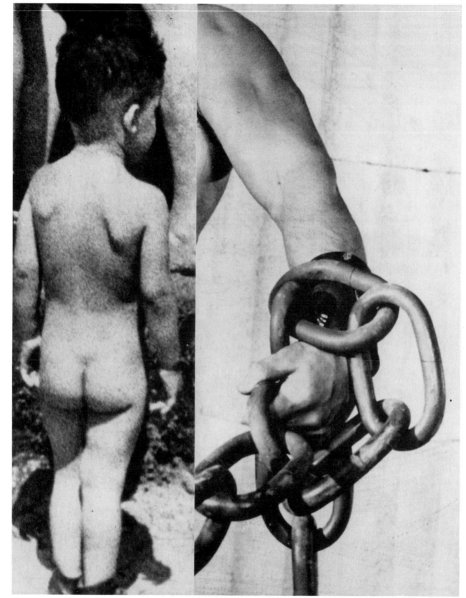

John Baldessari, *Announcement,* 1987. Black and white photograph, 30¼ × 24¼ in. Courtesy Sonnabend Gallery, New York.

Thomas Lawson

Nostalgia As Resistance

In the early 1920s, Man Ray clipped a photograph of an eye onto a metronome and called the result *Object to be Destroyed*. A notation on a later drawing of the piece suggests that the eye be of a former lover, and that the piece be smashed when whoever sets it in motion can stand the steady beat no longer. As it click-clacks back and forth, this unblinking eye of a faded desire taunts the viewer with its mechanical certainty, its invincibility. The famished gaze of the viewer, seeking possession of some ineffable truth, is confronted with the mockery of a stale stare that will not be understood. In the late 1940s, some students, angered by this implacable rejection of their subjectivity, finally reached the limit of endurance and destroyed the piece while it was on display in a Paris museum. But they found they could only redouble its derisive laughter. For in ridding the world of the original work, they brought into being its progeny of replicas, as Man Ray authorized the creation of an edition of replacements.

This irrepressible cyclops, maniacally ticking off the passing of time, can stand as a metaphor for both an all-encompassing media culture (particularly that other one-eyed monster, the television), and the avant-garde response to that mass produced nirvana. Each mimics the other, at a remove, as each attempts to wrest control of the soul of western civilization. Each attempts to outstare the other, to outmaneuver it. But each constantly removes its attention, as if to vanquish its opponent by ignoring it, only to return ever more fascinated. Occasionally the game is refused; one thinks of artists like Pollock, Newman, Rothko, and later, Serra and Marden, kindred spirits to the French students who wanted to smash the infernal machine, kindred spirits condemned to repeat their act of heroism over and over as

the gaze of their oppressor simply shifts itself, replaces itself with a representative copy. Since the 1950s, succeeding generations of avant-gardists, taking note of the self-defeating posturing of the refusniks, have tried in one way or another to accommodate the ticking metronome in order to somehow beat it at its own game. The resulting rhythm of change within a simple structure of repetition has been the heartbeat of art ever since.

Looking at art since the 1950s, it becomes apparent that there have been several wave patterns, which, at their points of intersection or contact, cause a greater complexity to develop. The larger pattern unfolds as a change in focus from thinking about presentation to thinking about representation. We have seen how, faced with a dominant notion of art as a transformative activity, Paolozzi could not, at first, declare his collected images and tear sheets art. He and the others of the Independent Group could only incorporate Pop material by expanding the idea of the art work to include the issues surrounding its presentation. The emphasis on exhibition design operated as a cover under which the non-artistic could be brought into contact with the real thing. In their different ways, Oldenburg and Warhol changed the terms of this argument, making the representation of mass media within an art context the central issue. Shortly thereafter, the epistemological researches of artists like Smithson and Bochner showed this concern to be relatively naive in understanding art's relationship to the other discourses of culture. Their inquiries paved the way for the work of the late 1970s and early 1980s which attempted to reconfigure the Pop project as a more abstract activity concerned with the workings of representation in all areas of the culture.

Robert Mapplethorpe, *Patti Smith*, 1975. Black and white photograph, 20 × 16 in. Courtesy the artist and Robert Miller Gallery, New York.

Within this overall pattern a smaller one emerges, more predictable in its trajectory. Each significant move generates a small industry determined to return the argument to the production line, manufacturing aesthetic packages that can be more easily dispensed to waiting collectors. Thus, the Royal College graduates of the early 1960s gussied up the ideas of the Independent Group, while countless artists worked to make the Pop Art of Warhol and the others more palatable to the public in the later part of the decade. More recently, we have seen a generation of artists reformulating the various strategies by which the artists of the early 1980s sought to address the commodification of discourse that results from a collapse of meaning within representation as a justification for the production of attractively meaningless commodities.

To many of us who arrived in New York around 1975, a similar situation seemed clearly in place. The stringent informality of Postminimalism had given way to a more academic and aestheticized practice that ultimately had to be understood as denying the achievements on which it was based. And this in turn allowed more room for all the varieties of deliberately dumb, pretty art to receive undue attention. Worse, there seemed little real connection between what was going on in the art world and what was going on elsewhere. Art was caught up in a narcissistic system, self-regarding, self-enclosed, and irredeemably boring.

While art was stagnating in New York, there were plenty of other things to look at and think about. The city itself was nearing bankruptcy, its physical structure rapidly deteriorating—one highway had collapsed, the bridges were declared in danger, the subways were more and more likely to break down. In some parts of town, buildings were being abandoned by their owners, while in others real estate speculation was rampant. The most arresting images were being presented by the propaganda industries—the mass media of television, movies, and advertising, with their devastating mixtures of news, nostalgia, and special effects. It was a darkly

romantic time, a midnight time. A claustrophobic inertia had developed since the end of the Vietnam conflict, since Watergate, since the oil crisis, seeping through the airwaves of our shared unconscious. The rebellions of the previous decade had been quieted, replaced by the narcosis of old movies and reruns on late night TV. It was a time in which a sense of history had mutated into a nostalgic phantasm.

During this strange period of limbo, the most interesting places to hang out were the bars and clubs where bands like the *Ramones* or Patti Smith performed. Artists began to realize that fast, psychotically repetitive rock music could provide a successful way to reinject life into the moribund idea of "performance art." Musicians like Rhys Chatham and Glenn Branca could claim to be continuing the traditions of serial music, but at the same time, enjoyed playing with the urgency and glamour provided by the rock format. Since so many of us had grown up with John Lennon, Mick Jagger, or Ray Davies as our idea of a living artist, it seemed natural. Suddenly everybody was in a band, mostly fairly transitory groupings confined to the art world. A few of these bands (most notably the *Contortions*) developed real ambitions and went on to compete with some success in the real rock scene. The music that came out of this activity tended to be fast and rough, betraying a studied carelessness. Attributes and images from the rock culture were appropriated and re-presented, with a deadpan irony. There was little regard for musical skill, or for originality per se. Anything could be lifted and reused as necessary, and could be done as badly as seemed appropriate.

In ways parallel to this club scene, a great many people became interested in cheap film production, using Super-8, the technology of home movies. The aesthetic here was as rough and ready as that of the music scene—production values were deliberately amateur, acting was for the most part desultory, story lines were left incomplete. The films were fast, providing a relatively cheap and accessible way to superimpose various meanings. The look was usually derived from *film noir*, as were the story lines and characterization, so there

Ant Farm (Lord, Michels, Schreier with Wienberg) *Media Burn*, 1975. Courtesy Ant Farm.

were both the implicit recollection of the Cold War period, and a ready-made style suitable for representing the self image of the downtown scene. Over this formula, filmmakers like Beth and Scot B and Eric Mitchell inscribed a relatively simplistic rhetoric of urban terrorism as a response to a fascistic system of political control. A great deal of mileage was made from unconvincing sado-masochistic imagery, with William Burroughs inevitably dragged in as a legitimizing influence. This insistent political reading, more stylish than thoughtful, was then given an art dimension by the deliberate poverty of production—the inclusion of over-exposed film, jumpy editing, poor sound quality, all signifying the honesty and truth to materials of the filmmakers.

What this work had in common was an attitude of familiarity towards popular culture, a mixture of love and contempt for the omnipresent images of capitalist consumerism. No longer grounded in experiences of a specific place, but rather in that widespread no-place of television and rock that transcends the old verities of history and nationality, this work tended to see itself as universal in a way very different from the mythically inspired transnationalism of high Modernism. At the same time, it remained locked within the extreme localism of downtown Manhattan. Most of this activity remained essentially ephemeral, true to its sources in popular culture and the art world. Yet there were some artists around who were interested in working with the same range of information, but in a more permanent way. At that time, such work kept, of necessity, a low profile. Gradually connections were made, studios visited, but it remained an essentially private affair. Matt Mullican and David Salle both had shows early on at Artists Space, while the gallery was still in SoHo. But few people saw them, and fewer cared. It was not until Helene Winer and Douglas Crimp put together the *Pictures* show at Artists Space in 1977, introducing the work of Jack Goldstein, Sherrie Levine, and Robert Longo, among others, that the tendency received proper attention. Crimp wrote a substantial catalogue essay outlining some of the reasons this work should be considered, but there was little follow-up in the art press, and no interest from commercial galleries. In fact, it was not until

Sherrie Levine, *Untitled* (After Alexander Rodchencko: 8), 1987. Black and white photograph, 20 × 16 in. Courtesy Mary Boone Gallery, New York.

Matt Mullican, *Untitled Circular Sign,* 1983. Poster paint on paper, 114 × 114 in. Courtesy
Michael Klein, Inc., New York.

David Salle, *Untitled,* 1976. Acrylic, photographs on paper, 50 × 74 in. Courtesy
Mary Boone Gallery, New York.

Richard Prince, *Untitled* (four men looking in one direction), 1978. Set of four Ektacolor prints, each 20 × 24 in. Courtesy Barbara Gladstone Gallery, New York.

Richard Prince, *Untitled* (watches), 1977–78. Ektacolor print, 20 × 24 in. Courtesy Barbara Gladstone Gallery, New York.

three years later that Brooke Alexander mounted *Illustration & Allegory,* the first commercial venture with the work, and by that time Metro Pictures was about to open and Mary Boone was ready to show Mullican and Salle.

The material formally appropriated was available to anyone who cared to use it. The fact that the material had possibly been observed or unconsciously collected by persons other than myself in effect defined its desire and threat. It was this 'prior availability' that verified my fictional transformation and helped cool down the reference to an observable reality.
Richard Prince[1]

At some point in 1977, Richard Prince started taking images from magazine advertising. Using a standard 35 millimeter camera as his only tool, he focused on what appeared to be significantly recurring motifs—watches, pens, cigarettes—and rephotographed them. The resulting pictures, freed of their usual frame of advertising copy, took on a totemic quality. Fragments of a lost discourse, they seemed as though they ought to mean a great deal but kept that meaning a mystery. The following year, Prince repeated the procedure, choosing first pictures of male, and later female models. What became articulated was a kind of comedic mime show, an elaborately stilted melodrama of pose. The flimsy rhetoric of the advertising image began to peel apart, and in the succeeding years, Prince continued to mine that collapse, using a growing repertoire of more sophisticated intrusions and manipulations.

Richard Prince has always declared an interest in the stance chosen to take the measure of the world. His own pose has been that of the detached observer, a detective seeking clues somewhere in the late-night fantasy, in a world where the repeating images of commercial breaks take on the aspect of a reality check. As he sifts through the image bank—collecting, selecting, categorizing—he provides the equivalent of a voice-over with the matter-of-fact accounting of psychological disabilities that fills his written work (much of this also appropriated from other sources). This introspective

[1] Richard Prince, "Menthol Pictures," CEPA Gallery, Buffalo, June 1980, and *REAL LIFE Magazine* #4, Summer 1980.

Clint Eastwood.

Jenny Holzer, *Messages to the Public*, 1982. Spectacolor light-board, One Times Square, Manhattan. Courtesy Public Art Fund Inc. and Barbara Gladstone Gallery, New York.

Edward Ruscha, *Untitled*, 1985. Oil on canvas, 59½ × 146 in. Courtesy Leo Castelli Gallery, New York.

interrogation of the means of representation yielded a sexualized reading surprisingly akin to that of the Surrealists. Just as they had wandered the streets of the city seeking a chance encounter with an eroticism that would redeem the banality of modern life, so Prince would let his fingers do the walking through the pages of glossy magazines, seeking the ineffable. The male gaze, which turns all it sees into fetishes of desire, is here turned on itself, evoking the claustrophobic closure of Warhol's voyeurism. Even in its somnambulist state, the Surrealist private eye is pursuing an investigation; here even that is slowed to a fictive reenactment in which what is sought is already known. Hypnotized by the illusion of its own power, this passive eye becomes increasingly introspective. An hallucinatory disengagement occurs, seeming to set the artist free of the everyday.

This delusion of freedom differs from other male fantasies of empowerment only in its passivity. Like its more active counterparts, this fantasy too is a movement towards closure, and the certainty of a final solution. And it must be said that the secret shame of the art world is its continuing, near-exclusive fascination with the expression of male desires and fears. Condoned by the modernist myth of originality, that fascination has survived intact in an era that is claimed to have outgrown the tradition of the new. The male artist's wish to create himself anew, through his own efforts, free of the prior constraints of the womb of culture, has been conceded as a masturbatory fantasy since the early 1950s, when Rauschenberg allowed his paints to come all over the bed linen. And yet this same fantasy has served to fuel the recent marketing success of the much-vaunted "new spirit in painting." The work of Prince, and to a greater extent of Salle, has been implicated in this regressive movement, and has only been able to escape inclusion by steadfastly refusing interpretation. Their work's ice-cold distance enables each to present misanthropic misogyny as a case to be studied, more or less as interesting as the other representational codes the work foregrounds.

The pervasive maleness of cultural expression persists despite the work of a growing number of women artists dedicated to breaking the stranglehold of this art world fascination. Exemplary in this regard have been Yvonne Rainer's restructuring of film narrative, exposing its standard conventions as mechanisms to lock in unthinking and unexamined sexism; Sherrie Levine's blunt appropriations of the work of emblematic male artists, denying the singularity of the discourse of originality; Jenny Holzer's anarchic listing of received ideas, contradictions piled upon each other in a delirious recital of absurd authority; and Barbara Kruger's agitprop phototexts, in which the rude laughter of the dispossessed rends the seamless fabric of a domineering ideology.

I have argued for a certain stasis in Prince's work, an hypnotic foreclosure. Sherrie Levine's early work can be understood to suggest a more active intervention in the mechanisms by which the media represent us to ourselves. For a show at The Kitchen in early 1978, she proposed making a presentation of three related images in three separate ways. Three pictures of an elegant young woman and child, in a high-resolution black and white reproduction, were taken from the pages of a glossy fashion magazine, each then cut to form the silhouette of one of the iconic presidents—Washington, Lincoln, Kennedy. In each case, a picture of a particular male fantasy, one that has resonated through art history since the Renaissance, is inscribed within an icon of male power as it is manifested in the modern state. To avoid turning these pictures into fetish objects, Levine intended to keep them ephemeral. A poster was to be made of the Washington, to be put up in the streets of SoHo, a postcard announcement of the Lincoln, and a slide presentation, in the gallery, of the Kennedy. Thus, the pervasiveness of a certain kind of representation would be emphasized, and its status as a projection, in the Freudian sense, made literal. The show went forward solely within the usual confines of the art world. The poster, which might have brought a larger segment of the public into a relation with the work, went unrealized.

It was precisely to this wider public that Jenny Holzer addressed her work of the same period, carrying out a campaign of small scale bill posting throughout lower Manhattan. Of a size that spoke of an economy that

was both necessary and right, her handbills listed, in alphabetical order, a cacophony of statements that, taken together, defied all logic. The confidence of these *Truisms,* statements of personal belief and public knowledge, is shattered in the confusion of their ridiculous contradictions. Here the various tongues that the authorities adopt are revealed as of a kind, as the reader, at first reeling from the range of oppositions presented as truth, begins to recognize that the statements clothe their meanings in rhetorical constructions. Coming across these anonymous warnings and imprecations on a broken-down wall in the East Village, or in a back alley in Tribeca, one recognizes a staginess, even a kind of hysteria. The voice of authority is made unbelievable. Holzer's reckless display of this absurd hollowness in public discourse, later effected through the use of electronic signs, T-shirts, and plaques as well as the posters, recalls the situationist strategies of Daniel Buren or Lawrence Weiner, but within a larger context than that framed by the institutions of art.

Holzer's stream of language denies the possibility of a personal voice, for the personal is seen to be constructed from the public realm. All one can do, then, is manipulate the given in such a way that the personal might emerge—a position surprisingly close to that of Richard Prince.

Taking a somewhat different approach, Barbara Kruger attacked this problem of self-representation by developing a very distinct persona through the idiosyncratic voice of her writing. Advancing at high speed, this voice pushes hyperbole to the limit, as it displays a position in relationship to the fantastic world of television and the movies. It is a voice by turns sympathetic, amused, and outraged. Its characteristics are already in place in an early piece written in 1979:

The audience is yelling and clapping, producing an unrelenting wall of sound. Lights flash. 'Johnny' is screaming the names of the contestants . . . The viewing audience focuses on the bodies of the lucky ones. The outfits, the bouncing breasts, the girth. People that shouldn't be caught dead in a pair of slacks. They

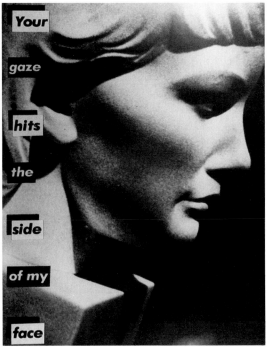

Barbara Kruger, *Untitled* (Your gaze hits the side of my face), 1981. Photograph, 55 × 41 in. Courtesy Mary Boone Gallery, New York.

assault the stage like a brigade of squirrels who haven't had an acorn for a week. And they are Smiling. They are Happy. They are Thrilled. They are on The Price is Right.
Barbara Kruger[2]

This voice, and the persona it articulates, is the generator of all Kruger's work. The descriptive aphorism—the hysterical shifting of attention from subject to object and back, the sense of detail as an index of the absurd, the referencing of present insults to a history of their return appearances in popular culture since the 1940s—these provide the structure upon which she builds everything, from her media column in *Artforum* to her large photo/texts. These last are her primary vehicle, and, like Holzer's *Truisms,* are designed so that they can function as art objects, billboards, T-shirts, even matchbook covers.

Typically, Kruger isolates and enlarges details of pictures appropriated in one way or another from mass media sources. Many of the images are rather ordinary, somewhat domestic, most are in black and white, often quite grainy. That is to say, they tend to be sentimental, filled with the nostalgic longing of most representations of male desire. Bursting across their surface in a controlled riot of typography, Kruger's voice shatters the complacency of these images which are of women, but not primarily for women. This voice sometimes seeks solidarity with the viewer, sometimes levies accusations. In either case, the viewer is confounded—just who is the ventriloquist behind these dumb pictures? The critical disruption the works perform takes place in that transaction between the piece and its audience. The work operates as a species of performance.

This recognition that the workings of representation in the cultural arena is a matter of performance can be seen as an animating factor in Cindy Sherman's work also. As early as 1977, she was dressing up, mostly in 1950s period drag, to go to work as a gallery assistant. These temporary displacements had a campy charm, but it was not until Sherman began to record them photographically, within an entire *mise en scène,* that

[2] Barbara Kruger, "Game Show," *REAL LIFE Magazine #2,* October 1979.

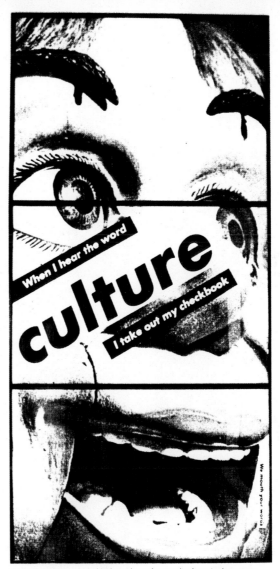

Barbara Kruger, *Untitled* (When I hear the word culture I take out my checkbook), 1985. Photograph, 138 × 60 in. Courtesy Mary Boone Gallery, New York.

David Robbins, *Talent*, 1986. Eighteen black and white photographs, 40 × 72 in. Courtesy Nature Morte Gallery, New York.

the work began to take off. The possibility of initiating a performance involving the adoption of another's identity and then stilling the game, freezing it within the frame of the camera, enabled a far more complex interaction to occur. For now the tables could be turned, the artist's dreamlike search for a self image reconfigured as a public act that is the subject of a singular gaze, the remote controlled camera standing in for the viewer. Thus, a private event is seen unfolding at the command of a stranger, the creation of a self demonstrated as a matter of convention. No wonder the later work turned nightmarish, as the perky secretaries and runaways were replaced by disfigured monsters and vomit.

Since 1978, Cindy Sherman has been engaged in a discursive examination of the public image of women as found in B-movies, soap operas, and the melodramas of fashion advertising, which is to say in the image constellation many women feel compelled to accept as oracular. Sherman, using herself as model, subjects herself to the rigors of the picturing of others in an attempt to work through to a position from which she might begin to picture herself for herself. Before the ever-vigilant eye of the camera, which unblinkingly records every hopeless mannerism, every mediated, compromised attempt at self-realization, she dresses up and acts out the roles assigned to photogenic young women. Secretaries and tramps, vamps and ingenues, the abused and abandoned, the seductive and sexy, the athletically asexual, the little girl lost, the haughty fashion queen—such are the images Sherman tries on for size. Lights and filters are manipulated to provide the requisite contextual clues: the chiaroscuro of *film noir* and its many progeny, the back lighting of the fashion shoot, the Vaselined filter of soft porn.

The success of these post-Pop appropriations lies in the complexity of the response they elicit. Staring at these works, we find them staring back at us. We recognize ourselves in the mirror of reproduction they hold before us, and we do not know if we should be flattered or offended. Like Man Ray's infernal object, they taunt us with the knowledge that our response is likely to be inadequate. Does Prince celebrate the triumph of a depol-

iticized aestheticism, or insult us for succumbing to the blandishments of the merely good-looking? Does Sherman seduce us with her pathetically pretty girls, or force us to reconsider the ways in which we view women? Does Kruger's aggressive address return a radical politics to the cultural arena, or merely provide a radical chic backdrop to business as usual? How do we resolve the puzzle of Warholian mimesis, the perfected realization of an amateur simulacrum of the hyperreal? No matter where we look, it is becoming increasingly difficult to recognize an "original" from a copy, or from a copy of a copy. Mimicry has replaced innovation as a creative value. We recycle everything. This is now a given; we understand the value of reuse. We no longer think we must discard what we have in order to gain access to that shimmering mirage, the new.

In May 1982, Alan Belcher and Peter Nagy opened a small gallery in New York's East Village. Dissatisfied with a moribund alternative system that seemed more interested in securing a stabilized grant income by presenting the familiar rather than taking risks, Belcher and Nagy were among the first artists of this period to extend the logic of artists' magazines, and open their own gallery. With a self-consciousness that seems almost parodic in retrospect, they called their gallery Nature Morte. In this deadly time of forgetting, when experience is valued less than appearances, when the real gives way to the reproduction, when "natural" refers to a flavor or a fashion look, the *double-entendre* in the idea of a *nature morte* takes on a melancholy cast. Perhaps this is not so new, for since the Renaissance reached Northern Europe, painters have used common objects of everyday life to construct elaborate morality tales. As we walk through our museums, ornate cups and simple beakers, exotic fruits and ordinary vegetables, fish, fowl, and sides of meat pile up in virtuoso displays of abundance and fecundity tinged with the ineffable sadness of death.

There were soon other signals of the emergence of a younger group of artists concerned in some way with issues similar to those that moved the group loosely associated with Metro Pictures that included Sherman.

Cindy Sherman, *Untitled*, 1985. Color photograph 72½ × 49⅜ in. Courtesy Metro Pictures, New York.

THINGS ARE PRETTY LOUSY

FOR A CALENDAR GIRL

Annette Lemieux, *Calendar Girl,* 1987. Black and white photograph, 51½ × 41½ (framed). Courtesy Josh Baer Gallery, New York.

These younger artists were drawn to the more intimate transaction that takes place at home, in front of the television. As a result, they sought to entrap meaning in the ceaseless flow of everyday products and the packaging that sells them rather than in the more spectacular events of the public realm. In this sense their work tends to engage in the rhetoric of still life, the simultaneous celebration of—and warning against—the delights of conspicuous consumption. The works tend towards intimacy, a quietude beyond the reach of public control. There is often a quality of deliberate tentativeness, even temporariness, about these works.

A show at White Columns during the last months of Josh Baer's directorship was presented by *REAL LIFE Magazine* and was intended to introduce a number of artists whose work seemed to take something of a sidelong glance at what often is ignored as peripheral information, a category that shifts with changing fashions and interests. Work by seven artists was presented, and included Jennifer Bolande's fugitive renderings, photostats of drawings of photographs, odd corners and details of important looking interiors; Ken Lum's amusing proposals for remaking minimal sculptures in contemporary home furnishings—an open cube using four sofas and end tables, a sofa partially buried in throw cushions; David Robbins' arcane meditation on the finer details of the Hammacher Schlemmer catalogue; Michael Ross' tiny fluorescent renderings of luxury homes for sale.

Cindy Sherman, *Untitled*, 1980. Color photograph, 20 × 24 in. Courtesy Metro Pictures, New York.

Characteristically, this work can be seen to operate through the strategy of the glance. The objects under examination are not analyzed or stared at. Often they are not even fully seen. They are glimpsed, caught momentarily before the channel is switched again. The subject of the work is not what is depicted, but the speed with which that image can be picked up and processed. If there is a stilled quality to the images of the life that surrounds and supports this work, there is nevertheless a transient humor flickering through the pictures, a quick laughter that is mostly bitter and despairing, but also contains real pleasure. Peter Nagy mimics the ethereal quality of the media image, that

seemingly transparent mirage that glances through the television screen, flits across the movies, fixes so lightly on the pages of the magazines, before disappearing into the depths of our unconscious. Nagy spirits up recombinant images that have a threateningly long half-life. His pictures have no substance; they are only Xerox. They are ideas barely made tangible, but with enough visibility to be subject to endless reproduction. The paradox is that Nagy convinces us of the credibility of these mongrel signs, patched together from fragments of the pre-existing, precisely because they have no body. They are not real, so we can believe in them. And when we do invest our faith in them, we find that the joke is on us.

David Robbins is involved in a prolonged investigation of a certain kind of power relation. This investigation unfolds in his writings as well as in his visual pieces and concerns the fascination media stars exert over their subjects. Robbins wants to understand that fascination and appropriate it for us all, to allow *everyman* [to become] *his own Elvis*. But he also knows that this is treacherous ground, an area in which it would be all too easy to slip into the bathos of self-aggrandizement. To prevent that possibility, Robbins deliberately disables the pretensions of the work, renders it in a certain way hopeless. For example, *The David Robbins Show,* an exhibition at Nature Morte, presented an array of self-portraits that were so variously pathetic that their irony could not be missed. Or again in *Talent,* his reprise of Man Ray's group portraits of artists, Robbins had a studio photographer of the ''stars'' make idealized head shots of eighteen of his peers, ensuring that the sheer quantity of optimistic good feeling and straight dealing packaged into the presentation would make it clear tha the work approaches the idea of artistic fame in a rather complex way. Robbins pictures celebrity rather than celebrities. In this sense, his work is about a fetishism, not of the object, but of the grid of repetitions that entraps both object and subject. As we know from reading *People* magazine or watching *Entertainment Tonight* on television, the objects of our fascination themselves are not important. They remain completely interchangeable. What is important is the mechanism of

Elvis Presley.

Advertisement tear sheet. Courtesy Thomas Lawson.

fame. Robbins' work makes clear the passion for a code that underwrites the fetishistic relationship.

Jennifer Bolande's project is to understand the way we look at photographs, and the way they look at us—that mutually exclusive gaze that transcribes our dealings with the modern world. In her earlier work, she pursued a taxonomic approach, collecting vast quantities of pictures, to be stared at, closely, in the expectation that some mysterious essence might materialize. The newer work abandons this wide-eyed stare in favor of a shifting point of view that can accommodate different kinds of details, and the shifting relationships between them. Previously, the work depended on an intense interiority. It now operates in a manner more accessible to external observation while maintaining a sense of the private in the public arena, an example being the improbably large fragment of a discarded photomural Bolande encountered on a late-night street. She repossessed it, bringing this dilapidated shard of sunset spectacular to rest in the gallery, removed from its original audience. The piece, like the rest of Bolande's work, conducts a hermetic discourse on perceptual difference and similarity, setting up contrasts of large and small, near and far, image and object, that cannot be resolved with certainty. The work holds an ambiguous position, and placing the viewer in an ambiguous position, it keeps its secrets.

This second generation of "pictures" artists can be understood to be involved with an updated version of the still life. These artists reprocess and re-present images that define our being in the world, but that have become almost invisible through overuse. These are images that have become a currency of a sort, tokens in a recurring exchange of received ideas. The point of this work, however, is not simply to picture these tokens, but to investigate the endless movement between them. An example of this might be Jeff Koons' decision to cast a "collectible", say a ceramic locomotive designed to contain a bottle of whiskey, in stainless steel, ensuring that the whiskey is properly replaced and resealed. With a certain intoxicating logic, the relatively inexpensive, and thoroughly tacky object is recast as a very modern item of cultural worth. In the process, the

Jennifer Bolande, *Nature Max,* 1987. Duratrans, 180 × 72 in. Courtesy Nature Morte Gallery, New York.

Haim Steinbach, *"exuberant relative,"* 1986. Mixed media construction,
25 × 56½ × 15 in. Courtesy Sonnabend Gallery, New York.

Jeff Koons, *Caboose,* 1986. Cast stainless steel Jim Beam bourbon decanter, 8 × 11 × 5½ in. Courtesy Sonnabend Gallery,
New York.

spirit of the original, mere alchohol, is alchemically transformed into the Spirit of Art. Such work, with its emphasis on mechanical processes, foregrounds its concerns with repetition and reduplication. Like all those involved with still life, artists like Koons are concerned with the workings of fetishism—not a fetishism of things, but rather one of signs. They would investigate what Baudrillard has called "a passion for the code which controls objects and subjects, subordinates both to itself, [and] delivers them up to abstract manipulation."[3]

All products have a limited shelf life. During that span they must be seen at their best and must be properly displayed or they will not achieve their purpose, which is to be consumed. If the packaging is wrong, or the display inadequate, the shelflife quickly reduces to zero. The product vanishes into a nether world of failed dreams and crushed hopes, of *DeLoreans* and *Tickles* and platform shoes. Haim Steinbach is a connoisseur of the deficient, of the product that tries too hard to overcome its predetermined limitations. And with the love of the connoisseur, he has no wish to photograph his trophies, or to paint, or otherwise re-create them. He simply wants to represent them, give them another chance. So he builds them special shelves, sympathetic shelves, on which their life can be prolonged infinitely through the healing graces of taste and composition.

The trajectory of the argument presented by this progression of artists has been a pessimistic one. Despite the undoubted vigor of the work, it can make no transformative claims. The larger culture remains unmoved. This, no doubt, reflects the feelings of impotence engendered in the opposition during the triumphant militarism of the Reagan years. Even Kruger's loud mouthed dissent has displayed a characteristic caution—her targets remain broad enough to attract a broad range of support. But now, with Reagan's spell broken, his charisma cracked, it is time to take on the fanaticism of the far right in a more direct way. It is time to break the hypnotic fascination of that unblinking stare with its death rattle beat, time to abandon the attempt to defeat it at its own game. It is time to name

[3]Jean Baudrillard. *For a Critique of the Political Economy of the Sign.* St Louis: Telos Press, 1981.

Mark Dion, anti-intervention poster installation detail from *This Is a Job for the Federal Emergency Management Agency/Superman at 50*, 1988. Courtesy the artist.

Jessica Diamond, *Jimmy Swaggart*, 1986. Ink and rice paper, 24 × 38½ in. Courtesy the artist.

names, point fingers, time to make accusations.

Jessica Diamond has been doing this for some years now, remarking, in her brittle *haikus,* on the hopeless optimism and bad faith that ooze from the reassuring voices and faces on television. Diamond is passionately disturbed by the Pop foolishness of the men and women who offer public commentaries on our lives—the self-satisfied newscasters and smarmy talk show hosts, as well as the more "creative" types like pretentious rock stars and neo-expressionist painters. But she knows the only way for an artist in her position to deal with that anger is with a distanced wit, a put-down so eerie as to seem almost disembodied. Indeed, her carefully worked collage drawings have that lightness of touch characteristic of the best jokes, a flash of wit that stings with an unexpected sharpness.

Diamond's process is one of distillation, reducing the babble of the airwaves to the succinct phrase that underscores a particular kind of threat or absurdity—*Buy a Condo or Die, Buy a House with 200 Credit Cards.* She homes in on the mantras and magic lists of pop culture's many-faceted religion, taking particular delight in the weird imprecations that do not quite add up. The fastidiously detailed moral-code-as-dress-code of the showman preacher—Jimmy Swaggart's pronouncement that "Shorts are Wrong"—is as likely to catch her eye as a newscaster's callow follow-up, briskly moving along from disaster to some good news for sports fans. It is a clarity of observation that makes the work sing: two bimboys of the neo-expressionist vogue, Lupertz and Immendorf, caught with their shirts off, jewelry on, are identified as the "lollipop guild;" five television detectives with loaded names are "five dicks;" a small, delicately drawn map of the world, asks the question, "Is that all there is?" The sharpness is undeniable, but if that were all there were, the sting would soon fade. What gives this very ephemeral work its weight, what gives it its pathos, is an undercurrent of sorrow, a recognition of sympathy.

As part of a 1986 exhibition at Artists Space that was designed as a politicized reconsideration of fairy tales,

Mark Dion built an hallucinatory shrine to the Smurf, one of the first products to be conceived as simultaneously toy and television cartoon show. Everything in a stage set of a child's bedroom—wallpaper, sheets, dishware, toys, and games—was a Smurf, or was covered with them. Against one wall of this giddy nightmare of commodity fetishism, a television played tapes of the Smurf show, only the soundtrack had been replaced with a discussion of the Smurf phenomenon in terms of the economics of its distribution and the ideological function of the show as a carrier of entrenched ideas of power, sexuality, and morality. This discussion was conducted in the squeaky voices typical of Smurf characters. In this and similar pieces, Dion develops his case through a strategic repositioning of the formal tropes of radical art, from Judd and Buren to Haacke and Atkinson, using these tropes as presentational devices. A thoroughly researched critique of a given subject, be it Coca-Cola or Superman, is delivered with a kind of disarray and humour that can also be understood to carry a sly rebuke to the often contentless radicalism of left-wing posturing in the art world.

The story so far has been about a series of oppositions, of stances taken and refuted, and taken again. The movement of the debate has apparently swung back and forth across the disputed terrain, that realm of fascination watched over by the glaring eye of the mass media, particularly as manifested in television. But another possibility has emerged in the recounting, one that suggests the possibility of an advance after all. That possibility is the discovery of talk as an antidote to the unremitting tyranny of the all-seeing. Most of the work discussed here, born of a concern with the means of representation, has been formed in some relation to language. The paradox, that a linguistic excess is the motor generating much of so-called "pictures" art, is a delight to consider. It may not be so completely unexpected, since the history of Surrealism is the history of a similar understanding. Perhaps it was only the gurus of high Modernism who sought a purifying beauty in the silence of painting. The rest of us have always known that every picture tells a story. Haven't we?

Afterword

The Clocktower has always enjoyed an unusual place in New York's art community. Perhaps, this is because it is such a peculiar place. Located on the unlisted, thirteenth floor of a large building, otherwise occupied by courts and municipal offices, the gallery itself is approached by a once-grand staircase leading to a long corridor and the gallery entrance. The visitor enters a large, relatively unornamented exhibition space. Above, a second, smaller gallery is reached by another staircase. This space is distinguished by its considerable height, exposed structural elements, and a spiral staircase that in turn ascends to a small chamber. More stairs lead to the works of a massive, functioning clock, which gives rise to the gallery's name. This structural apparition, planned by the architect Stanford White and realized after his death, is surrounded by terraces that offer spectacular views of Manhattan.

I did not discover the Clocktower accidentally; I was looking for it. In fact, I had been searching relentlessly for several years for a tower in the sky, a contemplative space to present art, a place where a viewer could be alone with paintings and sculpture, a place where nothing was for sale, a place where angels would not fear to tread. The first exhibitions, of Joel Shapiro, Richard Tuttle, James Bishop, and others were planned with all the idealism of the early 1970s. Popularity was not an issue.

With typical New York perversity, later exploited by successful nightclubs, which make attendance difficult if not impossible, the Clocktower became a raging success. Crowds mounted the old stairs and packed its openings. As its legend grew, more and more artists fell in love with its odd architectural realities, its history, and its curious ambience. By 1986, The Clocktower had succumbed to comfortable middle-age.

So, fifteen years after its founding, The Institute's curatorial and administrative team decided on a radically different direction for The Clocktower. We set out to experiment by stirring up commonplace factors of exhibition planning. We began by looking at the September-to-June calendar as a single time unit. We probed the relationship of catalogue to exhibition as a document of an exhibition, and that of a book that draws from, and elaborates on, a given theme. We came to see the production of these exhibitions and this publication as related but separate goals and worked to avoid the temptation of using the exhibition, and thus the art, to illustrate a book.

Our goal was to construct an ongoing conversation between the gallery and the publication. We dedicated an entire year to the exhibition and publication formats, in a discourse with past and present movements. We dealt with the logistics of scholarly reconstruction and with those problems related to the realization of installation pieces. In practical terms, we undertook four related exhibitions, each exploring a different aspect of the relationship between popular culture and the making of art. We intended to unify this information in a book produced at the conclusion of the project, accepting that the production of these exhibitions would initiate additional dialogue and commentary to be included in the final publication. And so it has.

Modern Dreams: The Rise and Fall and Rise of Pop, is linked to a group of four exhibitions that are its source. These exhibitions, collectively designated as "The Pop

Project," are connected thematically in an investigation of the relationship of art to popular culture from 1956 to the present. They were prepated for The Clocktower Gallery, the lower Manhattan exhibition center of The Institute for Contemporary Art, parent organization of P.S. 1 Museum and The Clocktower Gallery.

By inviting so many participants, and by rejecting the notion of a single curatorial line, we faced, perhaps, inevitable problems. It became clear that while we were assembling an anthology of ideas with different vocabularies, certain goals were shared. The organizational structure of *Modern Dreams,* the book, and of "The Pop Project" exhibitions, reflects the ambiguities inherent in a contemporary review of Pop Art and popular culture. But a core integrity lies at the heart of this disparity and community of ideas that is critical and rich with questions that call for understanding, change, and commitment. In a time often characterized by cynicism as a product of criticality, it is gratifying to identify a common concern for the ideas and problems that face today's art practitioners, curators, administrators, and the ultimate audience, the student of art and the art public.

Alanna Heiss
President and Executive Director
The Institute for Contemporary Art , Inc.

Acknowledgements

This publication and the four corresponding exhibitions would not have been possible without the support, assistance, and cooperation of many individuals. Major funding has been provided by The National Endowment for the Arts, Jay C· iat, and the Board of Directors of The Institute. Additional support has been provided by the New York State Council on the Arts, and the David Bermant Foundation: Color, Light, Motion.

We are grateful to the artists who have participated in this project for their graciousness, professionalism, and openness. We are also thankful to the exhibition curators for their dedication and accomplishment: Brian Wallis, Tom Finkelpearl, Patricia Phillips, Glenn Weiss, and Thomas Lawson.

We wish to thank the members of the Independent Group and their families who have kindly provided loans, reminiscences, and other timely assistance: Lawrence Alloway, Theo Crosby, Richard Hamilton, Magda Cordell McHale, Eduardo Paolozzi, Colin St. John Wilson, Alison and Peter Smithson, and Reyner Banham. For their help in securing research information and loans of artworks to *This Is Today Tomorrow,* we are indebted to: Clive Phillpot and Jeanne Collins of The Museum of Modern Art; Meg Sweet of the Victoria and Albert Museum; Sandy Nairne of the British Arts Council; Joanna Dunnett, James Lingford, and Iwona Blazwick of The Institute of Contemporary Arts, London; Dr. Gotz Adriani of the Kunsthalle Tubingen; Jon Bird, Barry Curtis, and Lisa Tickner of *Block* magazine; Graham Whitham and Marleen Marta. Lenders include Staatsgalerie Stuttgart; Museum Ludwig, Cologne; Kunsthalle Tubingen; The Museum of Modern Art; The Institue of Contemporary Arts, London.

For their contributions to the publication of the first section of the book, we are grateful to Judith Barry, Ursula Biemann, and Maud Lavin. We are especially grateful to Karen Marta in her role as project editor for that section.

For their participation in the conversation included here, we are pleased to acknowledge the valuable contributions of Leo Castelli, John Coplans, Betsey Johnson, Claes Oldenburg, and Roy Lichtenstein. Hank Stahler provided high quality recordings for transcription.

Dennis Adams' installation was fabricated on site by Chris Wynter and Ed Smith, and we thank them for their assistance. We are also thankful to Heidi Schlatter who built the prototype for Krzysztof Wodiczko's ''Homeless Vehicle;'' to Craig Baumhofer who consulted on the design; Rirkit Tirevanija who built the model; François Alacoque, technical assistant; and Jay Johnson, technical consultant. Thanks also to Kyong Park, whose conversations were important to the project; to Leslie Sharpe, who transcribed tapes for the Wodiczko brochure; and Jagoda Przyblak, who provided additional site photography. The ''Homeless Vehicle'' project is dedicated to Oscar and Alvin, who were interviewed for the accompanying audio tape.

A number of architects and architectural firms have been essential to this project as well. For their assistance and cooperation we are pleased to acknowledge Haus-Rucker-Co; Venturi Rauch and Scott Brown; Peter Cook; Cedric Price; Michael Webb; Archigram; SITE Projects; Zaha Hadid, Rem Koolhaas, Coop Himmelblau, Bernard Tschumi, Dan Graham, Alexandr Brodsky and Ilya Utkin, Michael Graves, Frank Gehry, and those

additional participants whose contributions were made after the time of this writing.

We are especially grateful to the artists of the final exhibition: Jennifer Bolande, Jessica Diamond, Mark Dion, Richard Prince, David Robbins, Cindy Sherman, and Haim Steinbach. For the assistance of the galleries in facilitating reproductions and the loan of work, we thank Mary Boone Gallery, Hal Bromm Gallery, Leo Castelli Gallery, Barbara Gladstone Gallery, Jay Gorney Modern Art, Metro Pictures, Nature Morte, Max Protetch Gallery, and Sonnabend Gallery. For research assistance we are indebted to Melanie Neilson and Jane Darcovich. John Ring effectively recorded the telephone interview conducted with Glenn Weiss. We also thank Rebecca Quaytman and Karen Ott.

This publication would not have been possible without the efforts of Carole Kismaric, Publications Director of The Institute for Art and Urban Resources; Lawrence Wolfson, designer; and Edward Leffingwell for his editorial direction. We are also grateful to Tom Finkelpearl, the Coordinator for the Clocktower, for his direction of the project.

Alanna Heiss

Bibliography

176
177

Pages 9–85

Albright-Knox Art Gallery, Buffalo. *The Expendable Ikon: Works by John McHale*. May 12–July 8, 1984. Catalogue, introduction by Charlotta Kotik and essay by John McHale.

Alloway, Lawrence. "Review of Max Ernst Exhibition." *Art News and Review* 4, no. 24 (December 27, 1952).

_____ . *Nine Abstract Artists*. London: A. Tiranti, 1954.

_____ . "Re Vision." *Art News and Review* 6, no. 26 (January 22, 1955): 5.

_____ . "L'intervention du spectateur." *Aujourd'hui*, no. 5 (November 1955): 24–26.

_____ . "Introduction to Action." *Architectural Design* 26, no. 1 (January 1956).

_____ . "Eduardo Paolozzi." *Architectural Design* 26, no. 4 (April 1956).

_____ . "The Robot and the Arts." *Art News and Review* 8, no. 16 (September 1, 1956). 1, 6.

_____ . "Design as a Human Activity." *Architectural Design* 26, no. 9 (September 1956).

_____ . "Technology and Sex in Science Fiction: A Note on Cover Art." *Ark*, no. 17 (Summer 1956): 19–23.

_____ . "Personal Statement." *Ark*, no. 19 (March 1957): 28–29.

_____ . "Communications Comedy and the Small World." *Ark*, no. 20 (Autumn 1957): 41–43.

_____ . "The Arts and the Mass Media." *Architectural Design* 28, no. 2 (February 1958).

_____ . "Notes on Abstract Art and the Mass Media." *Art News and Review* (February 27–March 12, 1960): 3–12.

_____ . "Paolozzi and the Comedy of Waste." *Cimaise,* no. 50 (October-November-December 1960): 114–123.

_____ . "Artists as Consumers." *Image* (Cambridge), no. 3 (1961): 14–19.

_____ . "Junk Culture." *Architectural Design* 31, no. 3 (March 1961).

_____ . "Pop Art Since 1949." *The Listener* 68, no. 1761 (December 27, 1962): 1085–1087.

_____ . "Artists as Consumers." *Image* (London), no. 27 (December 1962): 1085–1087.

_____ . "Metal Men." *Motif*, no. 11 (Winter 1963–1964).

_____ . "Pop Art: The Words." *Auction* 1, no. 5 (February 1968): 7–9.

_____ . "Popular Culture and Pop Art." *Studio International* 178, no. 913 (July-August 1969): 17–20.

Arts Council of Great Britain, London. *Fathers of Pop (The Independent Group)*. A film by Reyner Banham and Julian Cooper, 1979. Color, 40 min.

Astragal [pseud.] ["Discussion at Institute of Contemporary Arts, London, on Giedion's *Walter Gropius,"*] *The Architects' Journal* 121, no. 3126 (January 27, 1955).

Banham, Reyner. "Object Lesson." *Architectural Review* 115, no. 690 (June 1954): 403–406.

_____ . "Vision in Motion." *Art* (London) (January 5, 1955): 3.

_____ . "Machine Aesthetic." *Architectural Review* 117, no. 701 (May 1955): 295–301.

_____ . "Industrial Design and Popular Culture." *Civiltá delle Macchine*, no. 6 (November 1955): 61–65.

_____ . "Things to Come." *Design*, no. 90 (June 1956): 24–28.

_____ . "Futurism and Modern Architecture." *RIBA Journal* 64, no. 4 (February 1957).

_____ . "Space, Fiction and Architecture." *The Architects' Journal* 127, no. 3294 (April 17, 1958): 557, 559.

_____ . "Futurist Manifesto." *Architectural Review* 126, no. 751 (August 1959): 77–80.

_____ . "Machine Aesthetic: Industrial Design and Popular Art." *Industrial Design*, no. 7 (March 1960): 45–47, 61–65.

_____ . *Theory and Design in the First Machine Age*. London: The Architectural Press, 1960.

_____ . "Apropos the Smithsons." *New Statesman* 62, no. 1591 (September 8, 1961): 317, 318.

_____ . "Who is this Pop?" *Motif,* no. 10 (Winter 1962–1963): 3–13.

_____ . "The Atavism of the Short Distance Mini-cyclist." *Living Arts,* no. 3 (April 1964): 91, 97.

_____ . *The New Brutalism: Ethic or Aesthetic?* London: The Architectural Press, 1966.

_____ . "Representations in Protest." *New Society* (May 8, 1969): 717–718.

Banham, Mary and Bevis Hillier, eds. *A Tonic to the Nation.* London: Thames and Hudson, 1977.

Bayley, Stephen. *In Good Shape.* London: Design Council, 1979.

BBC. "Artists as Consumers: The Splendid Bargain." In the series *Art-Anti-Art.* Broadcast, March 1960. Produced by Leslie Cohn.

_____ . "Richard Hamilton: Interviewed by Andrew Forge." On the program *New Comment.* Broadcast, April 5, 1965.

Blake, John. "Space for Decoration." *Design,* no. 77 (May 1955): 9–23.

Cambridge Union, Cambridge. *Class of '59.* Exhibition February 7–19, 1959.

Chambers, Iain. *Popular Culture: The Metropolitan Experience.* New York: Methuen & Co., 1986.

Colquhoun, Alan. "Symbolic and Literal Aspects of Technology." *Architectural Design* 32, no. 11 (November 1962).

Condesse, Gerard. "The Impact of American Science Fiction." In *Europe in Superculture: American Popular Culture and Europe,* edited by C.W.E. Bigsby and Paul Elex, 1975.

Cordell, Frank. "Gold Pan Alley: A Survey of the Popular Song Field." *Ark.* no. 19 (March 1957): 20–23.

Crosby, Theo. "International Union of Architects Congress Building, South Bank, London." *Architectural Design* 31, no. 11 (November 1961): 484–509.

Finch, Christopher. *Image as Language: Aspects of British Art 1950–1968.* London: Penguin, 1969.

Forward to Back-To-Back Housing. A Preview of the Smithsons' Ideal Home." *The Architects' Journal* 123, no. 3183 (March 1, 1956).

Freeman, Robert, "Living with the 60s." *Cambridge Opinion* no. 17 (1959): 7–8.

Giedion, Sigfried. *Space, Time and Architecture. (1941). London: Phaidon, 1980.*

Graves Art Gallery. Sheffield. *The Forgotten Fifties.* March 31–May 13, 1984.

Hall, Stuart and Paddy Whannel. *The Popular Arts.* London: Hutchinson, 1964.

Hamilton, Richard. "Homage a Chrysler Corp." *Architectural Design* 28, no. 3 (March 1958): 120–121.

_____ . "For the Finest Art Try-POP." *Gazette,* no. 1 (1961).

_____ . "An Exposition of $he." *Architectural Design* 32, no. 10 (October 1962): 485–486.

_____ . *Collected Words.* London: Thames and Hudson, 1983.

Hanover Gallery, London. *Richard Hamilton: Paintings 1951–1955,* January 1955.

_____ . *Magda Cordell,* January 1956, Catalogue, essay by Lawrence Alloway.

_____ . *Richard Hamilton: Paintings,* October 1964. Catalogue.

Hebdige, Dick. *Subculture: The Meaning of Style.* London: Methuen, 1979.

_____ . "Towards a Cartography of Taste, 1935–1962." *Block,* no. 4 (1981): 35–56.

_____ . "Object as Image: The Halian Scooter Cycle." *Block,* no. 5 (1981): 44–46.

Henderson, Nigel, "Memories of London." *Uppercase,* no. 3 (1961).

Hoggart, Richard. *The Uses of Literacy.* London: Chatto & Windus, 1957.

Institute of Contemporary Arts, London. *Growth and Form,* July 4–August 31, 1951. Catalogue, with a foreword by Herbert Read. Exhibition organized and designed by Richard Hamilton.

_____ . *Tomorrow's Furniture,* June 5–29, 1952. Brochure, with essay by Toni del Renzio. Exhibition organized and designed by Toni del Renzio.

_____ . *Max Ernst,* December 10, 1952–January 24, 1953. Brochure, designed by Richard Hamilton.

_____ . *Opposing Forces,* January 28–February 28, 1953. Brochure, with statement by Michel Tapies, designed by Toni del Renzio. Exhibition organized by Michel Tapies and Peter Watson, designed by Peter Watson and Toni del Renzio.

_____ . *Wonder & Horror of the Human Head: An Anthology,* March 6–April 19, 1953. Catalogue, with statements by Herbert Read and Roland Penrose. Exhibition organized by Roland Penrose and Lee Miller, designed by Richard Hamilton and Terry Hamilton.

_____ . *Parallel of Life and Art,* September 11–October 18, 1953. Catalogue. Exhibition organized and designed by Nigel Henderson, Eduardo Paolozzi, Alison Smithson and Peter Smithson.

_____ . *Victor Pasmore: Paintings and Constructions, 1944–54,* March 31–May 15, 1954. Catalogue, with essay by Lawrence Alloway.

_____. *Collages and Objects,* October 12–November 20, 1954. Catalogue, with checklist. Exhibition organized by Lawrence Alloway, designed by John McHale.

_____. *Man, Machine and Motion,* July 6–30, 1955. (Previously shown at the Hatton Gallery, King's College, Newcastle, May 1955.) Catalogue, with text by Reyner Banham, designed by Andrew Froshaug. Exhibition organized and designed by Richard Hamilton.

_____. *John McHale Collages,* November 27–December 15, 1954. Brochure, with essay by Lawrence Alloway.

_____. *Statements: A Review of British Abstract Art in 1956,* January 16–February 16, 1956.

_____. *an Exhibit,* August 13–24, 1957. (Previously shown at the Hatton Gallery, King's College, Newcastle, July 1957). Brochure, with an essay by Lawrence Alloway, designed by Victor Pasmore and Richard Hamilton. Exhibition organized and designed by Alloway, Pasmore, and Hamilton.

_____. *William Turnbull: New Sculptures and Paintings,* August–September 1957. Brochure, with essay by Lawrence Alloway.

_____. *Three Collagists,* November 1958. Brochure, with statements by the artist (Gwyther Irwin, John McHale, and E.L.T. Mesens).

Jencks, Charles. "Pop-Non Pop." *Architectural Association Quarterly* 1, no. 1 (January 1969).

Jones, Barbara. *The Unsophisticated Arts.* London: The Architectural Press, 1951.

Karpinski, Peter. "The Independent Group, 1952–1955, and the Relationship of the Independent Group's Discussions to the Work of Hamilton, Paolozzi and Turnbull 1952–1957." Unpublished BA Dissertation, Leeds University.

Kennedy, R.C. "Richard Hamilton Visited." *Art and Artists* 4 (March 1970): 20–23.

Kirpatrick, Diane. *Eduardo Paolozzi.* London: Studio Vista, 1970.

Konnertz, Winifred. *Eduardo Paolozzi.* Cologne: DuMont, 1984.

Kunstverein Hamburg. *Pop Art in England: Beginnings of a New Figuration, 1947–1963,* February 7–March 21, 1976. Catalogue, with essays by Uwe M. Schneede and Frank Whitford.

Laing Gallery, Newcastle-upon-Tyne. *Eduardo Paolozzi: Sculpture, Drawing, Collages and Graphics,* April 17–May 16, 1976.

Le Corbusier. *The City of Tomorrow* (1921). London: The Architectural Press, 1971.

Lewis, Adrian. "British Avant-Garde Painting 1945–1956." Part I: *Artscribe,* no. 34 (June 1982): 17–31. Part 2: *Artscribe,* no. 35 (July 1982): 16–31. Part 3: *Artscribe,* no. 36 (August 1982): 14–27.

Lippard, Lucy, ed. *Pop Art* (1966). London: Thames & Hudson, 1976.

Massey, Anne. "Cold War Culture and the ICA." *Art and Artists,* no. 213 (June 1984): 15–17. "The Independent Group as Design Theorists," in *From Spitfire to Microchip* London: Design Council: 1985.

_____. "The Independent Group: Towards a Redefinition." *Burlington Magazine* 129, no. 1009 (April 1987): 232–242.

Massey, Anne and Penny Sparke. "The Myth of the Independent Group." *Block,* no. 10 (1985): 48–56.

McHale, John. "Technology and the Home." *Ark,* no. 19 (March 1957): 25–27.

_____. "Marginalia." *Architectural Review* 121, no. 724 (May 1957): 291–292, 330–332.

_____. "The Expendable Ikon." *Architectural Design* 29, no. 2 (February 1959): 82–83.

_____. "The Expendable Ikon 2." *Architectural Design* 29, no. 3 (March 1959): 116–117.

_____. "The Fine Arts in the Mass Media." *Cambridge Opinion,* no. 17 (1959): 29–32.

_____. "Universal Requirements. Check List—Buckminster Fuller." *Architectural Design* 30, no. 3 (March 1960).

_____. "The Plastic Parthenon." *Dotzero* (Spring 1967).

McHale, John and Magda Cordell. "Magda." *Uppercase,* no. 1 (1958). Edited by Theo Crosby.

McHale, John and Alvin Toffler. "The Future and the Functions of Art. A Conversation Between Alvin Toffler and John McHale." *Art News* 72, no. 2 (February 1973): 24–28.

McLuhan, Marshall, *The Mechanical Bride* (1951). London: Routledge & Kegan Paul, 1967.

Melville, Robert. "Eduardo Paolozzi." *Motif,* no. 2 (February 1959): 61–69.

_____. "Paolozzi as Writer and Craftless Sculptor." *Arts* 33 (February 1959).

_____. "English Pop Art." *Quadrum,* no. 17 (1964): 23–38.

Moholy-Nagy, Laszlo, *The New Vision,* London: Faber and Faber, 1939.

Myers, Bernhard S. and Gordon Moore. "Americana." *Ark,* no. 19 (March 1957): 16–19.

New Arts Laboratory Gallery, London. *Crashed Cars.* April 4–18, 1970.

178
179

Newby, Frank. "The Work of Charles Eames." *Architectural Design* 24, no. 2 (February 1954).

O'Hanna Gallery, London. *Dimensions: British Abstract Art 1948–1957* (1957).

Open University, London. "The Independent Group: The Impact of the American Pop Culture in the Fifties." A talk by Richard Hamilton. Broadcast by BBC Radio.

Ozenfant, Amédée. *Foundations of Modern Art.* New York: Dover Publications, 1952.

Paolozzi, Eduardo. "Notes from a Lecture at the Institute of Contemporary Arts, 1958." *Uppercase,* no. 1 (1958): 1–32.

Procktor, Patrick. "Techniculture." *The New Statesman,* no. 1756 (November 6, 1964): 710.

Reichardt, Jasia. "Pop Art & After." *Art International* 7, no. 2 (February 25, 1963): 42–47.

_____ . "Eduardo Paolozzi." *Studio International* 186, no. 858 (October 1964): 152–157.

_____ . "An Interview with Lawrence Alloway." *Studio International* 186, no. 958 (September 1973).

Renzio, Toni del. "Is There a British Art?" *Arts News and Review* 5, no. 16 (April 18, 1953): 2.

_____ . "Portrait of the Artist No. 120." *Art News and Review* 5, no. 16 (September 5, 1953): 1, 7.

_____ . "Art After Fashion." *ICA Publication,* no. 2 (1958).

_____ . "Shoes, hair and coffee." *Ark,* no. 2 (Autumn 1960): 26–30.

_____ . "Style, Technique and Iconography." *Art and Artists* 11, no. 4 (July 1976): 35–39.

_____ . "Pop Art and Artists." *Art and Artists* 11, no. 5 (August 1976): 14–19.

_____ . "Ideology and the Production of Meaning." *Block,* no. 3 (1980): 52–56.

_____ . "Instant Critic: Peter Fuller in 1980." *Block,* no. 4 (1981): 57–60.

Roditi, Edward, "Interview with Eduardo Paolozzi," *Arts* 78, no. 1 (May 1959).

_____ . In *Dialogues on Art.* Santa Barbara, California: Ross-Erikson, 1980. pp. 157–168.

Royal Scottish Academy, Edinburgh. *Eduardo Paolozzi: Recurring Themes* 1984.

Russell, John and Suzi Gablik, eds. *Pop Art Redefined.* London: Thames & Hudson, 1969.

Schneede, Uwe M. *Eduardo Paolozzi,* New York: Harry N. Abrams, 1970.

Smith, Richard. "The City: On The Sunny Side of the Street." *Ark,* no. 18 (November 1956): 54.

_____ . "Sitting in the Middle of Today." *Ark,* no. 19 (March 1957): 13–15.

_____ . "Man and He-Man." *Ark,* no. 20 (Autumn 1957): 12–16.

Smithson, Alison and Peter. "New Brutalism." *Architectural Design* 25, no. 1 (January 1955).

_____ . "The Built World: Urban Reidentification." *Architectural Design* 25, no. 6 (June 1955).

_____ . "New Brutalism: Discussion and Statement." *Architectural Design* 27, no. 4 (April 1957).

_____ . "Cluster City: A New Shape for the Community." *Architectural Review* 122, no. 730 (November 1957).

_____ . "Not with a Bang but with a Flicker: The End of Machine Aesthetics." *The Architects' Journal* (May 28, 1959).

_____ . "The Idea of Architecture in the Fifties." *The Architects' Journal* (January 21, 1960).

_____ . "The Appliance House." *Design,* no. 113 (May 1958).

_____ . *The Shift.* London: Academy Editions, 1982.

The Solomon R. Guggenheim Museum, New York: *Richard Hamilton,* September, 1973. Catalogue, with introduction by John Russell and commentary by Richard Hamilton.

The Tate Gallery, London. *Richard Hamilton,* March 12–April 19, 1970. Traveled to Stedelijk van Abbemuseum, Eindhoven, May 15–June 28, 1970, and Kunsthalle, Bern, July 25–August 30, 1970. Catalogue with essay by Richard Morphet.

_____ . *Eduardo Paolozzi,* September 22–October 31, 1971. Catalogue with essay by Frank Whiford.

_____ . *William Turnbull: Sculpture and Painting,* August 15–October 7, 1973. Catalogue with introduction by Richard Morphet.

Turnbull, William. "Images without Temples." *Living Arts,* no. 1 (1963): 15–27.

Walker, John. *Art Since Pop.* Woodbury, N.Y.: Barrons, 1978.

_____ . *Art in the Age of Mass Media.* London: Pluto Press, 1983.

Whitechapel Art Gallery, London. *This Is Tomorrow,* August 8–September 12, 1956. Catalogue with essays by Lawrence Alloway, David Lewis, and Reyner Banham. Catalogue designed by Edward Wright.

Whiteley, Nigel. *Pop Design: Modernism to Mod.* London: Design Council, 1987.

Whitford, Frank. "Speculative Illustrations: Eduardo Paolozzi in conversation with J.G. Ballard and Frank Whitford." *Studio International* 182, no. 937 (October 1971): 136–143.

Williams, Raymond. "Britain in the 1960s." In *The Long Revolution*. London: Chatto & Windus, 1961.

Whitham, Graham. "The Independent Group at the Institute of Contemporary Arts: Its Origins, Development and Influences 1951–1961." Unpub. PhD. diss., University of Kent at Canterbury, 1986.

York Art Gallery, London., *Just What Is It? Pop in England 1947–1963,* Arts Council May 29–July 4, 1976.

Pages 111–117

Adams, Dennis. *Behind Social Studies*. New York: self-published. 1977 (illus.).

_____ . "Questionnaire." *Zone,* vol. I–II (1986): 423, 455.

Alloway, Lawrence. *American Pop Art*. Exhibition catalogue. New York: Collier Books and Whitney Museum of American Art, 1974.

_____ . "Pop Art: The Words" (1962). *Topics in American Art Since 1945*. New York: W.W. Norton, 1975.

_____ . "Popular Culture and Pop Art." *Studio International* (July/August 1969): 17–21.

Biennale di Venezia. "Public Projections." Introduction by Diane Nemiroff. Ottawa: National Gallery of Canada, 1986.

Brown, Ellen. "Finding the Common Denominator. *The Cincinnati Enquirer* (May 3, 1975): 22 (illus.).

Canaday, John. "Pop Art Sells On and On—Why?" *The New York Times Magazine* (May 31, 1964): 7, 48, 52–53.

Crimp, Douglas, Deutsche, Rosalyn, and Lajer-Burcharth, Ewa. "A Conversation with Krzysztof Wodiczko." Deutsche, Rosalyn. "Krzysztof Wodiczko's Homeless Projection and the Site of Urban 'Revitalization.' " *October*, vol. 38 (Fall 1986).

Decter, Joshua. "Review." *Arts Magazine* (December 1986): 35.

Gablik, Suzi. "Protagonists of Pop." *Studio International* (July/August 1969): 9–16.

Geldzahler, Henry, and Moffet, Kennworth. "Pop Art: Two Views." *Art News* (May 1974): 30–32.

Glueck, Grace. "Art People." *The New York Times* (November 24, 1978): C-21.

Heartney, Eleanor. "Studio/Dennis Adams." *Art News* (October 1986).

_____ . "Sighted in Münster." *Art in America* (September 1987): 141–143, 201 (illus.).

Hume, Christopher. "Projecting Visions of Ambiguity." *The Toronto Star* (March 1985).

Hess, Thomas B. "Editorial: Pop and Public." *Art News* (November 1963): 23, 59–60.

Indiana, Gary. "Dennis Adams at Nature Morte." *Art in America* (January 1987): 133–134 (illus.).

Karp, Ivan. "Anti-Sensibility Painting." *Artforum,* vol. 2., no. 3 (1963): 26–27.

Kozloff, Max. "Dissimulated Pop." *The Nation* (November 1964): 417–419.

_____ . "Through the Narrative Portal." *Artforum* (April 1986): 86–97 (illus.).

Kuspit, Donald. "Pop Art: A Reactionary Realism." *Art Journal* (Fall 1976): 31–38.

_____ . "The Critic's Way: Review of Bus Shelter IV, Münster." *Artforum* (September 1987): 109–120 (illus.).

Lajer-Burcharth, Ewa. "Understanding Wodiczko." *Counter-Monuments*. List Visual Arts Center. Cambridge, Mass.: M.I.T. Press, 1987.

Lippard, Lucy. *Pop Art*. New York: Praeger Publishers, 1966.

Lucie-Smith, Edward. "Pop Art." Edited by Nikos Stagos. *Concepts of Modern Art*. New York: Harper & Row, 1981.

Lurie, David. "Review." *Arts Magazine* (March 1986).

Marzorati, Gerald. "Hearst Heist." *The Soho Weekly News* (November 23, 1978): 11 (illus.).

Meeks, Fleming. "Dennis Adams at Broadway and 66th Street." *Art in America* (September 1984): 207 (illus.).

Meelrod, George. "Luminous Noir/The Shades of a Scary Era." *Eue* (December 1986): 35.

"Patricia Hearst—A thru Z." Introduction by John Bowsher. Minneapolis College of Art and Design, 1979 (illus.).

Papenfuss, Mary. "On the West Side, Art that Stops Traffic." *New York Daily News* (July 7, 1983): M-3 (illus.).

Phillips, Patricia C., and Halle, Howard. "Dennis Adams/Building Against Image/1979–1987." New York: Alternative Museum, 1987 (illus.).

_____ . "Review." *Artforum* (January 1987): 116 (illus.).

Reindel, Eric. "Editorial: Spies Shouldn't Deface the City's Street." *New York Post*. (December 1, 1986): 24 (illus.).

Rosenblum, Robert. "Pop and non-Pop: An Essay in Distinction." *Canadian Art* (January 23, 1966): 50–54.

Russell, John, and Gablik, Suzi. *Pop Art Redefined*. Published in conjunction with an exhibition at the Hayward Gallery. London: Thames and Hudson, 1969.

Skulptur Projekte in Münster, 1987. Introductions by Klaus Bussman and Kaspar König. Monographs by Klaus Bussman, Edith Deker, Kaspar König, Friedrich Meschede, Susanne Weirich, and Ulrich Wilmes. Essays by Thomas Kellein, Veit Loers, Benjamin H.D. Buchloh, Hannelore Kersting, Antje von Graevenitz, Marianne Brouwer, and Gundolf Winter. Exhibition catalogue for the Westfälischen Landesmuseums für Kunst und Kulturgeschichte der Stadt Münster. Cologne: DuMont Buchverlag, 1987.

Selz, Peter. "Special Supplement: A Symposium on Pop Art." *Arts Magazine* (April 1963): 36–45.

Swenson, Gene. "What is Pop Art, Part I: Jim Dine, Robert Indiana, Roy Lichtenstein, Andy Warhol." *Art News* (November 1963): 24–27, 60–64.

_____ . "What is Pop Art, Part II: Stephen Durkee, Jasper Johns, James Rosenquist, Tom Wesselman." *Art News* (February 1964): 40–43, 62–67.

Tillman, Sidney. "Further Observations on the Pop Phenomenon. 'All Revolutions Have Their Ugly Aspects . . .' " *Artforum* (November 1965): 17–19.

Tuchman, Phyllis. "Pop! Interviews with George Segal, Andy Warhol, Roy Lichtenstein, James Rosenquist, and Robert Indiana." *Art News* (May 1974): 24–29.

Wallis, Brian. *Art After Modernism/Rethinking Representation*. New York: The New Museum of Contemporary Art, 1985.

Waggoner, Walter H. "Artist Protests City's Removing Miss Hearst Show." *The New York Times*. (November 19, 1978): A-64.

Wodiczko. Krzysztof. "West/East: The Depoliticalisation of Art." *Fuse* (March 1979): 140.

_____ . "Public Projections 1980-82." *Canadian Journal of Political and Social Theory*. Montreal: Concordia University (Winter/Spring 1983).

_____ . "Un-marking Monuments." *Section A* (February/March 1984): 2.

_____ . "Toward the Deincapacitation of the Avant-Garde." *Parallelogramme* (April/May 1984): 22–26.

Pages 119–131

Alloway, Lawrence. *Topics in American Art Since 1945*. New York: W.W. Norton & Co., Inc., 1975.

Banham, Reyner. *Design by Choice*. Edited by Penny Sparke. New York: Rizzoli International Publications, Inc., 1981.

Caotes, Nigel. *Arkalbion*. London: Architectural Association, 1984.

Cook, Peter. *Archigram*. New York: Praeger Publishers, Inc., 1973.

_____ . *Architecture: Action and Plan*. New York: Reinhold Publishing Corporation, 1967.

_____ . *Peter Cook: 21 Years–21 Ideas*. London: Architectural Association, 1985.

Haus-Rucker-Co. *Haus-Rucker Co 1967 bis 1983*. Braunschweig: Friedr. Vieweg & Sohn, 1984.

Meyrowitz, Joshua. *No Sense of Place*. New York: Oxford University Press, 1985.

Portoghesi, Paolo. *After Modern Architecture*. New York: Rizzoli International Publications, Inc., 1980.

Scott Brown, Denise. "A Worm's Eye View of Recent Architectural History." *Architectural Record* (February 1984): 69–81.

SITE: The Highrise of Homes. New York: Rizzoli International Publications, Inc., 1982.

Smithson, Alison, editor. *Team 10 Primer*. Cambridge, Mass.: The M.I.T. Press, 1968.

Venturi, Robert. *Complexity and Contradiction in Architecture*. New York: The Museum of Modern Art, 1966.

_____ , Scott Brown, Denise and Izenour, Steven. *Learning from Las Vegas* (revised edition). Cambridge, Mass.: M.I.T. Press, 1977.

von Moos, Stanislaus. *Venturi, Rauch & Scott Brown: Buildings and Projects*. New York: Rizzoli International Publications, Inc., 1987.

Wines, James. *De-architecture*. New York: Rizzoli International Publishers, Inc., 1987.

Pages 151–170

Bolande, Jennifer. "A Mood on the Rise. *Real Life Magazine* (Summer 1980).

"Brie Popcorn: An Interview with the Directors of Nature Morte." *Real Life Magazine* (Summer 1984).

Brokerage of Desire, A. Exhibition catalogue, introduction by Walter Hopps and essay by Howard Halle. Los Angeles: Otis Art Institute of Parsons School of Design Exhibition Center, 1986.

Brooks, Rosetta. "From the Night of Consumerism to the Dawn of Simulation." *Artforum* (February 1985): 76–81.

Buchloch, Benjamin H.D. "Allegorical Procedures: Appropriation and Montage in Contemporary Art." *Artforum* (September 1982): 43–56.

Cameron, Dan. *Art and Its Double: A New York Perspective*. Exhibition catalogue. Barcelona: Fundacio Caixa de Pensions, 1986.

_____. "Art and Its Double: A New York Perspective." *Flash Art* (May 1987): 58–71.

_____. "Post-Feminism." *Flash Art* (February/March 1987): 80–83.

_____. "Seven Types of Criticality." *Arts Magazine* (May 1987).

Content: A Contemporary Focus 1974–1984. Exhibition catalogue, essays by Howard N. Fox, Miranda McClintic and Phyllis Rosenzweig. Hirshhorn Museum. Washington D.C.: Smithsonian Institution Press, 1984.

Crimp, Douglas. "The Photographic Activity of Postmodernism." *October*, vol. 15 (Winter 1980).

Dion, Mark. "Tales from the Dark Side." *Real Life Magazine* (Summer 1985).

Foster, Hal. "Subversive Signs." *Art in America* (November 1982): 88–92.

Infotainment. Exhibition catalogue, essays by Thomas Lawson, David Robbins and George W.S. Trow. New York: J. Berg Press, 1985.

Liebmann, Lisa. "M.B.A. Abstraction." *Flash Art* (February/March 1987): 86–89.

" 'Meaning' of 'New', The: The '70s/80s Axis: An Interview with Diego Cortez." *Arts Magazine* (January 1983).

Melville, Stephen W. "The Time of Exposure: Allegorical Self-Portraiture in Cindy Sherman." *Arts Magazine* (January 1986): 17–21.

Morgan, Susan. "And That's the Way It is . . . The Works of Applebroog, Diamond and Wegman." *Artscribe* (June/July 1986).

Nagy, Peter, moderator. "From Criticism to Complicity." *Flash Art* (Summer 1986).

Nickas, Robert. "Shopping with Haim Steinbach." *Flash Art* (April 1987): 70–72.

Olander, William. *Holzer, Kruger, Prince*. Exhibition catalogue. Charlotte, North Carolina: Knight Gallery, Spirit Square Arts Center, 1984.

Oliva, Achille Bonito. "Neo-America." *Flash Art* (January/February 1988): 62–69.

Owens, Craig. "The Medusa Effect on the Specular Ruse." *Art in America* (January 1984): 97–105.

Portrayals. Exhibition catalogue, introduction by Charles Stainback, essay by Carol Squiers. New York: International Center of Photography/Midtown, 1987.

Prince, Richard. "Primary Transfers." *Real Life Magazine* (March 1980).

_____. Excerpts from *Why I Go to the Movies Alone*. *L.A.I.C.A. Journal* (Fall 1983).

Robbins, David. "An Interview with Richard Prince." *Aperture* 100 (1985).

_____. *The Camera Believes Everything*. Stuttgart: Editions Patricia Schwarz, 1988.

Cindy Sherman. Introduction by Peter Schjeldahl and afterword by I. Michael Danoff. New York: Pantheon Books, 1983.

Smith, Roberta. *Originality, Appropriation, and So Forth*. Exhibition catalogue, Sydney Biennale, Sydney, Australia, 1986.

Squiers, Carol. "Diversionary (Syn)Tactics/Barbara Kruger Has a Way with Words." *Art News* (February 1987): 76–85.

This Is Not a Photograph: Twenty Years of Large-Scale Photography 1966–1986. Exhibition catalogue, essays by Joseph Jacobs and Marvin Heiferman. Sarasota, Florida: The John and Mabel Ringling Museum of Art, 1987.

T.V. Guides. Edited by Barbara Kruger. New York: Kuklapolitan Press, 1985.

Wallis, Brian. *Damaged Goods: Desire and the Economy of the Object*. Exhibition catalogue. New York: The New Museum of Contemporary Art, 1986.

Photography Credits

Index

184

185

abstraction, 9, 39, 45, 89, 145

abstract expressionism, 79, 92, 94, 99, 129

Adams, Dennis, 6, 94, *110*, 11, 112, *113*, 115, *116, 117*

Adams, Robert, 35, *36*, 39

advertising, 9, 10, 12, 16, 31, 32, 41, 43, 53–55, 63, 78, 80, 81, 114, 120, 123, 130, 144, 146, 148, 149, 152, 157, 159, 163

aesthetics, 9, 10, 15, 16, 17, 31, 64, 66, 69, 84, 85, 122

Alloway, Lawrence, 12, 15, 22, 26, 31–33, 39, *40*, 45, 58, 71, 77, 80, 85, 87, 88

an Exhibit, 40, 41, 45

Ant Farm, The, *153*

anthropology, 15, 22, 24, 31, 48, 73, 80, 87, 94, 114

appropriation, 16, 83, 115, 119, 120, 153, 157, 163

Archigram, 7, *120, 121*, 123, 124, *125*, 126, 129, 130, 131

Archigram (magazine), *120, 121*, 124, *125*, 126

Architectural Design, 35

Architectural Review, 47, 48

architecture, 9, 14, 16, 39, 45, 47, 48, 49, 50, 51, 54, 55, 65, 69, 99, 100, 112, 118–131, 133–143

architecture, theoretical, 124, 131

Art and Industry, 10

art, commercial, 78, 88, 115

art, folk, 42, 53, 89

art, high (fine), 9, 10, 12, 15, 16, 27, 31, 33, 39, 45, 53, 54, 71, 77, 78, 79, 88

art history, 6, 9, 10, 41, 78, 79, 89, 99, 145, 159

arts, popular, 31, 39, 53, 54, 60, 67

automobiles, 9, 16, 17, 24, 32, 49, 57, *58*, 59, *60, 61, 62, 64*, 65, *66, 67*, 69, *79*, 80, 81, 82, 83, *127*, 131

Baldessari, John, *150*

Ballard, J.G., 71, 72, 83, 74

Banham, Reyner, 6, 10, 14, 15, 22, 24, 41, 45, 48, 51, 65–69, 72, 77, 85, 118, 123, 137

Barry, Judith, 41–45

Bauhaus, 10, 94, 99

Belcher, Alan, *136, 147*, 164

Benjamin, Walter, 115, 117

Bickerton, Ashley, *147*

Black, Misha, 58, 59

Bolande, Jennifer, 165, *167*

Boshier, Derek, 27, 77

Brodsky, Alexandr, *138, 139*, 142

brutalism, 22, 39, 45, 47–51, 65, 69, 123

Bunk, 12, 19, 22, 24

capitalism, 9, 16, 88, 126, 144, 149, 154

Carter, Peter, *36*, 39, 48, 50

Castelli, Leo, 6, 87, 88, 89, 92, 93, 94, 97, 98, 99, 101, 102

Catleugh, J.D.H., *36*, 38

Clegg & Guttman, 94, *95*

Clocktower Gallery, The, 6, 87

collage, 12, 24, 25, 41, 73, 80, 82, 85, 94

collectors, 41, 54, 89, 91, 92, 96, 98, 99, 152

Colquhoun, Alan, 41, 48, 50

comics, 19, 24, 25, 28, 39, 91

commodification, 6, 115, 117, 145, 148, 152

communism, 111, 123

constructivism, 9, 10, 35, 39, 48

consumption, 9, 10, 14, 15, 16, 17, 25, 31, 32, 45, 49, 57, 58, 59, 60, 62, 63, 66, 77, 85, 123, 144, 146, 148, 149, 154, 165

Cook, Peter, 124, *125*

Coop Himmelblau, 134, 142

Coplans, John, 6, 87, 88, 89, 93, 94, 98, 99, 100, 101 (portrayed); 102

Corbusier, Le, 50, 53, 65

Cordell, Magda, 8 (pictured); 9

Coventry Cathedral, 12, 48

criticism, 9, 10, 31, 41, 45, 98, 99, 115, 117, 119, 123

Crosby, Theo, 25, 35, *38*, 39, 41, 45

Crow, Thomas, 113, 115

culture, popular, 6, 9, 10, 12, 14, 15, 16, 17, 22, 24, 26, 27, 28, 31, 35, 41, 42, 45, 48, 49, 71, 72, 83, 84, 85, 87, 88, 89, 113, 114, 115, 119, 121, 123, 124, 129, 130, 131, 154, 161, 171

dada, 83, 84

Daily Mail Ideal Home Exhibition, 49, 51

del Renzio, Toni, 12, 14, 39

design, 14, 32, 41, 57, 58, 60, 62, 63, 115

design, exhibition, 10, 24, 41–45, 151

design, industrial, 14, 41, 58

design, interior, 15, 41

Diamond, Jessica, *168*, 170

Dine, Jim, 88, 114

Dion, Mark, *168*, 170

Duchamp, Marcel, 27, 45

Dubuffet, Jean, 24, 48

Dwyer, Nancy, *149*

Einstein, Albert, 134, 136

Eisenhower era, 6, 89, 97

entropy, 73, 75

environment, 35, 72, 73, 119, 129

ephemera(l), 6, 9, 12, 84, 131, 154, 171

Ernest, John, *37*, 39

Facetti, Germano, *38*

fashion, 16, 22, 28, 77, 78, 85, 91, 99, *108,* 115, 159, 163, 165

fetishism, 25, 82, 159, 166, 167, 168

fifties, the, 20, 57, 60, 63, 82, 83

Finkelpearl, Tom, 6, 7, 111–117

Forbidden Planet, 70, 71, 72, 73

formalism, 12, 51, 99

Frampton, Kenneth, 47–51, 140

Freud, Sigmund (also Freudian), 10, 24, 33, 71, 85, 117, 159

Froshaug, Andres, *44*

function, 10, 14, 58, 117

futurism, 14, 20, 24, 45, 114

gaze, 84, 151, 159, *161,* 167

Gehry, Frank, *98, 99, 100*

Giedion, Siegfried, 12, 44

Gilbert and George, *144*

Graham, Dan, *135,* 137, 138

Graves, Michael, 129, 142, *143*

Greenberg, Clement, 73, 75, 83, 99, 113

Gropius, Walter, 51, 53, 55, 57, 65

Groupe Espace, 35, 38

Growth and Form, 43, 44

Hadid, Zaha, 134, 136, *137*

Halle, Howard, 7, 144–149

Halley, Peter, 94, 95 (n.)

Hamilton-McHale-Voelcker, *8, 9, 11, 13,* 39, 45, 71, 72, 87, 88

Hamilton, Richard, 6, 8 (pictured); 9, *11,* 12, *13,* 16, *23,* 24, *25,* 26, 27, 28, 38, 39, *40,* 41, 42, 43, *44,* 45, 49, 57–63, 71, 72, 77, 80, 81, *82,* 83 (n.); 85

Hamilton, Terry, 8 (pictured), 9

187

Haus-Rucker-Co, 130

Haus-Rucker-Inc., *126*

Hearst, Patricia, 117 (pictured)

Heath, Adrian, *36,* 39

Hebdige, Dick, 77–85

Heiss, Alanna, 6, 87, 88, 91, 92, 93, 94, 96, 97, 98, 99, 101

Henderson, Nigel, 12, 20, 24, *26, 27, 29* (pictured); 39, 44, 45, *46, 48, 49,* 50, *53, 79,* 114

Hepworth, Barbara, 38, 93

Hill, Anthony, *37,* 39

history, 19, 31, 39, 102, 120, 122, 123, 131, 138, 145, 146, 148, 149

Hitchcock, Alfred, 31, *32*

Hockney, David, 27, 77

Holzer, Jenny, *158,* 159, 160, 161

Hopps, Walter, 100, *101*

House of the Future, 48, 51, 54

Howell, William, 48, 50

Hull, James, *36,* 39

humanism, 10, 32, 33, 47, 48, 149

Independent Group, 6, 9, 10, 12, 14, 15, 16, 17, 19, 22, 24, 25, 26, 27, 28, 35, 41, 42, 43, 45, 71, 72, 73, 77, 87, 88, 94, 101, 114, 117, 123, 151, 152

Industrial Design, 59, 66, 69

installation, 9, 35, 38, 39, 41, 45

Institute of Contemporary Arts (ICA), 10, 12, 15, 22, 24, *40,* 41, 44, 45 (n.); 48, 71, 77, 121, 123

irony, 88, 89, 94, 101, 102, 120, 123, 124, 129, 153, 166

Jackson, Anthony, *37,* 39

Jackson, Sarah, *37,* 39

Jenkins, Ronald, 24, 44

Johns, Jasper, 88, 89, 92, 113

Johnson, Betsey, 6, *86,* 87, 91, 92, 93, 94, 96, *97,* 99

kitsch, 9, 83

Kline, Franz, 24, 92

Koolhaas, Rem, 134

Koons, Jeff, 94, *95,* 101, 167, 168, *169*

Krazy Kat Archive, 28

Krier, Leon, 134

Kruger, Barbara, *160, 161,* 165, 168

Lannoy, Richard, 12, 14

Lawson, Thomas, 7, 19–28, 151–170

Leffingwell, Edward, 6, 87, 133–143

Lemieux, Annette, *162*

Levine, Sherrie, 115, *154,* 159

Lichtenstein, Roy, 6, 87, 88, 89, 91, *92,* 93, 94, 96, *97,* 98, 99, 100, 101, *102, 107* (pictured)

McHale, John, 8 (pictured); 9, *11,* 12, *13,* 15, 16, 24, 38, 39, 45, 71, *72,* 78, 85

magazines, 12, 15, 16, 17, 24, 28, 31, 39, 42, 54, 57, 66, 82, 83, 96, 98, 159, 165, 166, 167

man, 31, 33, 39, 137, 159

Man Ray, 151, 163, 166, 171

manifesto, 10, 42, 126

Man, Machine and Motion, 44, 45 (n.); 114

Mapplethorpe, Robert, *152*

Martin, Kenneth, 38, 39

Martin, Mary, 38, 39

mass media, 6, 26, 31, 32, 33, 39, 85, 111, 115, 119, 120, 123, 142, 148, 151

mass production, 9, 31, 55, 58, 59, 78, 82, 124

Matthews, Richard, *37,* 39

Modernism, 10, 12, 16, 19, 22, 83, 93, 113, 115, 120, 122, 123, 129, 134, 144, 146, 154, 159, 170

Moholy-Nagy, Laszlo, 12, 44

Monroe, Marilyn, 9, 17 (pictured); 62, 93 (pictured)

Moore, Henry, 79, 93

Morris, William, 57, 78

movies, 10, 14, 15, 16, 17, 22, 31, 32, 39, 45, 66, *70, 73,* 77, 96, 102, 138, 152, 153, 154, 160, 163, 166

Mullican, Matt, 154, *155,* 157

museums, 10, 24, 31, 42, 94, 98, 99, 100, 114, 115, 146, 149, 165

Museum of Modern Art, 10, 22, 43, 98

music, 9, 12, 15, 28, 31, 78, 85, 91, 102, 115, 148, 152, 154

Nagy, Peter, 165, 166

Nelson, George, 57, 58, 59

Newby, Frank, *36,* 39

Newton, Isaac, 134, 136

New Worlds, 71, 72

Nochlin, Linda, 112, 113

nostalgia, 19, 25, 122, 131, 145, 146, 153

obsolescence, 17, 33, 58, 65, 66

Oldenburg, Claes, 6, 7, 87, 88, 89, *90* (pictured); 92, *93,* 94, 96, 97, *98,* 99, *100,* 101, 102, 104 (pictured); 105, 106, 108, 109, 113, 114, 151

Onassis, Jacqueline Kennedy, 89 and 90 (portrayed); 91

Ozenfant, Amedee, 12, 44

painting, 16, 31, 41, 79, 89, 93, 99, 112, 113, 115

Paolozzi, Eduardo, 6, 12, *18,* 19, 20, *21,* 22, 24, *27,* 28, 29 (pictured); 39, 44, 45, *46,* 48, *49,* 50, *68,* 71, 72, *76,* 77, *83,* 85, 114, 151

Paolozzi, Freda, 12

Parallel of Life and Art, 21, 24, *42, 43,* 44, 45 (n.); 48, 114

Pasmore, Victor, 12, 35, 39, *40,* 45

Patio and Pavilion, 27, 39, *46, 49, 50,* 114

Penrose, Roland, 10, 22

Pevsner, Nikolaus, 14, 47

phenomenology, 140, 142

Phillips, Patricia, 7, 119–131

photography, 6, 12, 14, 24, 43, 44, 94, 110, 111, 112, 115, 117, 140, 141, 142, 148, 151, 157, 159, 161, 163, 166, 167, 168

Picasso, Pablo, 24, 88, 102

Pine, Michael, *37,* 39

politics, 84, 93, 111, 112, 113, 114, 115, 144, 154

Pollock, Jackson, *21,* 25, 79, 101, 151

Pop, 7, 15, 28, 77, 78, 79, 80, 81, 82, 83, 84, 85, 87, 93, 94, 113, 114, 115, 119, 120, 123, 126, 129, 131, 151, 170

Pop architecture, 119, 120, 129, 131

Pop Art, 9, 12, 15, 16, 17, 22, 26, 39, 54, 60, 77, 78, 79, 80, 81, 82, 83, 84, 87, 88, 92, 94, 99, 100, 102, 112, 119, 152

Pop, British, 6, 25, 77, 78, 79, 80, 81, 82, 83, 87, 88, 151

"Pop Project, The," 6, 87

populism, 22, 47, 49

Postmodernism, 120, 122, 126, 129, 134, 140, 141, 142, 146

prefabrication, 51, 55

Presley, Elvis, 84 (portrayed); *166* (pictured)

Prince, Richard, 115, *148, 156,* 157, 159, 160, 165

Quant, Mary, 91, 93

radio, 12, 15, 57, 136, 137, 148

Rauschenberg, Robert, 88, 92, 113, 114, 159

Read, Herbert, 10, 12, 16, 22, 43, 73

realism, 93, 112, 113, 115

Robbins, David, *164,* 166, 167

Robby the Robot, 35, 39, 68 (pictured); 70, 71

robots, 9, 28, 70, 71, 72

Rosenquist, James, 94, 102, *107* (pictured)

Ruscha, Edward, *158*

Salle, David, 94, 154, *155,* 157, 159

Scanavino, Emilio, *37, 39*

Schwitters, Kurt, 10 (n.); 12

science, 14, 15, 22, 24

science fiction, 9, 19, 22, 28, *30, 33, 70,* 71, 72, *73,* 83, 85, 114, 123, 124, 146

Scott Brown, Denise, 126, 130

Scull, Robert and Ethel, 92, 109 (Robert pictured)

sculpture, 39, 41, 75, 79, 89, 100, 101

Sedgwick, Edie, 86 (pictured): 91

sex, 17, 42, 69, 71, 82, 85, 158, 163

shelter, 111, 112, *113, 116,* 117

Sherman, Cindy, *92,* 94, 161, *162, 163,* 165

signs, semiotics, 10, 15, 16, 17, 20, 31, 39, 48, 69, 77, 85, 130, 131, 140, 144, 146, 148, 149, 168

simulation, 115, 117, 127, 146, 165

SITE Projects, 7, *127, 128, 130,* 131

site-specific, 41, 75, 112

Smith, Patti, 152 (pictured); 153

Smithson, Alison, 6, 12, 24, *26,* 29 (pictured); 39, 41, *42,* 44, 45, *46,* 47, 48, 50 (pictured); 51, 53–55, *54,* 85, 114, 123, 130

Smithson, Peter, 6, 12, 24, *26, 27,* 29 (pictured); 39, 41, *42,* 44, 45, *46,* 47, 48, 50 (pictured); 51, 53–55, 54, 85, 114, 123, 130, 133

Smithson, Robert, 71, 73, *74,* 75, 151

Steinbach, Haim, 94, *95,* 168, *169*

Stern, Robert A.M., 129, 141

Stirling, James, *37,* 39, 41, 50

Store, The, 89, 90 (pictured); 96

suburban, 123, 126, 138

surrealism, 10, 20, 24, 159, 170

technology, 12, 14, 15, 17, 22, 24, 33, 41, 42, 44, 45, 51, 58, 59, 69, 71, 72, 73, 120, 123, 124, 126, 129, 138, 148

telephone, 25, 39, 92, 94, 133, 136, 137

television, 6, 10, 12, 15, 17, 25, 32, 39, 49, 78, *132,* 133, 134, *135,* 136, 137, 138, 140, 142, 145, 146, 148, 151, 152, 153, 154, 160, 161, 166, 167, 170

This Is Tomorrow, 8, 9, 10, *11, 14, 15, 17, 24,* 25, *26, 27, 34,* 35, *36, 37, 38,* 39, 41, 42, 45, *46,* 48, *50,* 51, 71, 72, 73, 82, 114

This Is Tomorrow Today, 6, 45, 86

Thornton, Leslie, *36,* 39

transformation, 16, 53, 84, 89, 93, 119, 130, 133, 151, 157, 168

Tsai, Eugenie, 71–76

Tschumi, Bernard, *140, 141*

Turnbull, William, 12, 20, *38*

Utkin, Ilya, *138, 139,* 142

utopia, 9, 10, 16, 17, 124

Vaisman, Meyer, *147*

van Bruggen, Coosje, 97, *98, 100*

Venturi, Rauch and Scott Brown. *118, 122, 124, 125,* 126, 129

Venturi, Robert, 7, 124, 126, 129, 130, 131, 141

vernacular, 50, 51, 92, 99, 100, 126, 129

Vietnam, 19, 91, 153

Voelcker, John, 8 (pictured); 9, *11, 13,* 39, 45, 71, 72

Wallis, Brian, 6, 8–17, 87 (n.)

Warhol, Andy, 24, 83 (n.); *84,* 87, 88, *89, 91* (pictured); 96, 97, 98, 100, 102, *103* (pictured); 108, 109, 113, 151, 159, 165

Webb, Michael, 124, 131

Weeks, John, *36, 39*

Weiss, Glenn, 7, 133–144

Wesselman, Tom, *106* (pictured)

Westwood, Vivienne, 28, 85

Whitechapel Art Gallery, 9, 25, 35, 38, 41, 45, 48, 71, 87 (n.)

Whitham, Graham, 35–39

Williams, Denis, *37, 39*

Wilson, Colin St. John, 35, *36, 37,* 38, 39, 41, 48

Wodiczko, Krzysztof, 7, *110,* 111, *112,* 113, *114,* 115, *116,* 117

woman, 32, 33, 39, 83, 85, 91, 92, 93, 94, 137, 159, 161, 162, 163, 165

Wright, Edward, *15, 38,* 41

The Institute for Contemporary Art

Richard Ekstract
Andre Emmerich
Wouter Germans van Eck
Mathew and Edythe Gladstein
Barbara Gladstone
Sara and Seth Glickenhaus
Marian Goodman
Barbara and Donald Jonas
June and Ira Kapp
Mr. and Mrs. I.H. Kempner III
Nathan Kolodner
Robert Layton
Ira Levy and Stan Gurell
Vera G. List
Ronay and Richard Menschel
Sue and Eugene Mercy
Enid and Lester Morse
Zachary P. Morfogen
Louis and Mary S. Myers
Maxine and Ned Pines
David Rockefeller
Phillip E. Romero
Jackson S. Ryan, Jr.
Douglas Schoen
Tony Shafrazi Gallery
Fredrick Sherman
Jerry I. Speyer
Sean O. Strub
Estelle and Harold Tanner
George H. Waterman, III
Sperone Westwater
Anonymous

Contributing Members
Jay and Madeleine Bennett
David Bermant
Eddo A. Bult
Confort & Co. Inc.
Mr. and Mrs. Kenneth N. Dayton
Dudley Del Balso
Valerie and Charles Diker
Virginia Dwan
Mr. and Mrs. Anthony T. Enders
Ronald Feldman Fine Arts Inc.
Mr. and Mrs. Arnold C. Forde
Arthur Goldberg
Daryl Harnisch
Michael and Marianne Keeler
Robert and Ryda Levi
Lewis Manilow
Alfredo de Marzio
Bea Medinger
Midori Nishizawa and Akira Ikeda
T. Pelham
James G. Pepper
David N. Pincus

Mr. and Mrs. Frederick Phineas Rose
Mikael Salovaara
Mr. and Mrs. James S. De Silva
Mr. and Mrs. Michael Sonnabend
Frederieke S. Taylor
Robert G. Wilmers
Anonymous

Board of Directors
Anthony M. Solomon, *Chairman*
Brendan Gill, *Chairman Emeritus*
Alanna Heiss, *President and Executive Director*
John Comfort, *Treasurer*
Jane Timken, *Secretary*

Richard Bellamy
Kenneth D. Brody
Leo Castelli
Christo
Edward L. Gardner
E. William Judson
John Kaldor
Nathan Kolodner
Gianni De Michelis
Zachary P. Morfogen
Claude Picasso
Robert Rauschenberg
Renny Reynolds
Douglas Schoen
Francois de Seroux
Ruth L. Siegel
Roger R. Smith
Sean O. Strub
Virginia Wright

Lists complete as of September 1, 1987

Staff
Alanna Heiss, *President and Executive Director*
Gwen Darien, *Deputy Director*
Chris Dercon, *Program Director*
Kathleen Fluegel, *Director of Public Affairs*
Barry Johnson, *Building Director*
Karen Ernst, *Education Director*
Thomas Finkelpearl, *Clocktower Director*
Hank Stahler, *Chief Preparator*
Joshua Decter, *Program Coordinator*
Jane Darcovich, *Development and Fiscal Assistant*
Karen Ott, *Publications and Executive Assistant*
Rebecca Quaytman, *Receptionist and Program Assistant*
Gaspar Gorbea, *Building Manager*
Kathy Kao, *Bookkeeper*

Carole Kismaric, *Director of Publications*
Edward Leffingwell, *Curator Emeritus*
Pieranna Cavalchini, *European Coordinator*

US $30 —